Public Monuments

Art in Political Bondage 1870–1997

Sergiusz Michalski

REAKTION BOOKS

To my mother
and the memory of my father

Published by Reaktion Books Ltd
11 Rathbone Place, London W1P 1DE, UK

First published 1998

Series design by Humphrey Stone

Printed and bound in Great Britain by
Biddles Limited, Guildford and King's Lynn

British Library Cataloguing in Publication Data:

Michalski, Sergiusz
 Public monuments: art in political bondage 1870–1997. –
 (Essays in art and culture)
 1. Art – Political aspects 2. Monuments
 I. Title
 306.4'7

ISBN 1 86189 025 7

Contents

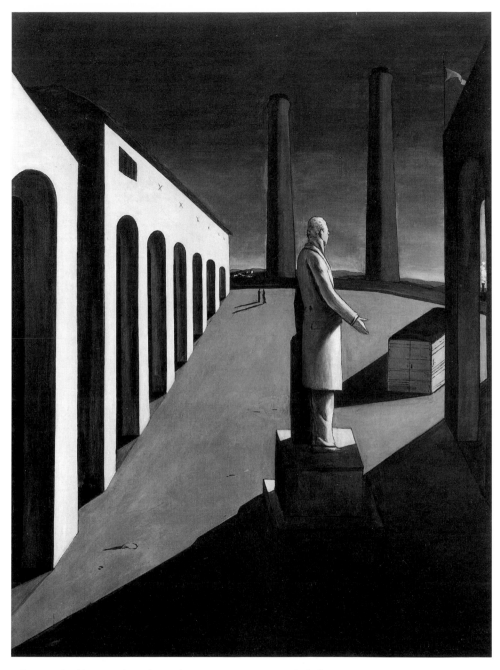

1 Giorgio de Chirico, *The Enigma of a Day*, 1914, Museum of Modern Art,
New York.

Preface

In 1914 – which was in a way the last year of the nineteenth century – Giorgio de Chirico painted his famous *Enigma of a Day* (illus. 1). In the centre of the picture, there appears a typical nineteenth-century 'statue d'un grand homme'. The individual honoured in timeless, mythological marble wears a fin-de-siècle coat; with his left hand resting on a column, he turns his right one invitingly towards the audience. This pose belongs to the repertoire of gestures used when commencing a speech – the viewers were assumed to be in place, reflecting the rhetorical flourish of the statue's subject. This is clearly another great man of the nineteenth century who is enjoying the honours of the meritocratic, bourgeois Pantheon of statuary.

But suddenly, fissures and cleavages become apparent. Bidding for eternal validity, for timeless monumentalization, the statue cannot, alas, deny its all too apparent fashionable trappings. The costume and scenic attributes all echo the most minuscule conventions of their epoch. The area in front of the monument is disconcertingly empty; no viewer, worse still no connoisseur of statuary, can be seen there. In lieu of the timeless representation the statue was striving for, one sees instead the signs of time's passage. Shadows mercilessly encircle the statue, as if on a dramatized sundial. But it is the boundless space – de Chirico's masterly evocation of a space without confines – which finally unmasks the statue's effrontery by confronting it with real timelessness, thus reducing its quest for eternity to the level of a misplaced scenic gesture. Even the monument's compositional qualities are questioned: the stark chimney pieces in the background have an obelisk-like quality in direct contrast with the jagged outline of the statue. The latter seems strangely out of character, out of place, out of time. Clearly, its epoch must already have passed. August 1914 was approaching, bringing with it a calamitous end to the old order and heralding the advent of a new cultural age.

The public figural monument whose demise the prophetic de Chirico was sensing was one of the favourite elements

of nineteenth-century culture. As a consequence, the crisis of figuration in the twentieth century has incorporated that of the public political monument. What is more, in our own age the cult of the great man seems to have lost – despite the media's exuberance – much of its normative appeal.

Old forms die hard, however. The crisis of the statue, as pictured by de Chirico, might already be 80 years old, but classic figural monuments are still being erected all over the world, though more so in the Third World. They still provide a standard of sorts and are imbued with an archetypal vivacity of their own. Attacks on and parodies of this scheme as undertaken by Claes Oldenburg or Gilbert & George tend paradoxically to highlight their continuing relevance.

In Europe, the public political monument began to evolve at the end of the Middle Ages in a slow, gradual process, with the category becoming difficult to discern among monuments with sepulchral connotations or public decorative sculpture of the Renaissance and Baroque. The statue which the Sicilian town of Messina erected in honour of the victor of Lepanto, Don Juan of Austria (1572), was the first statue destined solely for public space, earlier monuments having been designed for or kept in the non-civic space of castle or court. The Messina statue thus marked the commencement of an almost three-century-long process of evolution in the course of which the fledgling public monument lost most of its monarchical or aristocratic strictures and became – in the late nineteenth century – the preserve of bourgeois political culture and representation.

This book begins with the historical moment in the 1800s when the urge to erect monuments to commemorate important personages or patriotic events and memories acquired a new (in both the ideological and numerical sense) dimension, moving beyond the limitations of individually conceived acts of homage. It ends with the late 1990s, close to the beginning of the third millennium, when most of the premises which guided this efflorescence have been abandoned or changed fundamentally, at least in the leading countries of the Western world. It is the historical– and in part the methodo-logical – assumption of this short presentation, which is meant to be interpretative rather than synthetic, that at some time in the 1870s the erecting of public monuments became an artistic, political and social domain in its own right. Earlier

monuments, though often of great political relevance or artistic value – as the works created by Thorvaldsen, Rude or Rauch – had been conceived as individual tokens of respect. Although the number of monuments continued to grow in the course of the nineteenth century, it was only in the 40 or 50 years before the terrible caesura of 1914 that a specific *Denkmalkultur* (the only really accurate term) came into being. The first country where this happened was Republican France after 1871; there, artistic traditions and ambitions were joined with novel political imperatives, resulting in the creation of a wide and varied system of public statuary. By starting with the Parisian statuary, the present volume will both refer back to the accumulated experience of the nineteenth century and show new lines of development after the Belle Epoque.

Thus, this study will attempt to sketch, by choosing the most significant – not the most representative – phenomena, the development of public monuments since the apogee of the tradition at the end of the 1800s. The first chapter describes the synthesis of the old figure-and-socle scheme with the urban fabric of Third-Republic Paris. The Parisian monuments represented the epitome of a Republican meritocracy with strong historicist leanings which led to unprecedented 'statuo-mania'. Concluding this chapter with an analysis of the attitude of the Parisian Surrealists to these monuments, we shall explore their poetic and magical conceptions of mundane statuary. Wilhelmine Germany opposed to Parisian elegance and clarity the mythic aspects of Teutonic granite – as seen in the singular cult of Bismarck – thus embarking on the road which led ultimately to Nazi irrationality. Amazingly, in 1918 the nascent Communist regime in Soviet Russia tried to continue the educational aspects of the Parisian programme, though in more avant-garde terms. Soon, however, the twin phenomena of stylization and gigantism set in, giving Communist statues their grim, depressing quality. The fall of the Soviet statues in 1989 provides us with a unique example of the removal of a whole universe of compromised public monuments. A chapter on Nazi monuments will present another model of totalitarian strategy.

The next two chapters present little-known but significant examples of Western attempts to recreate a heroic, or pseudo-heroic, monument style after 1945. They analyze the

phenomena which increasingly determined the evolution of the public monument: inversion, invisibility and mirroring. An excursion into the quixotic aspects of public monuments in the Third World will – after analyzing the cases of Mexico and North Korea – bestow compliments on that most unlikely of candidates, Saddam Husain. The concluding chapter surveys and analyzes the salient qualities of the monuments of the 1990s.

The future of the public monument is now more open than ever, the distinctions between public monument and public sculpture, between concept and realization, becoming increasingly blurred. Some aspects of this development are quite recent, while some date from the beginning of this century. Thus, some of the roots of the abstract monument – to be seen after 1951, the year of the erection of the West Berlin Airlift memorial – can be traced back to the artistic experiments in Soviet art of the Revolutionary period. It seems, however, that another tradition of abstract solutions was established by intra-war memorials dedicated to the fallen soldiers of the First World War. In the third chapter on these memorials, we try to indicate the circumstances which induced both planners and artists to discard figurative solutions totally or at least limit them substantially. Lesser modern phenomena, such as the placing of advertising figures on socles – a picturesque habit encountered since the 1970s – have their antecedents in Surrealist ideas of the 1920s and 1930s.

Other lines of development which we shall attempt to pursue include the growing symbolic polyvalence of monuments and the various attempts to create – mostly by means of signposts – more or less cohesive agglomerations of monuments in broad urban expanses. Much attention has been devoted to the ever stronger penchant for paradoxes of form and function as exemplified by both blackness and the concept of inversion and by recent ideas espousing permanent transformations and so-called counter-monuments.

In recent decades, the public monument has been charged with the task of commemorating and symbolizing humankind's most terrible catastrophe: the Holocaust. Theodor Adorno's famous Auschwitz adage might not have hindered the writing of poetry, but it certainly weighs heavily on modern consciousness. In the domain of public memorials devoted to Jewish suffering, it seems by implication to favour

abstract solutions. Some comments about recent Holocaust memorial competitions provide the closing chords of this book.

While writing, I was helped in a variety of ways by my friends Prof. Adrian von Buttlar, Reinhard Steiner and Victor Stoichita. My friends Dres. Alexandra and Wladyslaw Bartoszewski corrected my English with Benedictine patience, eliminating many mistakes and narrative loose ends. Further corrections were provided by Mrs Doris Pfister, MA, who typed up the difficult manuscript in admirable fashion. I profited greatly from the succinct reviews of the first draft of the book by Prof. Stephen Bann and Prof. Dario Gamboni. Mrs Johanna Faist, Julia Ricker, the great photographer Pierre Jahan, Prof. Anders Åman, Hans-Ernst Mittig, Bernd Roeck, Klaus Schwabe and Dr Tomasz Torbus helped me with the photos. To all of them I feel a keen sense of gratitude.

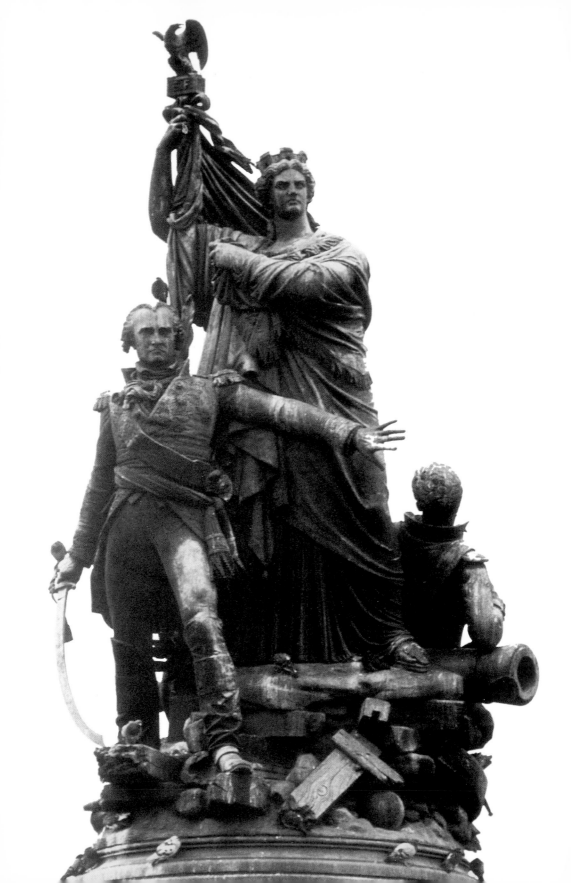

1 Democratic 'Statuomania' in Paris

On 15 August 1870, the ceremonial unveiling of an important monument was scheduled to take place on the Place de Clichy in Paris (illus. 2). The Emperor himself had promised to lend his presence to this significant state occasion. The monument constituted the first major commission of the city of Paris, then governed and being transformed with a firm hand by the famous Baron Haussmann. An imposing, free-standing allegorical-historical group – a novelty in the context of Parisian statuary of the period – was to present the spirited defence of the Barrière de Clichy, under the command of General de Moncey, against the troops of the anti-Napoleonic coalition at the end of March 1814. After seven years of deliberations and constant changes, the sculptor Amédée Doublemard had finally completed a three-figure group. General de Moncey stood before a towering personification of Lutetia (Paris), protecting her with sabre in hand, while, on her other side, a wounded young student, glowing with patriotic fervour, slowly sank to the ground.

Judged by the standards of mid-nineteenth-century allegorical art, Doublemard had hit upon an excellent solution, one which combined the figure of a real person with that of a social type and a personification, thus establishing an important triadic model for later statuary. In a move in keeping with the anti-Revolutionary ideology of the state, the artist created in the figure of the young student of the Ecole Polytechnique – an important institution of the Empire – a physiognomic substitution for the type of Revolutionary Parisian urchin immortalized by Hugo and Delacroix. The pyramidal form of the group followed a hallowed Academic scheme, but adroitly combined classicizing pathos with Romantic-style flowing movement. Looking towards the fortifications of Paris – whence the enemy had come – the statue nevertheless fits well into the Place de Clichy.

The ceremonial unveiling did not take place, however. In mid-August 1870, Napoleon III had already joined his

2 Amédée Doublemard, *Monument to the 1814 Defence of the Barrier of Clichy*, Place de Clichy, Paris, 1870.

retreating armies and the Prussians had just commenced their march towards Sedan. The siege of Paris two months later reflected the monument's theme once again. A photograph taken in early 1871 shows the statue surrounded by cannons, as if striking a defensive pose.

The monument on the Place de Clichy thus had a singular fate: inaugurated not by an official ceremony but by a re-enactment of its historical narrative, it became by chance the first statue of the fledgling Third Republic, a state born amidst battle and cannon fire, which in turn was destined to create the most remarkable metropolitan agglomerate of political and historical monuments in human history. What is more, the fact that Doublemard's work had come about because of a municipal commission (in view of Haussmann's position somewhat nominal) set a pattern for most of the monuments which were later to grace the Third Republic's capital.[1]

MODEST BEGINNINGS

The first decade of the Republic's existence, spanning the 1870s, hardly presaged such a course of events. In a demonstrative act of anti-iconoclastic restitution, the Republic restored the demolished Vendôme column (1875) and charged Gustave Courbet – who had been only marginally involved in the demolition[2] – with the costs, thus forcing the hapless painter into exile in Switzerland. Since the Tuileries palace, which had burnt down, was not rebuilt, and the reconstruction of the destroyed Hôtel de Ville went on until the 1880s, the column's restoration was intended to symbolize the re-establishment of the 'public moral order'. Even the fact that the restitution of Napoleon's statue had by then taken on an undesirable Bonapartist ring was considered less important than the need to reverse its demolition by the dreaded Commune of Paris.

Of greater importance, with regard to the future, was the erection of an equestrian statue of Joan of Arc (1874),[3] a notable work by Emmanuel Fremiet, on the Place des Pyramides (illus. 3). By the nineteenth century, the cult of Joan had become the rallying point of different factions of French conservatism,[4] and Fremiet's monument, the slightly Gothicizing 'troubadour' allure of which evoked reminiscences of Restoration art,[5] provided the Right with a most

14

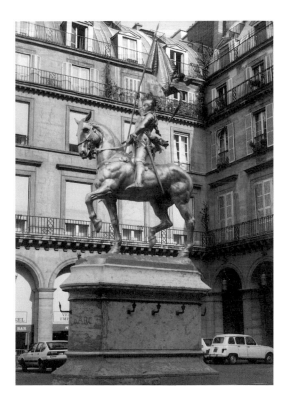

3 Emmanuel Fremiet, *Joan of Arc*, Place des Pyramides, Paris, 1874.

welcome symbol. Contrary to June Hargrove's suggestion, however, the monument did not appeal to all Frenchmen. When moderate Republicans celebrated the centenary of Voltaire's death in 1878, the Right responded – Voltaire having created in his 'Pucelle' a biting satire of Joan – by organizing ceremonies of homage before her monument.

The original intentions of the patrons of this equestrian statue certainly went farther than to provide a focal point for conservative counter-demonstrations, however. When it was conceived in 1872, the entry into Paris of a legitimate Bourbon pretender – the then Count of Chambord, who upon investiture was to take the name of Henri V – seemed imminent. Bishop Dupanloup of Orléans, who was the driving force behind the Joan cult, was also the (albeit unsuccessful) chief mediator between the two main monarchical factions. Joan's pose, and the role the statue was to play, can be understood properly only when we recall her mission: to liberate and enter French cities on behalf and in the service of her legitimate monarch. When, on a wintry February day in 1874, the

15

equestrian statue entered the indifferent or hostile city of Paris, it assumed the function which Joan herself had had and signalled by her pose and by the gestures of the leader of an imaginary cortège the imminent arrival of King Henri V.

However, through his constant refusal to accept the *tricolore*, the Pretender, a narrow-minded bigot, had by 1875 lost all chances of reversing the Republic. His entry into Paris – for which decorative carriages bearing the new royal monogram had already been constructed – never took place. This context may explain the fact that in the 1880s and later, the statue lost much of its appeal in conservative circles. When the sculptor Paul Dubois was commissioned to model another equestrian statue of Joan for Reims cathedral (1889–95), he chose (in accordance with the changed political climate) another motif: Joan's heavenly vision. Evidently, the bellicose aspects of the Paris statue were no longer judged palatable, a change evidenced also by the fact that a replica of the Reims statue was erected in 1897 on the Place St-Augustin in the metropolis.[6]

At the end of the 1870s, after the demission of President MacMahon, the Republic stabilized itself politically and gained a sense of its task as well as its destiny. With a marginalized Right licking its mostly self-inflicted wounds, the Republic turned towards the arduous task of establishing an ethos of its own, and that embraced the fields of self-representation and political propaganda. The year 1879 constituted a turning-point in this respect. That was when the first signs of a Republican tradition began to appear. Alphonse Thiers, who had died two years earlier, was the first politician of the Third Republic whose busts – from 1879 on – graced many an official building. From 1879/80, *préfectures* and *mairies* were decorated by official busts of the Republic, which public opinion preferred to address as 'Marianne'.[7] This popular cultic designation – admirably studied by Maurice Agulhon – was restricted to busts or painted images. Thus, when the City Council of Paris decided in early 1879 to proclaim a competition for a great statue of the Republic, it used the official designation 'Monument to the French Republic'.

The 90th anniversary of the French Revolution had provided the external stimulus for the City Council's decision. Unofficially, a thematic link to the events of 1789–92 – but not to the Jacobine terror which followed – was stipulated. The monument in question was to be erected on the Place de la République. The results of the competition were no doubt representative of the state of statuary art in France. By a slim majority, a Neoclassical *République* with three stiff seated personifications, submitted by the brothers Leopold (sculptural segments) and Charles Morice (architectural segments), carried the day. A vociferous minority opinion among the jury members claimed precedence for the second prize, a submission by the ex-Communard Jules Dalou. Dalou had just returned from exile in England and proposed a monument consisting of an attractive mélange of late Baroque and realistic elements.

Paradoxically, Dalou's project encountered opposition from both the Left and the Right. Both resented his stylistic dependency on Carpeaux and thought the project too overt a reference to the frivolous debauchery of the 1860s, exemplified by the latter's *Dance*. The classicizing inclinations of the Left – though many Leftists rejected the idea of public monuments as such – and the neo-Gothic penchant of the Right were at odds with the neo-Rococo and -Baroque style of Napoleon's failed regime. Going further, the contest between the Morice brothers and Dalou implied the need to choose between a static (the former) and a highly dynamic (the latter) conception of a public monument.

The Morices' statue, unveiled in 1883,[8] showed the Republic in a pose reminiscent of the (not yet unveiled) Statue of Liberty by Bartholdi, the torch's place being taken by an outstretched olive branch (illus. 4). This was a most appropriate symbol for the French Republic of the 1875–85 interlude, when a generally pacific inclination and a placid foreign policy seemed to have quenched any thoughts of revenge for Sedan and the amputation of Alsace-Lorraine. Leopold Morice decided to surround the main statue with personifications of the Republic's slogan, Liberty, Equality and Fraternity. He did this in a way which seemed to stress their links with

17

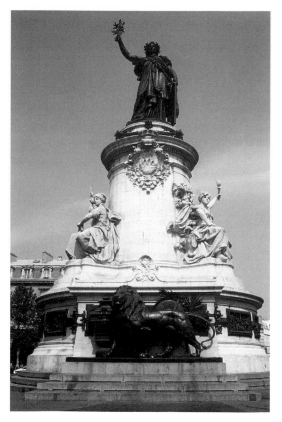

4 Leopold and
Charles Morice,
*Monument to the
Republic*, Place de
la République,
Paris, 1879–83.

the medieval system of the three theological virtues. Six
bronze tablets affixed to the base presented a meticulously
balanced choice of scenes from the years 1789–92, before
Robespierre's seizure of power. The only unconventional
element was provided by a lion in the foreground, which
guarded – as a living, functioning symbol of democracy – not
the habitual coat of arms but the simile of a ballot box (illus. 5).
The 23-m-high monument harmonized perfectly with its
surroundings. Although accepted by Parisians of the time, it
proved unable to inspire a deep attachment in later decades.
Somehow, the choice of the Morice brothers seemed too facile.

The City Council and competition jury must have realized
this, because half a year later they took what, judged by the
standards of modern statuary competitions, was a unique
decision. In early 1880, it was decided to erect a second monu-
ment to the Republic on the adjacent Place de la Nation and to
use the project of Dalou. Since Dalou's conception was totally

different, it was felt that the nominal duplication would not lead to thematic redundancy.

Dalou dressed his Republic[9] – in marked contrast with Morice's – in a Phrygian cap, thus establishing solid left-wing credentials from the outset and pointing to the statue's Revolutionary heritage (illus. 6, 7). He showed the Republic marching on a globe, her hand extended in a gesture of protection which somewhat resembled the holding of reins. Where Morice had presented a Republic suing for peace, Dalou demonstrated – by means of a truly Baroque iconographic formula – that republicanism as a form of government had a universal value – this despite the fact that France was by then the sole republic on European soil. The Republic claimed the same archetypal position on the globe which Christian iconography had reserved for Christ, the Virgin Mary or personifications of Religion and Faith.

The globe was fixed onto a chariot pulled by two lions. The Republic's protective gesture, by simultaneously implying the holding of entirely imaginary reins, stressed her directing role. Compositionally, this gesture found a visual response in the raised torch of the figure of Freedom, which sat daringly on a lion. Freedom looked, half-jubilantly, half-questioningly, at the Republic. It was she who by the splendidly polyvalent gesture of her hand gave Freedom his prerogatives while determining the limits of liberty. Labour – shown in the realistic form of an apron-clad worker with a hammer – and Justice

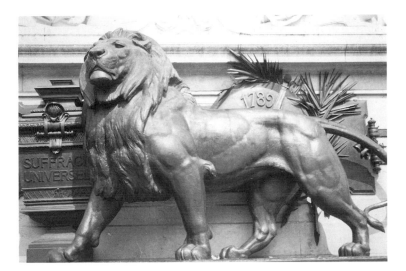

5 Morice and Morice, *Monument to the Republic*, detail showing lion guarding the ballot box.

19

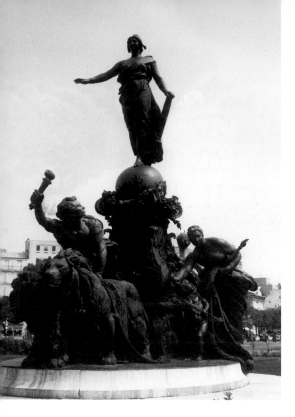

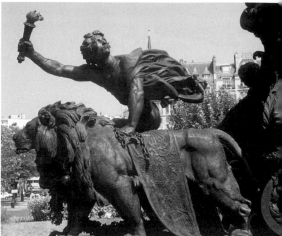

6 Jules Dalou,
The Triumph of the Republic,
Place de la Nation,
Paris, 1889–99.

7 Dalou, *The Triumph of
the Republic*, detail.

accompanied the Republic on both sides of her chariot, while
Peace, amidst signs of abundance, completed the cortège.

With a baroque exuberance which proved immensely
popular with the public, Dalou equated the historical mission
of the French Republic with the progress of human civiliza-
tion. In a certain sense, however, his solution had a historicist
ring. He shrewdly referred to the allegorical chariots employed
in the festivities of the Revolutionary era (*Fête de l'être suprème*,
1794; David's *Triomphe du peuple français*, 1794 and others),[10]
thus designing his monument according to a traditional left-
wing formula of civic pageantry, seemingly frozen for eternity
yet echoing the progress of modern life.

Dalou's *République* was one of the few monuments in Paris
whose location possessed a symbolic value of its own. The
concept of an uniform 'tissu urbain' promoted in the Paris of
the Third Republic an egalitarian view with regard to urban
locations: few places were considered especially worthy or, on
the contrary, undignified enough to receive a monument. The
choice in 1880 of the Place de la Nation – which until 1871 had
been called Place du Trône and had been the site of important
monarchical ceremonies – was the result of symbolic consider-

ations. It was as if the chariot had just passed the two royal statues (of Philippe-Auguste and Louis IX, erected in 1844–6) which stood atop two tall columns at the point where the Avenue du Trône reached the Place. Thus, the progress of the Republic left France's royalist past – as evidenced by the statues, the name of the thoroughfare and also the nearby Capetian Château de Vincennes – squarely behind. The Republic and her allegorical entourage – in a deeper sense a counter-march to that undertaken a decade earlier by the monarchist statue of Joan – moved purposefully towards the Faubourg de St-Antoine – that is, towards that old hotbed of all Parisian revolutions. Having travelled the length of the street, the imaginary cortège would have reached in due course the Place de la Bastille with its revolutionary tradition. The tall July column, erected there in the 1830s as a memorial to the July Revolution of 1830, was topped in 1840 by a winged *Spirit of Liberty* by Augustine Dumont, with a lion on the socle as a symbolic guardian of popular sovereignty. Both motifs also cropped up in the *Républiques* of Morice and Dalou, though in contexts which explained precisely their function in social life (the lion as guardian of the ballot box, liberty being restrained by Republican principles). It is interesting to note that through its didacticism, the Third Republic endowed traditional allegorical figures with modern or semi-modern functional differentiations. In the opinion of his contemporaries, Dalou's monument achieved – by virtue of its axial orientation and its representation of a pacific, Republican, but universalist France – a visual antonym to the Arc de Triomphe on the Place de l'Etoile, the latter standing for a 'France militaire et conquérante'.

Last but not least, the monument crowned a kind of 'Republican triangle' formed by the three great squares of the Parisian east (Place de la Bastille – Place de la République – Place de la Nation), since the Boulevard Voltaire with its programmatic name linked Dalou's work with its rival on the Place de la République. Dalou thus admirably resuscitated the iconography of the festivities of the Revolutionary era, permeated it with a blend of neo-Baroque form and naturalistic details and conferred on the result characteristics of enlivened urban pageantry, thus aspiring less to monumental immortality than to the impression of immediacy generated by the Revolutionary 'tableaux vivants'.

21

Dalou's monument was to experience not one but two memorable unveiling ceremonies. Both came about in periods of acute political tension, and both generated ample polemical overtones. Because of the many technical problems, it was decided to go through the stage of exhibiting a plaster cast in public, the festive inauguration of which took place on 21 September 1889 (illus. 8). This was the year of the lively celebrations of the French Revolution's centenary. With great acumen, the committee chose not the overburdened 14 July but the later September date, a date which referred to the establishment of the first French Republic in 1792. This provisional unveiling was accorded a splendid military ceremony in the presence of the President of the Republic and the Prime Minister. The official speeches placed the monument in a tradition begun by the events of 1789. They pointed out that the monument embodied the very Republican values which the ascent of General Boulanger and his movement might fatally threaten. The very next day, the Boulangists were narrowly defeated in elections, an event which, though it did not dissipate entirely the menace of the militaristic Right, presaged Boulanger's final defeat in 1891.

Ten years later, on 19 November 1899, the final bronze

8 Anonymous illustration showing the inauguration of the plaster cast of Dalou's *Triumph of the Republic* in 1889.

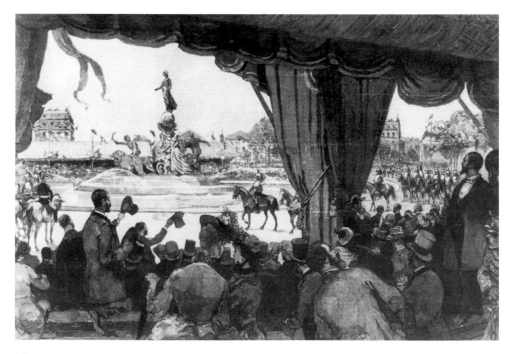

version was unveiled with far grander pomp and celebrations, but amidst an even greater state crisis. Although not threatening – in marked contrast to Boulanger – with a lightning coup d'état from the Right, the Dreyfus Affair was tearing the Republic's fabric asunder. A section of the Parisian press hostile to the Republic, representing the traditional Right as well as the nascent anti-Semitic movement, howled vociferous protests against the government of the day and against Dalou's '. . . triumph of a Jewish Republic . . . and Dreyfus'.[11] Two months earlier, Dreyfus had been granted a presidential pardon, without, however, being wholly rehabilitated. The man responsible for the affair, Major Esterhazy, had just fled to London. Although the supporters of Dreyfus were slowly gaining ground, the Affair was far from being terminated.

A quarter of a million Parisians watched the unveiling, this being '. . . an enormous crowd which agrees in proclaiming Dreyfus' innocence'.[12] The threat from the anti-Dreyfus Right had eased the tensions between the socialist Left and the ruling Republican centre – thus the prohibition against carrying red flags was waived for the duration of the ceremony. The march past the monument – in 1889 mainly by members of the military – now had a pronounced left-wing and civic, if not working-class, character. More than sixteen hundred workers filed past, many of them in work clothes and with the tools of their professions: this in direct reference to the attire of the bronze labourer. The march amounted to a re-enactment of Dalou's sculptural group and of his main idea – that the Republic as a political form served the advancement of civilization. But this was also a re-enactment of the Parisian Revolutionary processions of 1790–4. The speeches extolled the subject of Republican unity, a virtue sorely needed to shore the country up against enemies within and outside. For a fleeting historical moment, the rituals of the fledgling workers' movement merged with petit-bourgeois Republican pageantry, continuing a Revolutionary tradition. In the next century, workers' parades became the sole preserve of the Communists and, to a lesser extent, of right-wing populist or fascist movements. Any links to the centre were severed.

Dalou, allowed to return to France thanks to the amnesty of 1878, belonged to what may have been the last generation of bourgeois radicals of the non-socialist type who could

hope to bridge these two worlds. He expressed his views in a characteristic way in a press interview in 1899:

> When the man who works with his hands will be called to march past [my monument] while the crowd acclaims both the Republic and the workers, perhaps then he will better understand that a tool is not only made of metal or wood, but that it constitutes the true force of the country.[13]

An amusing sequel soon followed: Dalou's monument was surrounded by a decorative basin. When in 1908 bronze alligators and reptiles were placed on the basin's rims (following a suggestion by Dalou himself, though the execution was not by him), Parisian Republican opinion saw in these agitated creatures poignant caricatures of the anti-Republican Right howling in futile anger. The removal and melting down of these reptiles during the German Occupation seemed to many a confirmation of that popular theory (illus. 9). But by then, Dalou's work had lost much of its political relevance, becoming one more decorative element of the capital, with a message heeded less and less by friend and foe alike.

The constellation of 1879 of the two diametrically opposed projects by Dalou and the Morice brothers exerted a signal influence on the development of Parisian public monuments. In the decades which followed, Dalou's *République* provided Parisian statuary art with an excellent model, a continuous, fluid combination of a main figure and its allegorical companions unfolding in space in a circular composition. This tendency – in stark contrast with the style of Morice – would come to constitute a *differentia specifica* of Parisian monuments. The best Parisian works evoke the illusion of free-flowing, soft bronze and – to a lesser extent – translucent, vibrant marble; one could even speak of a sub-Impressionist quality. This quality elevates Parisian monuments above staid British Victorian statues and Vienna's *Ringstraßendenkmäler*. Only in Berlin did the neo-Baroque sculptor Begas attempt similar effects, without achieving a comparable quality of detail: the impact of his artfully interlocked figures was marred by gigantomania and the broad expanses of Berlin's squares. On the whole, the Germans preferred to oppose rustic granite to the intimate qualities of Parisian bronze and marble, granite being a rough material uncorrupted by civilization which espoused mythogenic Germanic qualities.

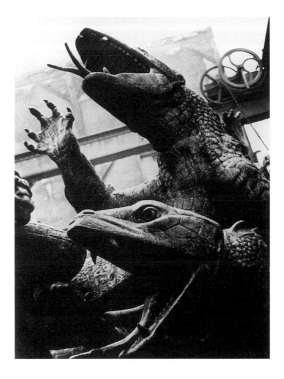

9 The reptiles which once surrounded Dalou's *Triumph of the Republic* lying in a Parisian scrap-yard in 1941. From Pierre Jahan, *La Mort et les statues* (Paris, 1946).

The public monuments of the Third Republic in Paris consisted of an astounding variety of types. Of crucial importance was the sitter's conventional, 'timeless' attire, presenting a synthetic image without striking personal attributes. An important strand presented convivial details of costume and lifestyle – thus, the writer François Coppée was allowed to smoke his beloved (bronze) cigar in public. But everyday objects could sometimes provide the starting points for a historical narrative. Thus, Marat was shown in his bath-tub, and the deputy Baudin awaited the mortal salvo with top-hat in hand.

These latter monuments introduce us to a specifically Parisian type which strove to capture the significant moment.[14] Coincidentally with the advent of the Third Republic, history painting had lost its status as the leading branch of official Salon art. The void thus created seems to have been filled in part by public monuments, which had taken over some of the narrative aspects of their sister art. A measure of discernment is necessary here. Marat's bath-tub naturally evokes the memory of Corday's fatal deed, but it can also serve as an attribute of, or wider reference to, the revolutionary's last years. The three

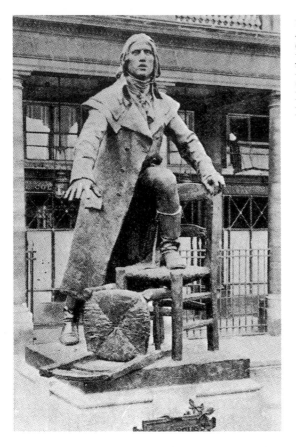

10 Eugène Boverie, *Monument to Camille Desmoulins*, Jardin du Palais Royal, Paris, 1905 (destroyed 1942). Photograph from a postcard of *c.* 1910.

memorialized martyrs of religion – Dolet, Servet and the Chevalier de la Barre – were all shown in bondage, awaiting imminent execution. Whereas the stake or the pillory could be conceived, in medieval fashion, as mere attributes, the Deputy Baudin with his top-hat re-enacted his own death as if in a bronzed snapshot of a famous incident of the 1852 anti-Bonapartist revolt.[15] The courageous Sergeant Bobillot storming forward to meet the enemy's bullets, and Desmoulins leaping from his chair to harangue the Parisians into storming the Bastille (illus. 10), provided two further examples of figures in narrative settings. Needless to say, the numerous bas-reliefs and plaques on the pedestals of these statues served as a source of additional historical information.

26

The monumental art of the Third Republic in Paris directly reflects the state's ideological foundations. Established in the wake of a crushing military defeat, the Third Republic unreservedly accepted the wider implications of Sedan and Metz. Pinpointing the terrible incompetence of the Bonapartist government, the Republicans were nonetheless very aware of the technical, organizational and cultural superiority of the Prussian enemy. The cannons of Krupp might have triumphed at Sedan, but behind them stood the advanced Prussian system of elementary and middle-grade education. The Republicans were determined to achieve revenge not only through military prowess but also by equalling German achievements in science and education. In the late 1870s and 1880s, there evolved out of these premises a pedagogically orientated, meritocratic system of democratic advancement and public honours, a system which was extremely optimistic about the future and which upheld the banner of civilized progress.[16]

Quite early on, the Republic decided to promote and create statues of its ideological and political antecedents. When petitioned for help to erect a monument to the Romantic writer and art critic Théophile Gautier, President Jules Ferry stated outright: 'But this is a Republic. We must begin with our own heroes . . . Gautier merits all our praise . . . but he was a Bonapartist.'[17] Knowing also that the isolated Republic lacked the decorum of adjacent monarchical systems, the ruling circles were determined to create with and around public monuments a system of institutionalized democratic pageantry suited to the particular aspirations of the urban middle class and of the intelligentsia in government or municipal service. Since each public monument was the fruit of a well-publicized initiative, of the actions of one or even several committees, of long-winded deliberations by administrative bodies, the mere workings of the political-administrative process bestowed on many a participant a measure of democratic glory, decorum and recognition. Many state functionaries and aspiring members of the bourgeoisie found in the erection of monuments a congenial field for meritocratic expression and self-enhancement. All this was crowned by the ceremony of the

unveiling – usually a great festive occasion, no less attractive than a première at the Opéra. Such events were highlighted not only in the political sections of the journals but also in the newspapers' social and gossip columns. To address the gathering during an unveiling was a much coveted honour.

The statue-building activity of the Third Republic centred on Paris. Although many monuments were erected in the major provincial towns, few of them possessed any artistic or iconographic importance transcending regional barriers.[18] Two notable exceptions are well known: Bartholdi's *Lion of Belfort* (1880) and Rodin's *Burghers of Calais* (1895). Not surprisingly, variants (Bartholdi) or casts (Rodin) also reached the capital after a time.

Only in Paris did the number, iconography and character of monuments result in the creation of a new urban aspect. When we speak of these works, the designation 'urban monument' suggests itself quite automatically. 'National monuments' of the Wilhelmine type, erected at picturesque or grandiose spots in the German landscape, exerted no fascination for the rational French, although it might be worth recalling that French Catholics erected great statues of 'Nôtre-Dame de France' during the reign of Napoleon III on picturesque hills in the countryside; an example is the popular monument in Le-Puy-en-Velay. The Emperor, on the other hand, sponsored a great figure of Caesar's valiant Gallic opponent, the tribal chieftain Vercingetorix (Alesia). But with Napoleon's fall in 1870, that particular strand of provincial monuments – ignored by the Republicans, disregarded by the Parisian public and the fledgling tourist industry – passed into a long oblivion, at the very moment, interestingly, when the Germans discovered the attraction of monuments in rustic locations.[19] Only in Paris was the ideological message propounded by the agglomeration (it would be far-fetched to speak of a closely knit system) of public monuments discernible by even an uninvolved layperson. And Paris was by then the cultural capital of Europe. The only comparable urban complex of public monuments in Europe – the *Ringstraßendenkmäler* on the great half-circular boulevard in fin-de-siècle Vienna – presented a less than homogenous assemblage of differing statuary and iconographic types.

Many factors had shaped Parisian policy regarding public statuary. One legacy of the Revolution and the Napoleonic

period was a penchant for tall columns – for example, the much-copied Victory column, the Vendôme-column or the July column.[20] However, columns of that type required a certain type of urban arrangement and axes of view, and were difficult to integrate into an existing city structure. The city planners of the Third Republic, tired of and frightened by Haussmann's changes of the Parisian street system, did not want to introduce great changes. They were inspired by the English system, according to which many public monuments were placed in gardens and public parks seemingly at random. Thus, many of the public monuments in Paris after 1870, even when erected on squares or at intersections, display a certain asymmetrical placement. The positioning of smaller monuments directly on the pavement without any rearrangement of their surroundings lent them an endearing, convivial touch – the Surrealists were to refer to these statues as the shadows and companions of the flâneur. Enemies of the statuary policy and many urbanists complained, however, that the city had become 'stuffed' in a random fashion. Writing shortly before 1914, the leading urban architect Eugène Hénard expressly demanded[21] a return to the system of monuments located atop tall columns, pointing out how they enhanced urban environments. Needless to say, his suggestions went unheeded.

Between 1871 and 1914, the political culture of Paris invariably leaned further to the left than did the rest of the country. As a rule, the City Council – with the exception of a short right-wing term around 1900 – espoused a more radical Republican policy in the domain of political representations and symbols than the short-lived governments of the Republic itself. Of course, the central authorities had both the money and the power to influence statuary policy: the role of the Under-secretary of Public Education, the enlightened bureaucratic administrator Dujardin-Beaumetz, can hardly be underestimated. But they were usually forced to come to an uneasy consensus with the Parisian municipal authorities. The Presidents of the Republic, by virtue of conferring or withholding their 'haute patronage', could also influence the success of particular monuments.

The erection of a monument in Paris was usually initiated by a semi-private committee and then forced through by prolonged negotiations with and deliberations by various

administrative bodies. The situation was further complicated by the fact that the City Council controlled the whole city save the Jardin des Tuileries, supervised by the government, and the Jardin du Luxembourg, the property of the Senate. Both were favourite locations for statues. Although erecting a monument sometimes called for intricate political and administrative manoeuvring, small groups with strong convictions regarding potential honourees often – too often – carried the day. One could even say that never before in history had it been so easy for small pressure groups to force their candidates through than in the Paris of the Belle Epoque.

The choice of the person to be commemorated had, in the majority of cases, a definite political connotation. By refusing to erect statues of great military leaders (with few exceptions), the Republicans established a very important premise. The defeat of 1870 and the royalist or Napoleonic links of many commanders had considerably narrowed this particular field. But this tendency was not based solely on tactical considerations. The Republic did not repudiate military valour and abilities as such – after all, it needed them for future revenge – but it preferred to conceive future wars in terms of the progress of civilization and technology. As a result, hidden bellicose inclinations were re-routed into monuments which praised the military indirectly. This might explain the fact that three war painters or illustrators (Raffet, Meissonier, Neuville) received monuments in Paris, despite the fact that one of them (Raffet) was an avowed Bonapartist while the two others had no strong Republican affiliations. According to the inauguration speeches, the drummer at the base of Raffet's monument beat his drum for revenge yet to come – but the monument as such certainly implied the sublimation of brute nationalism by culture and civilization. The one prominent statue devoted to an individual soldier praised a low-ranking military man (Sergeant Bobillot) who through his self-sacrifice had saved a remote colonial outpost. It thus displayed a most praise-worthy democratic view of military heroism notably absent in the next century's Communist military monuments.

Although by the 1880s, Parisian public monuments had acquired a definite political connotation – as seen in the two *Républiques* – by following a moderate Republican orientation, greater political conflicts arose only after 1890/91 – that is, after the end of the Boulanger Affair. In 1887, left-wing City

11 Jean Baffier, *Marat*, 1887 (before its destruction in a Parisian scrap-yard in December 1941). From Jahan, *La Mort et les statues*.

Councillors had decided to erect a statue of Marat (on the lawns of Parc de Montsouris) executed by Baffier (illus. 11). Knowing that in this peculiar case the public would not accept the erection of a 'normal' monument on a boulevard, they put forward the grossly improbable argument that in a park it would not function as a commemorative statue but solely as a decorative element. No doubt Baffier's Marat, shown leaning forward in a bath-tub, was an unlikely candidate for place-ment on a high plinth, but the sculpture appeared equally ill at ease as a garden decoration. When a play by Sardou, *Thermidor*, provoked a public debate about the French Revolution in 1891, right-wing City Councillors forced the authorities to remove the statue to a depot, from whence it surfaced in 1906 – the year of the final rupture of Church and State – to grace the Parc Buttes-Chaumont.

During the Third Republic, the attitude towards the French Revolution served as a sort of political litmus test; passions on the subject were still running very high. Marat was on the outer fringe of the Revolutionary Pantheon, detested by moderate Republicans but saved from utter disgrace by his martyr's death. His park statue was often vandalized, but survived until the time of Vichy and the ensuing destruction

of Parisian monuments. Robespierre and Saint-Just were beyond the pale. The person who embodied acceptable Revolutionary politics was Danton. The monument which the city of Paris decided to erect to his memory in 1887[22] was also intended to express the views of the Republican centre as to the events and lessons of 1789–94. Danton incarnated an ideal Republican formula: not having been a professional military man, he had been a talented organizer of the 'levée en masse' and, at the same time, a champion of mass education. A century later, these elements had become fundamental to the ideology of the Republic and its political-military outlook. The statue of Danton by Auguste Paris (1891), erected near the Odeon theatre, idealized these contrasts (illus. 12). He was shown in a dynamic rhetorical pose – clearly influenced by David's unfinished *Jeu de Paume* painting – haranguing the volunteers of 1792. He was both military commander and parliamentary orator (as we said, the Republic was wary of purely military qualities), but was also presented as a promoter of popular education. An inscription on the pedestal immortalized his words: 'After bread, education is the most basic need of the people.' Just as Dalou had done in his *République*, Auguste Paris took up iconographic schemes from the art of 1789–94.

Tempers ran high during the public deliberations about the statue of Danton. The Right spoke against erecting a statue of the man responsible for the September massacres of 1792, which would be thus dedicated to 'violence and hatred'. On the other hand, few aspects could better illustrate the historical mode of thought of the engaged Left than the proposal of its City Council faction to demolish the Chapelle Expiatoire devoted to the memory of Louis XVI and his family and to place Danton's statue there – since it was he who had repelled the foreign armies which the monarch had called in by subterfuge to defend the monarchical system. In the end, the intervention of the state and of Republican moderates carried the day.

Instead of navigating the stormy waters of Revolutionary historiography and axiology, the Republican centre preferred to sponsor statues of personages from a less controversial epoch. Without much controversy, two rival statues of Diderot and figures of Voltaire, Rousseau, Condorcet and Beaumarchais found their place in the 1880s and 1890s on Parisian streets

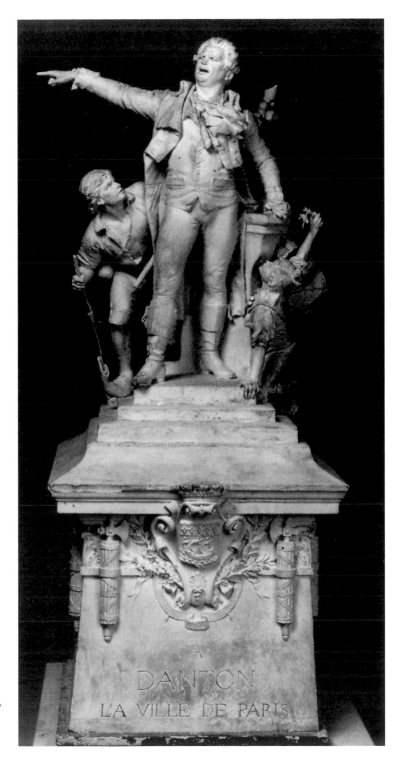

12 Auguste Paris,
bozzetto for
*Monument to
Danton* (1891), 1889,
plaster. Depot des
Oeuvres d'Art de
la Ville, Paris.

and boulevards. Although no fixed programme or common location was ever established, and although the styles differed and the poses ranged from the stiffly statuesque (Condorcet) to the domestic (both statues of Diderot [illus. 13]), these statues as a group constituted an homage to thinkers 'qui ont été les préparateurs de la Révolution'. Middle-of-the-road Republicans felt at ease commemorating this illustrious circle. This was a statuary Pantheon which complemented the very real Panthéon with its tombs nearby and which lent itself easily to all kinds of ceremonies. For the hundredth anniversary of the establishment of the Republic (21 September 1792), the City Councillors proposed to

> decorate and illuminate, thus rendering them more imposing, the statues of patriots, orators, soldiers and philosophers who prepared the Revolution or who took part in it like Diderot, Voltaire, Rousseau, Danton . . .'[23]

Presaging twentieth-century rites, this interesting proposal identified the ideological core of the Parisian statuary effort and the central tradition of the Republic. Some Republicans deplored the elevation of Rousseau; some extreme leftists criticized the erection of statues at all, calling this a reversal to feudal usage. But Republican support for this type of commemorative statue was very broad. Although the Right grumbled – especially with regard to the honours accorded to Voltaire – it did not at that time question the Enlightenment statues as a group. It preferred to champion its own heroes, like Richelieu or Talleyrand, although the Republican majority did not accord statuary honours to them on both ideological and foreign-policy grounds.

Things changed after the Dreyfus Affair (from 1894 on), and the battle for the separation of Church and State (which ended in 1906) deepened political divisions and embittered the clerical and militaristic Right. The mere fact that a prominent supporter of Dreyfus like Zola had championed Rodin's *Balzac* sufficed to block this important commission. More than a decade later, a commemorative statue of Zola was vehemently refused a location by Parisian anti-Dreyfusards in arrondissement after arrondissement. The Dreyfus Affair had two direct spin-offs: in 1908/09, two monuments were erected in Paris to pro-Dreyfus politicians (Scheurer-Kestner, Floquet). In both cases, the unveilings were marred by rightist counter-

34

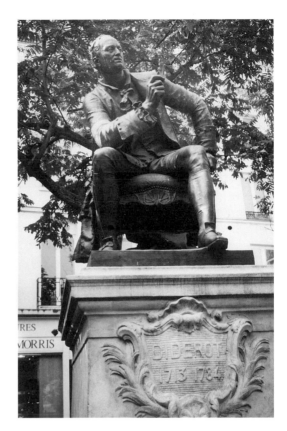

13 Jean Gautherin, *Denis Diderot*, Boulevard St-Germain, Paris, 1886.

demonstrations, but owing to the relative insignificance of those being commemorated, these episodes did not have any lasting effects.

More far-reaching were the consequences of the erection of a statue of Etienne Dolet, one of the first Protestant martyrs in France, who in 1547 had been burnt at the stake in Paris.[24] Championed by the Freethinkers but paid for out of city funds, the statue was located in 1889 on the very spot (Place Maubert) where the flames had devoured him (illus. 14).[25] Historical accuracy notwithstanding, this was a location adjacent to Notre-Dame: in fact, the bound martyr could be seen to greatest advantage with the cathedral as his backdrop. By virtue of this provocative placement but also in the context of the worsening relations between Church and State, this artistically less than convincing statue by Ernest Guilbert had astoundingly wide resonances, becoming one of the most popular Parisian monuments. Dolet's and two further statues – dedicated to Admiral Coligny, who had been murdered

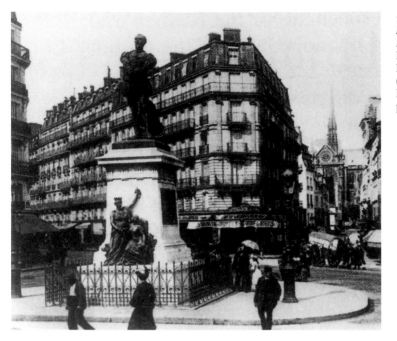

14 Ernest Guilbert,
*Monument to
Etienne Dolet*,
Place Maubert,
Paris, 1889
(destroyed 1942/3).
Photograph from a
postcard of *c*. 1900.

during the Night of St Bartholomew, and to an eighteenth-century Freethinker and martyr, the young Chevalier de la Barre – provoked the latent anti-Protestant feelings of the nationalist Right.[26] Its reaction was somewhat oblique with regard to the controversy surrounding Dolet and straightforward as regarded the supposed 'holier-than-thou' attitude of the Protestants. In a most unusual move, the conservatives demanded permission from the City Council to erect a statue devoted to the Spanish anti-Trinitarian Michel Servet, who had been burnt in 1557 in Geneva (from a theological standpoint an even worse heretic than Dolet). They proposed to locate the new statue in direct proximity to Dolet's. Two martyrs burnt at the stake – one by Catholics, one by Protestants – would thus have faced one another, in silent contest and reproach, on the Place Maubert (illus. 15). The city authorities blocked this plan, and Baffier's *Servet* was unveiled in 1908 on the Place Brunot; the date of the unveiling was deliberately chosen to coincide with the anniversary of the execution of the Chevalier de la Barre. The statue showed Servet waiting at the stake. A poignant inscription – the work's pièce de résistance – stated that he had been '. . . burnt on orders of Calvin'. The prefect, anxious to keep a measure of religious peace, forced the committee

to obliterate this (historically somewhat doubtful) reference to the great Genevan reformer.

In a certain sense, this purely polemical stratagem, which pushed aside fundamental Catholic dogma, reveals the desperation and ideological disarray of the nationalist Right after 1900. Nonetheless, it illuminates most poignantly the historicist temper of that age. Already in the first post-war years, which saw the demise of historicism, the confrontational placement of the two monuments seemed ludicrous at best and was soon forgotten. Only the Surrealists with their keen sense of paradox and humour endeavoured to keep it in memory by constant references in their Parisian novels.[27]

FORMAL CHANGES AFTER 1900

The year 1902 saw, following a long delay, the final unveiling of a great monument to Victor Hugo created by Louis-Ernest Barrias and erected on the Place Victor Hugo (illus. 16). This project represented in mature form the type of allegorical monument devoted to a great man of letters. Bas-reliefs on the lower part of the plinth showed scenes from Hugo's works – but also the profiles of outstanding members of the project committee. Above this 'terrestrial' level, a graded symbolic ascent took place. One step higher up, four Muses were captured in admiring poses. Thus, a winged Ode offered

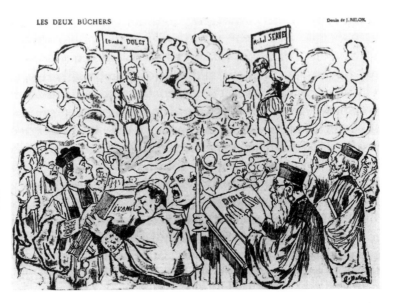

LES DEUX BÛCHERS

Dessin de J. BELON.

15 J. Belon, *The Two Stakes*, caricature showing the aborted confrontation on the Place Maubert of statues of Michel Servet and Etienne Dolet. From *L'Intransigeant* (3 October 1900).

Hugo a lyre, Drama drew the mask from her tragic face, Epic Poetry proclaimed the poet's fame and Satire cracked her whip. The poet himself stood one step higher up, at the very top. Notwithstanding the pensive pose showing him on Guernsey (adapted from photographs which were propagandistic images of an émigré's longing), Hugo had already reached the third – the heavenly – sphere, higher than Paris but also higher than Parnassus.

The three grades of this allegory were joined together to create a 'conical' apotheosis. One might find a similar ascending structure in the triadic composition of a laudatory ode – and indeed it was the personification of the Ode which joined the earthly and heavenly spheres together. The monument to Hugo represented in a mature, refined form the stylistic and iconographic ideal of the years around 1890. At its unveiling a

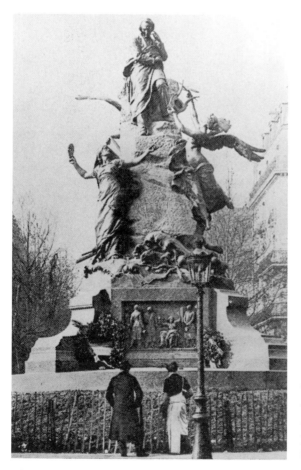

16 Louis-Ernest Barrias, *Monument to Victor Hugo*, Place Victor Hugo, Paris, 1902 (destroyed 1942).

dozen years later, doubts were raised regarding its aesthetic relevance.

The first years of the new century brought about an important change in the structure of the Parisian allegorical monument. Proponents of the fledgling *Denkmalskritik* (as usual, the German term has a more precise ring than the somewhat gross concept of 'statuophobia') began to attack allegorical structures like the Hugo monument or an earlier one dedicated to Gambetta (1885). Although Rodin's grandiose *Balzac* found only isolated support, a groundswell of public opinion turned against the Beaux-Arts tradition. The idea of subservient allegorical figures swirling or sitting demurely around the base of a statue seemed less and less relevant to the developing tenets of modernism; even in its heyday, this concept had displayed an all too distinct neo-Baroque quality. None other than the once leading neo-Baroque sculptor Dalou tried to rework the scheme of his last monument, striking a delicate balance between a structure determined by allegorical need and a statuary group exhibiting mundane realism. A necessary prerequisite was the lowering and broadening of the plinth as in Rodin's plans for the *Burghers of Calais* (1895), but with other sources as well. A broad, low, platform-like base gave the viewer a feeling of intimacy, challenging the stereotype of socled aloofness.[28]

Dalou's monument to J. L. A. Alphand on Avenue Foch (1899) is an astounding work, both with regard to the flagrant autothematization of the statuary movement and the endeavour to bestow a new lease of life on the old scheme of subservient figures (illus. 17). The omnipresent and enlightened Director of Public Works in Paris was the driving force behind many of the initiatives to erect monuments and was seen as the man who had transformed the Paris of kings into a 'city of democracy'. For the side reliefs, Dalou relied on the then-novel themes of labour. The project's most striking feature, however, was the thematic and compositional linkage of the figure of Alphand – shown on one of his habitual inspection tours of the city – with the artfully subordinated, but not subservient, figures of his colleagues who were involved under his leadership in the process of embellishing Paris. Among them was a painter, an architect and Dalou himself as the representative of sculpture, while the fourth person symbolized the corps of civic engineers. Dalou thus took up an old

tradition of representations of the three main fine arts, but expressed it with a directness which reminds one of Courbet's curious blend of autobiography, realism and allegory.

The pedestal of this work was covered by a sort of workman's canvas which even exhibited simulated metal eyelets. Thus, Dalou – who at first sight seemed to be referring to the traditional decorative formula of Baroque drapery – actually endowed the motif with a naturalistic and narrative touch. This solution reflected the artist's *modus procedendi* when conceiving the monument.

This curious depiction of an idealized working meeting of five persons – with the most important one occupying the low plinth – had, thanks to its semi-naturalistic trappings, an endearing quality. It exalted the immediacy of a personal encounter, including that of the beholder, reflecting the novel theme of an urban democracy at work. Yet despite its naturalistic immediacy, the old scheme of a figure on a socle with four subordinated figures appeared outmoded at best. The compromise postulated by Dalou had no important consequences for statuary art, but acted in the complicated situation of the fin de siècle as a harbinger of a new psychological approach.

In some ways, the changes underway in Paris were reflected in the dichotomous scheme (absorption vs. theatricality) elaborated by Michael Fried with regard to eighteenth-century French painting.[29] Traditional monuments, placed at safe distances on high plinths, addressed themselves to the beholder in a general way. The new type, which appeared just after 1900 and which situated sculptures at eye-level (monuments to Boucicaut-Hirsch, Chopin and Watteau), tried to present a scene of absorbed activity, thus putting distance between themselves and passers-by. A somewhat different type transformed the triadic zoning of the Hugo monument into a complex structure, clearly showing successive layers of reality. The allegorical figures surrounding the apotheosized bust or central figure were joined by admiring everyday figures standing lower down who by virtue of their location and attire, constituted a link between the zones of monument and beholder (as in Jean Boucher's *Monument to Ludovic Trarieux* [1907]). These intertwined tendencies weakened the visual cohesiveness essential for a successful monument. This dilemma was not resolved in Parisian statuary art before 1914, nor was the new type continued after the First World War.

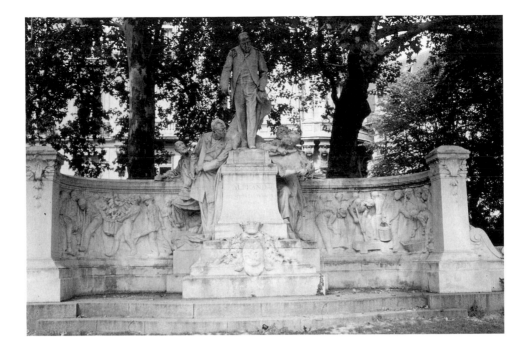

17 Jules Dalou,
*Monument to J. L. A.
Alphand*, Avenue
Foch, Paris, 1899.

Parisian monuments of the new type were still meant to be viewed from one side. Rodin's decision to do away with a plinth in the *Burghers of Calais* – a decision misunderstood or opposed by his contemporaries[30] and only implemented in 1924, seven years after his death – had as its essential premise the idea that a monument should not be seen from a single point of view. Rodin aimed for a 'dramatization from all sides'; he wanted his scenes to be viewed by passers-by at eye-level, from the pavements of their city. Parisian public monuments of around 1900 seem to have taken up some of the formal and even some of the psychological elements of this concept. But the problems which were thrown up by the viewer's new role could not be resolved. Nonetheless, a certain zest for experiments, and even more so for novel themes, was evident in the immediate pre-war years.

One of these novel public monuments was the extraordinary triumphal arch built by Dalou and his workshop to commemorate the French automobile pioneer Emile Levassor at the Porte Maillot (1907; illus. 18). The arch evokes the symbolism of city gates – a reference to the ancient function of the Porte – but also represents a kind of finish line through which the automobile driven by Levassor charges at high

18 Jules Dalou and workshop, *Emile Levassor*, Porte Maillot, Paris, 1907.

19 Dalou and workshop, *Emile Levassor*, detail showing Levassor in his car.

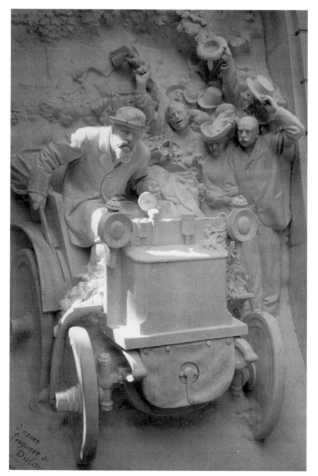

speed (and in high relief) with a sort of naturalistic panache, with the reckless driver surrounded by jubilant onlookers (illus. 19).

Although it can hardly be called a great work of art, this aesthetically less than plausible combination of different motifs and strands astounds us with its iconographic acumen and daring. The arch is modelled on Baroque fountain screens, while the relief has the biting directness of Art Nouveau cartoons lampooning the 'craze for automobiles'. In early modern prints depicting ceremonial state 'entries', allegorical chariots pass through elaborate city gates; here, the automobile has inherited that old formula. The onlookers are grouped in Baroque fashion and applaud with Baroque pathos, but with top-hats in hand. Clearly, change was in the air: Parisian public monuments had begun to embrace, however clumsily, the lure of modern life and technology. The next unconventional project was devoted to another famous automobile pioneer: Jean Boucher's *Léon Serpollet* (1911). This, however, ended in dismal artistic failure. The monument shows a speeding car; the onlookers and the incredible cloud of rising steam form a bewildering, amorphous marble pyramid, on top of which looms the figure of Serpollet. The Rodinesque marble technique is at variance with the semiotic exigencies of the complicated group. No other city in the world would have dared to take up such a subject, in fact not presentable in sculptural terms, for a public monument.

In one respect, however, the Republican tradition and rules still held firm: no living person could be given a monument. A living individual could pose as a model, of course, particularly when a thematic link or prerequisite existed. A young Parisian labourer who worked as an assistant to Louis Pasteur had posed in the 1890s for a small monument which showed him – already vaccinated by Pasteur – holding a mad dog. Twenty years later, *L'Illustration* printed a photograph showing the stately, elderly concierge of the Institut Pasteur as a 'gardien de sa propre statue' (illus. 20). Little more than a small, witty display, this confrontation demonstrated, just before 1914, that the Parisian statuary movement had indeed come full circle.[31]

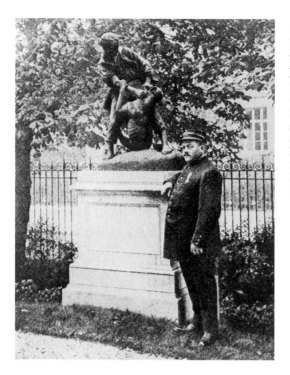

20 'Guardian of his own monument': Jean-Baptiste Jupille, the concierge of the Institut Pasteur, vaccinated by Pasteur in 1885, standing in front of a statue showing him as a young boy with a mad dog. From *L'Illustration* (November 1913).

MOUNTING CRITIQUES OF 'STATUOMANIA'

That things had gone too far and that the trend to erect more and more public statues – 30 finished monuments awaited plinths and sites in 1913 alone – could not continue for much longer was indeed observed frequently in Paris in the years before the First World War. The tendency to erect monuments to persons of public merit acquired an insulting new name: statuomania. A book by Gustave Pessard on the statues of Paris was thus entitled *La Statuomanie parisienne* (1912). In the introduction, Pessard wrote in no uncertain terms:

> . . . if we take into account the 335 mythological or assorted statues . . . the 328 illustrious Parisians of both sexes which ornament the façades of our Hôtel de Ville . . . if we add the 180 other monuments devoted to the memory of individuals . . . without forgetting the 72 statues which are at the moment just at the project stage . . . we come up with the fantastic figure of more than nine hundred-odd statues . . .[32]

Pessard had indulged in grotesque exaggeration to prove his point; the actual number of public monuments erected in Paris during the Third Republic was closer to two hundred. Nonetheless, many critics felt that too many were being built and that they did not necessarily embellish the city. A noted critic, Paul Escudier, deplored '. . . this invasion of statues and monuments without any beauty'. Réné Bazin formulated this idea more elegantly but just as acerbically in 1910: 'il est du bronze, comme de l'encre, il en coule trop.'[33] Degas joined the ranks of the statuophobes, sardonically proposing to wall off green spaces in order to protect them from new monuments. When in 1911 the journal *La Quinzaine* inaugurated a debate on the subject, the writer Fréderic Masson struck an almost Dadaesque note:

> As concerns the many commemorative statues, I would like to state the same as Marat once did – I need 300,000 heads. I am thinking of female and male mannequins in Roman costume and endowed with interchangeable endings: those which no longer please us should be promptly exchanged for new ones. As far as Paris is concerned, I would introduce a simple procedure: to possess a statue or a bust there, one has to be born in the capital. By means of this simple ploy, the number of monuments will be reduced by nine-tenths. All other monuments should be evacuated forthwith to their native regions. And if these measures do not suffice, I would pledge my allegiance to a small, nice iconoclastic sect.[34]

PHANTOMS OF THE SURREALIST FLÂNEUR

In his sarcastic little essay 'Die Denkmale' (1926), the great writer Robert Musil developed a semiotic argument about public monuments:

> There is nothing in the world which approximates the paradoxical invisibility of public monuments. They are erected, no doubt, with the aim of attracting public attention, but on the other hand they seem to be strangely impregnated against attention from the outside. This attention seems to be deflected from them just as drops of water are, when sprinkled on an oily surface – it turns

away from their very surface in a smooth but continuous way . . . Most of us show the same attitude towards these statues. One considers them – like a tree – to be a part of the street, one would be immediately struck by their disappearance, but one does not look at them and one does not have the slightest idea whom they represent . . .[35]

Musil stated that the pallid aura surrounding public monuments, their penchant for a historic, worn-out patina, contributed to their invisibility. Their gestures were meaningless, their sabres were drawn to no avail – they could not move or threaten the viewer: 'By Jove, the statues do not move an inch, and somehow they manage to commit permanent faux pas.' Half-jokingly, Musil suggested the creation of a new genre which would use the latest advertising techniques.[36] Inscriptions modelled on advertising posters could proclaim in bold letters the achievements and qualities of the historic personage being commemorated – an idea which, Musil thought, would slowly gain ground.

Ten years later, the sculptor Ossip Zadkine presented his project for a monument devoted to Apollinaire to the public. The great poet, having himself invented a most unusual statue for the poet Croniamantal (we shall discuss this later), inspired unconventional statuary projects, like that by Picasso discussed in Chapter 7. Zadkine's ideas for a supplementary installation appear to echo Musil's caustic remarks:

The idea is that it [the monument to Apollinaire] should be permanently enlivened, day and night. During the day, it should proclaim the concept of a sculptural form bathed in sunlight; at night, however, it should attract the passer-by, who, astonished but at the same time ravished by the idea, should come nearer and read a poem by Apollinaire as one reads the news on light newsreels. During the day, this would be a sculpture, during the night an instrument of public instruction.[37]

It is debatable whether Zadkine's ideas influenced new sculptural trends after the 1960s, though no doubt they prefigured a modern aesthetic. But taken as a commentary on the aura of the public monuments of the Belle Epoque, they display a superficial Surrealistic tinge without, however, taking into account the Surrealists' attitude towards nineteenth-century allegorical and figurative sculpture.

The Paris of the later Third Republic, of the intra-war period, was the great metropolis of French Surrealism. The city provided a steady stream of themes and motifs for the Surrealists,[38] who conceived it as a great, mysterious, often labyrinthine place distanced, however, from the dangerous trappings of an urban Moloch. They saw its human scale, the fact that its metropolitan dimensions were assuaged by its small, familiar neighbourhoods. The manifold details of its 'architecture parlante' – the advertisements, posters, inscriptions and, last but not least, the countless public statues – provided welcome signs of reference and recognition, giving structure to the sprawling city and permitting a poetic reading of its details. Paris was the place where the Surrealists' poetic itineraries took place, their seemingly spontaneous strolls through the maze of streets and small squares, the monuments[39] serving as their favourite meeting places.

Being avowedly 'in the service of Revolution', the Surrealists were always ready to ridicule the civic, Republican and national pathos of the public monuments of the pre-war period. Even so, they would never have seen them as alien, repellent intruders into the city's texture – an idea propounded by the growing group of statuophobes. The Surrealists appropriated the monuments because of their supreme qualities as icons and their gestural poignancy. Moreover, the statues did not have to be discovered in as laborious a way as the small signs or inscriptions in shop windows, on façades or in passages. In marked contrast to Musil, the Surrealists saw in the public monuments suitable elements of a dialogue, a dialogue between the flâneur and his city. They constituted, in Breton's words, a 'figure de participation' to be questioned and provoked in a free play of rhetorical and poetic associations. Thus, the placid familiarity engendered by daily encounters with monuments could be overcome. The Surrealists acknowledged some elements of Musil's diagnosis, but not his conclusions.

Even the most modest Parisian monuments presented the flâneur with their 'silent greetings'. Many of them had magic capabilities, a sort of 'magie en puissance'; often placid and apparently inactive, they seemed suddenly to pursue passers-by with malicious glances. The monuments possessed their own potential power:

Oh things of daily life, one cannot come too close to the things of daily life . . . In their stuffed morning coats, in their house jackets, by virtue of their seemingly smiling unobtrusiveness, these idols of modern times possess a magic power of their own, a potential force to which neither Angkor nor Ephesus can aspire.[40]

The Surrealist symbolism of public monuments was characterized by binary opposites, by the contrast between the topoi of the Golem and the immutable idol, the contrast between phantom-like fleetingness and physical omnipresence. It finally was reduced to the contrast between consciousness and oneiric states of mind.

The Third-Republic monuments of Paris appear in many Surrealist poems; they play an important role in the novel *Nadja* (1928) by André Breton and in *Les dernières nuits de Paris* (1928) by Philippe Soupault.[41] The most beautiful passages devoted to Parisian monuments – an ecstatic and oneiric vision sparkling with brilliant poetic ideas – can be found in Aragon's 'Le Paysan de Paris' (1926). The monuments are the stop signs of black magic which interrupt 'la flânerie du reveur'.[42] The ancient topos of the 'demonic statue' finds a powerful representation in 'Paysan'. Although Aragon suggests that the statues might intervene in the lives of passers-by, he refuses them a Pygmalion-like life on their own. A reciprocal dependence exists; the monuments require cultic devotion. Official wreath-laying ceremonies are likened to occult, semi-conspiratorial rites of 'monumentolators'.

Aragon could not make up his mind about one point. On the one hand, he appreciated the magical attraction of monuments, their ability to abbreviate forms or reduce objective reality to quasi-abstraction ('a black abyss of dead eyes, hollowed slightly above earth level'). This stance concurred with the evolution of modern art. On the other hand, passages of 'Paysan' suggest that the statues derived their 'magic potency' from their naturalistic attire, including spectacularly bronzed morning coats.

The artistic quality of the Parisian statues was of no great importance to the Surrealists. They did not mention Rodin at all: 'It is not the image which is great, but the emotion it arouses' (Reverdy).[43] The one dissonant voice was that of a marginal adherent, the poet Robert Desnos. Desnos detested

effigies, preferring the narratives of such monuments as the *Balloon of Ternes* (about which more will be said later) or Levassor's charging automobile, to which he ascribed the surreal potency to continue their course of motion. Even more importantly, he postulated the socling of advertising figures, an idea whose time was to come half a century later, in the late 1970s: 'I would love to see a Cadum child in porphyry leaving a marble bath-tub and the little Menier chocolate girl standing forever in granite . . .'[44]

THE FALL OF PARISIAN PUBLIC STATUES

By 1918, the great time of Parisian statuomania had ended. Growing statuophobia – or plain weariness – had succeeded in halting the educational and meritocratic programme of the earlier Republicans. The catastrophe of war, which had, despite its victory, bled France white, had rendered obsolete the optimism of earlier decades about the progress of civilization. Monuments of the period between the two world wars were fewer in number and did not compare thematically or artistically with the pre-1914 works. The series of statues that the Republic found necessary to erect to its military commanders (Gallieni, Fayolle, Ferrié, Mangin, Foch and Joffre) also signalled a rupture with the non-military practice of the past.[45]

Even when measured against the recurrent waves of political iconoclasm, the demolition of almost a hundred public monuments in Paris in 1940–44 was an act without precedent in the history of modern statuary.[46] Habitual statuomania gave way to extreme statuophobia, rather as if a later generation had decided to do away with the ethos, meritocracy and symbolic legacy of the Third Republic. An extreme political situation had led to repugnance for traditional political and aesthetic symbols.

The Nazis deliberately destroyed many public monuments in the occupied countries of Europe, Poland providing the most blatant example. The ravages committed in Paris were not of the same magnitude. The few monuments the Germans considered absolutely unacceptable (those dedicated to Edith Cavell and to General Mangin, whose use of colonial troops on the Western front was considered by the Germans to be a violation of the white man's ethos) were destroyed immediately

after their entry into Paris in June 1940. After that, however, their direct involvement ceased, though no doubt some administrative pressure was applied behind the scenes. The French – precisely speaking, the Vichy government – were left alone to cope with the sculptural legacy of better times.

In October 1941, the Vichy authorities, whose executive powers included Paris, issued a decree which by describing the shortage of metal alloys underlined the dire need to 'reintegrate the constitutive metals of public statues into the circuit of industrial and agricultural production'. The destruction of many Parisian bronze monuments was announced through this partial euphemism so typical of the language of murderous bureaucracies. A commission was created forthwith to deal with the matter, and it spoke of great benefits to be expected from the proposed action, benefits which would be of an 'aesthetic' and 'industrial' nature.

The essential slogans had been coined. The collaborationist press took them up immediately by announcing a 'revanche du goût' along with the cleansing of the national Pantheon of undesirable personages. In the beginning, the criteria were somewhat lenient; after 1942, additional lists of monuments targeted for destruction were published. Although some statues were saved – as in the mysterious case of Dalou's *République*[47] – by the time of the Liberation in August 1944, the results of statuophobia had become obvious and horrifying. In Paris alone, more than 80 Third-Republic monuments had gone, via a scrap-yard in the XIIth arrondissement, to the melting oven.

An astonishingly large segment of the French bureaucracy and intelligentsia seems to have accepted – even welcomed – this destruction. For many it was a time to settle old scores. The traditional Right of clerical, Pétainist or Action Française vintage wanted to strike at the core of the Third Republic's ideological tradition, symbolized by the statues of Enlightenment philosophers and thinkers. The so-called younger Parisian fascists, while welcoming the cleansing, stressed the outmoded Victorian allure of the monuments and the inflationary consequences of the Republic's meritocratic system. Influenced by Nazi thinking, they opted for a rigorous élitist policy. Although some fissures did appear among the statuophobes (as in the early Third Republic, the most heated quarrel once again concerned Rousseau), there was little real controversy amongst

the otherwise quarrelsome collaborationist factions. The man responsible for the policy's implementation, the statuophobic Culture Minister Abel Bonnard, was on good terms with both the 'old' Right and younger Parisian circles.

The Parisian collaborators, some of whom had long been left-wing, stressed aesthetic considerations. Of all the groups, they were the most vitriolic, calling the destruction a 'disparition du laid'.[48] Yet even these extremists exhibited a certain fascination with the narrative aspects of the monuments, as when a collaborationist journal asked: 'Will we have enough courage to send Dolet to the stake once again?'[49]

Not only was the Right seized in these months by an acute bout of statuophobia. Many leftists, while deploring the circumstances of the action, tended to agree with Le Corbusier and other functionalists that the monuments belonged – to quote the title of a 1936 exhibition – to the 'fundamental errors committed in Paris during the nineteenth century'.[50] The break in the artistic tradition went deeper than purely political divisions might suggest; it pertained to a changed set of stylistic and psychological references. One apparently endearing – at least to our eyes – trait of the Parisian statues, namely the bonhomie and conviviality of most of the figures, came under sustained attack from both sides. Both were quick to point an accusing finger at the statues' 'undignified' demeanour and the untoward familiarity provoked by such representations (the Surrealists in particular had liked this trait). In reality, both the Left and the Right seem to have been infected around 1940 by the arid, distance-imposing classicism of public sculpture under Stalin and Mussolini and dreamt of a French counterpart. (Hitler's brand of sculpture was judged less palatable.) As we know, the Almighty spared France that alternative.

LA MORT ET LES STATUES

In the autumn of 1946, two years after the end of the German Occupation, a somewhat unusual photographic book appeared in Paris in a limited edition. Entitled *La Mort et les statues* (*Death and the Statues*), it showed twenty artistic photographs of overturned, dismembered or set-aside Parisian bronze monuments in a scrap-yard in the XIIth arrondissement of

German-occupied Paris.[51] The photographs had been taken secretly by a young Parisian photographer called Pierre Jahan on an early December morning in 1941. None other than Jean Cocteau had provided captions and a poetic commentary. This little-known publication, the fruit of a collaboration between an outstanding photographer and a great poet and essayist, documents Vichy's ugly work in gripping images. Nostalgia for the Paris of the Belle Epoque with its gaiety and optimism pervades the book.

Jahan's photos are among the masterpieces of modern photography. They convincingly combine the distanced, un-emotional focus of New Objectivity with incursions into and references to Surrealist photographs by Brassaï and Bill Brandt. They reveal, aided paradoxically by new combinations and juxtapositions of forms, the amazing richness and variety of detail that characterized the Parisian monuments.

But it is in Cocteau's commentary that a masterful inter-mingling of different rhetorical styles and poetical levels takes place. Cocteau constantly changes the tone and temper of

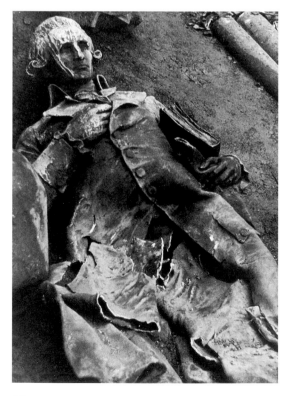

21 Jacques Perrin, *Monument to Condorcet*, 1894, in a Parisian scrap-yard in December 1941. From Jahan, *La Mort et les statues.*

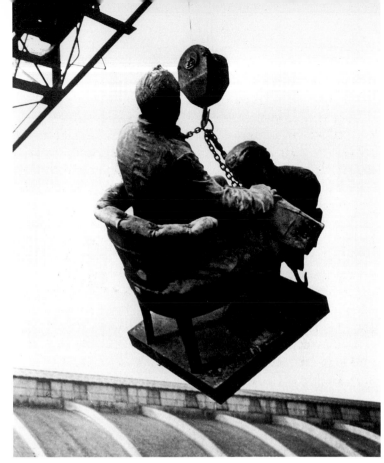

22 'The aerial journey of Monsieur Thiers', 1941. From Jahan, *La Mort et les statues*

his remarks. On viewing the scattered remains of a figure, he evokes a mysterious crime; in the next passage, these remarks are revealed as an artful pastiche. When describing the scattered alligators from Dalou's *République* awaiting their terrible fate in anger (illus. 9) – an anger they once directed at the Republic – Cocteau indulges in baroque hyperbole. One photograph later, the poet, on seeing the martyred statue of Condorcet, changes to a quiet, measured recollection of the Enlightenment ethos which permeated his own Parisian lycée (illus. 21).

Surrealist poetics and the surrealistic situation at the scrapyard provided Cocteau with his leitmotif: a boundless astonishment expressed in many voices in the presence of the mélange of statues and parts lying confusedly on the ground – but in new iconographic configurations which gave rise to new narratives. Cocteau ends with a thought central both to Surrealism and to the ideology of anti-positivist history, equating the fall of the monuments with the end of the historical narratives they represented. Linear historic and cultural progress has

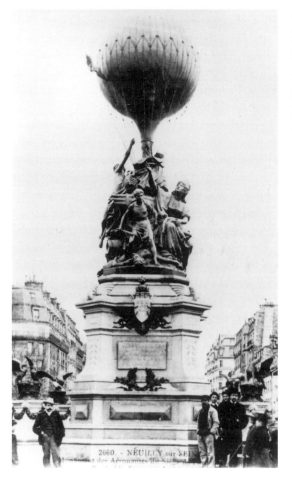

23 Frédéric-
Auguste Bartholdi,
Balloon of Ternes,
Place de la Porte
des Ternes,
Paris, 1906
(destroyed *c.* 1942).
Photograph from
a postcard of
c. 1914.

ceased; the narrative is thus disjointed; it proceeds by means
of quirks and even mistakes. It is by drawing our attention
to the latter process that Cocteau evokes a metaphorical chain
of associations that brilliantly shows how Parisian public
statuary was perceived. Commenting upon a photo showing
a seated Alphonse Thiers being carried through the air on an
'aerial journey' of sorts (illus. 22), he quotes from an essay by
a young girl who had written that another hero of the siege of
1870, Léon Gambetta, had left Paris with a 'captive balloon'.[52]
Behind this endearing mistake stood an unconscious refer-
ence to another famous Parisian monument, the so-called
Balloon of Ternes by Bartholdi (1906; illus. 23). This work had
commemorated in an eternalized (at least until 1942) bronze
ascent one of the courier balloons which in 1870 had made

communication possible between the besieged capital and the provinces. A semiotic circle made itself apparent here: the monument to the 'free' balloons took on, by virtue of its being bronze, the allure of a captive balloon. The *Balloon of Ternes*, one of the most extraordinary items in the history of public statuary, exerted a strange fascination on contemporary viewers by virtue of its illogical appearance. Thus, Robert Desnos dreamt of the day when the balloon would rise at dusk into a bewildered sky.[53]

A famous and oft-quoted definition of Surrealist poetics characterizes them by means of the image of an unexpected meeting, on an operating table, of a sewing machine and an umbrella. Cocteau often referred indirectly to this central motif when describing the new configurations in the scrap-yard. Although public monuments should, by definition, possess a metonymic – that is, a *pars pro toto* – structure, Cocteau, in true Surrealist fashion, stuck in his poetic commentary to metaphorical comparisons.[54] He knew that the intertwined and fragmented monuments awaiting 'execution' stood for the demise of the system of the symbols and values they had represented. He also knew that the Parisian monument of the Third Republic could convey its raison d'être – even in such terrible circumstances – not by means of the stultifying pathos of state ideology, but through the sheer variety of its details and the 'bonne foi' of its naturalistic and allegorical idiom.

2 Bismarck and the Lure of Teutonic Granite

For the German *Kaiserreich* established by the proclamation of Versailles in January 1871, France, though defeated, remained the main political and cultural enemy. The Germans looked with a mixture of admiration and real or feigned repugnance at the efflorescence of Paris in the Belle Epoque. However, while German conservatives found the Third Republic's meritocratic statuary programme unpalatable, the artistic forms of the bronze allegorical monuments exerted a profound influence on neo-Baroque court art in Berlin. After 1900, with the advent of the new type of Parisian monument, this influence ceased.

Germany possessed a different tradition of national symbolism. From the beginnings of the nineteenth century, the nation's artistic energy centred on the creation of so-called *National-denkmäler* (illus. 24).[1] This concept, of Romantic origin, was somewhat imprecise, comprising great public monuments, buildings like the famed Bavarian Walhalla near Regensburg, but it was also applied to Köln cathedral with its mostly neo-Gothic nineteenth-century appearance. The first Romantic visions and projects authored by Friedrich or Schinkel concerned monuments or churches in urban settings. In the centre of Berlin, the neo-Baroque sculptor Reinhold Begas erected a pathetic monument to Wilhelm I which received the designation of a *Nationaldenkmal* (illus. 25). The last one, created after a century of development, was the famous *Monument to the Battle of Nations* (1913), built on the outskirts of the great metropolis of Leipzig. Nonetheless, beginning with Joseph-Ernst von Bandel's Arminius monument on a wooded hill in the famous Teutoburger Wald (1839–75; illus. 26),[2] the concept was narrowed down to apply to monuments outside urban settings, with both ideologues and artists becoming ever more fascinated by rustic, mountainous locations. The Arminius monument offered an almost ideal point of departure for the iconographic repertoire of German patriotic mythology, since the very process of its inception and construction comprised an ample number of mythogenic

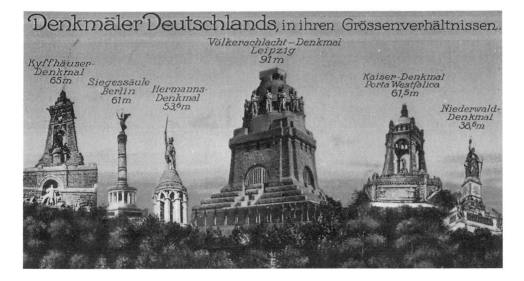

Denkmäler Deutschlands, in ihren Grössenverhältnissen.

Völkerschlacht–Denkmal
Leipzig
91m

Kyffhäuser-
Denkmal
65m

Siegessäule
Berlin
61m

Hermanns-
Denkmal
53,6m

Kaiser-Denkmal
Porta Westfalica
61,5m

Niederwald-
Denkmal
38,6m

aspects. Von Bandel, a less than talented sculptor, had intentionally broken quite early in his career with cosmopolitan Classicism. Espousing the Gothic as the truly Germanic style, and forever on the lookout for an even more primitive version associated with the country's early history, he erected his statue of the tribal chief Arminius, Germany's first hero, in the course of a long, lonely, often bitter campaign of work. In the year 9 AD, Arminius had defeated, on the very spot in the Teutoburger Wald, the Roman legions sent by Augustus and commanded by Varus. In the nineteenth century, he was rescued from oblivion to become one of the pivotal figures in the creation of German national identity, since he had succeeded, albeit for a short time, in uniting the quarrelsome Germanic tribes. Arminius also stood for the triumph of rustic valour and simplicity over refined Roman cosmopolitan culture.

All of these premises weighed heavily upon von Bandel, whose Arminius stands on a high Gothic baldachino towering over endless forests, brandishing his sword towards the West. The gigantic scale (almost 60 m) and rustic setting alleviate somewhat the figure's pathetic clumsiness. When after 40 years of construction the monument was unveiled in 1875, it reflected the changed national mood of a now unified country; the battle of Arminius seemed to predict Sedan as well as the post-war *Kulturkampf* against Roman Catholicism. The inauguration was an important moment in the history of

Wilhelmine state pageantry. Von Bandel's monument was the first to generate nation-wide publicity in illustrated magazines, and it inspired a kitschy souvenir industry. Both it and later German 'national monuments' are inconceivable without this media framework and the burgeoning patriotic tourism industry.

The next such monument was the so-called Niederwald monument by Johannes Schilling, located near Rüdesheim on the Middle Rhine (1883; illus. 27).[3] A giant Germania on a steep Rhine slope guarded that very German river against the designs of the French arch-enemy. Looking like a clumsy derivation of the Statue of Liberty (whose long-delayed inauguration finally took place three years later), Germania held, instead of a torch, the crown of the new Empire. Seen from a distance, she looked like one more tower in the picturesque string of medieval castles located along that romantic portion of the Rhine. This ambivalence was intentional: by making the monument resemble an ancient tower amidst rustic scenery,

25 Reinhold Begas, *National Monument to Wilhelm I*, Schlossfreiheit, Berlin, 1897 (destroyed 1945–50). From a photograph of *c.* 1900.

the Niederwald monument – together with the Arminius project – set the tone for the monuments of the 1890s with their predominance of architectural elements.

The confluence of the Moselle and the Rhine provided a unique location for Bruno Schmitz's monument of the Rhine province dedicated to Emperor Wilhelm I (1897; illus. 28–31).[4] In the beginning, the authorities wanted to place it in a cavernous niche hewn out of a giant rock overlooking the Rhine, which would have invested the work with a chthonic aura (illus. 28). Soon, however, the unique advantages of the narrow wedge of land between the broad, swiftly flowing waters of Germany's two mythical rivers won the day; the choice of this highly evocative place – inspired perhaps by eighteenth-century architectural capriccios – made the work seem rather like a magnificent ship. The heavy granite base topped by the equestrian group with its jagged outline (illus. 29) seems to rise out of the water; seen against the background of changing skies, clouds and sunbeams, the project has a distinctly Wagnerian flavour (illus. 30, 31). True to form, its festive inauguration in the presence of Wilhelm II on 31 August 1897 was greatly impeded by torrential rain. Heinrich Mann satirized these events, as well as the Wilhelmine obsession with statues and ceremonial unveilings, in his novel *The Subject* (1914).

26 Knut Ekwall, Illustration showing the inauguration of Joseph-Ernst von Bandel's Arminius monument (*Hermannsdenkmal*; 1839–75) in the Teutoburger Wald, 10 August 1875. From *Gartenlaube* (1875).

27 Johannes Schilling, Niederwald monument, Rüdesheim, 1883. Postcard, *c*. 1900. Private collection.

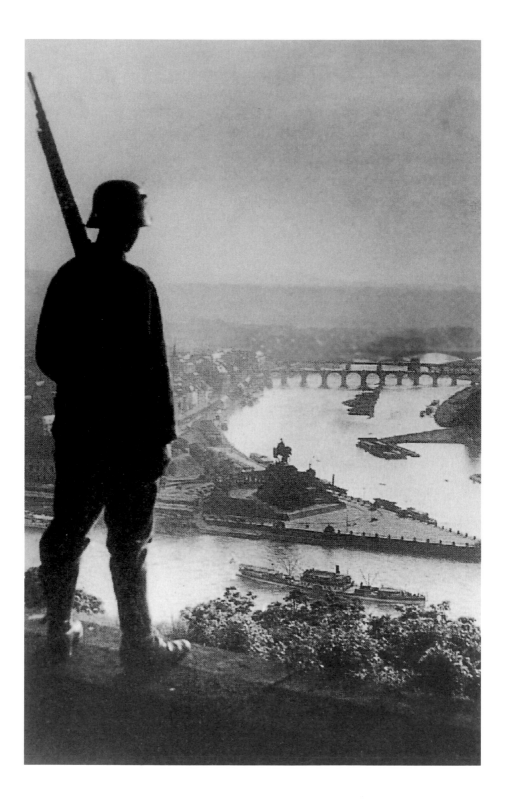

28 (*left*) Jakobs and Wehling, architects, project for *Kaiser Wilhelm Monument of the Rhine Province*, 1889. Archiv des Landschafts-verband Rheinland, Brauweiler.

29 (*below*) Bruno Schmitz, *Kaiser Wilhelm Monument of the Rhine Province*, Koblenz, 1897. Photograph, *c*. 1900. The equestrian group, by Emil Hundrieser, was destroyed in 1945 and reconstructed in 1993.

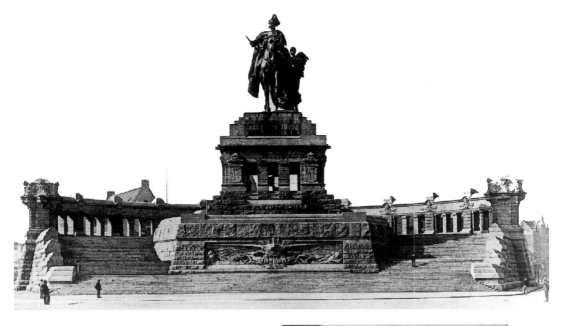

30 (*opposite*) A Wehrmacht soldier guarding the Rhine after Hitler's remilitarization of the river's left bank, with the *Kaiser Wilhelm Monument* in the back-ground. Propaganda photograph, 1936.

31 (*right*) Wehrmacht soldiers taking their oath before the *Kaiser Wilhelm Monument*, 1938.

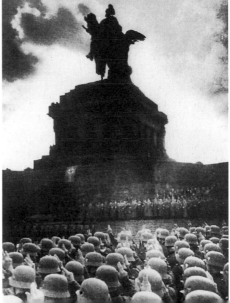

The tendency to mythologize the past reached its apogee in the mid-1890s in two further monuments by Schmitz: the *Porta Westfalica* (1896) and the Kyffhäuser monument (1896).[5] Both were tower-like structures; both were constructed out of rough-hewn sandstone or granite blocks; both were meant to be seen from far away. In the *Porta Westfalica*, the imperial crown surmounting the high baldachino seems to float over the adjacent wooded hills.

With the famous Kyffhäuser monument on the southern side of the Harz foothills, we are at the very heart of Wilhelmine national mythology (illus. 32–4). A late medieval legend had it that the famous emperor Frederick I Barbarossa had not drowned in an Anatolian river during the Third Crusade in 1189, but had fallen into a deep sleep in a cave in the Kyffhäuser mountain. Later versions suggested that on the day Germany was restored to greatness, the Emperor would awake.

The victory of 1870/71 and the unification of Germany gave a new impetus to this old myth, the white-bearded Wilhelm I having seemingly fulfilled the hopes and longings of the old red-bearded Emperor. In 1890, a competition was held for the creation of a monument devoted to both men, to be situated on the famed Kyffhäuser Mountain, where the remains of a medieval castle still stood.

A tower with the crown of the Reich at the top – similar to the *Porta Westfalica* motif – is the highest point of the whole complex (illus. 32). The ascent to it is quite long and not without difficulty or surprises. After some time, the small, winding road traverses the slope and reaches the lower terrace, a wide expanse intended for patriotic gatherings. The main path passes through a half-sunk Romanesque portico which was made to look like an archaeological excavation of ruins. The unsuspecting visitor is next confronted with the fact that the quadratic forecourt between the portico and the tower is unpassable. A seemingly natural rugged cavity appears in the rock behind; it contains a seated statue of the old Emperor chiselled out of stone (illus. 33). Barbarossa is clearly awakening: '. . . dazzled by the splendour of the new empire', he clutches his gigantic beard in astonishment. For the creation of this symbolic cave, Schmitz obligingly utilized the quarry which had been used during the construction of the entire edifice. The irregular stone blocks seem to continue the natural rock base of the monument, and this false natural

32 Bruno Schmitz, *Monument to Wilhelm I*, Kyffhäuser Mountain, 1896. Postcard, *c.* 1900. Private collection.

33 Schmitz, *Monument to Wilhelm I*, detail showing the Barbarossa statue with part of the quarry in the foreground. Postcard, *c.* 1940. Private collection.

34 Schmitz, *Monument to Wilhelm I*, detail of Hundrieser's equestrian group. Postcard, *c.* 1920. Private collection.

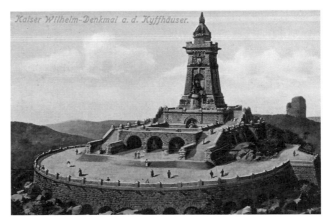

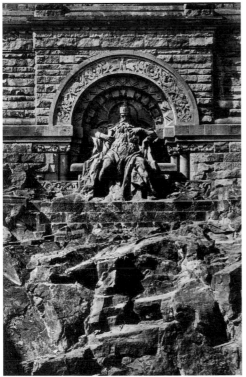

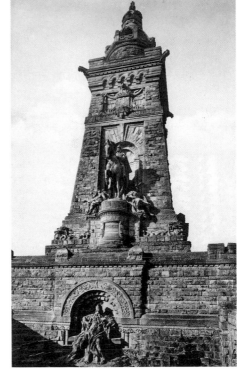

cavity combines with the pseudo-Romanesque 'excavated' portico, with the real medieval vestiges of the castle, and with new elements of Wilhelmine imagery to form a magnificently suggestive whole. This is an architectural complex whose very structure seems to have been determined by successive layers, of both natural and symbolic character, starting with the primeval rocks.

Barbarossa sits at the base of the tower, while some metres above him the equestrian statue of Wilhelm I occupies a protruding pedestal (illus. 34). The first Emperor of unified Germany is shown as the man responsible for the ultimate fulfilment of the historical cycle. This arrangement vaguely reflects medieval typological schemes showing apostles 'standing on the shoulders of prophets'. The way to the top bypasses Barbarossa's sunken forecourt and reaches the tower with its steep internal stairs. A splendid view of the 'green heart of Germany' rewards the patriotic visitor.

The rustic location, the medieval legend used to glorify the victory at Sedan, the hardiness of German granite – all combined to praise a chthonic primevalness. The monument became a favourite meeting place of the veterans' associations throughout the Wilhelmine period and later. The fatal consequences of this mythology – as seen, for example, in 'Operation Barbarossa' in 1941 – are all too well known.

The *Monument to the Battle of Nations* in Leipzig was the last in Schmitz's series of tower-like national monuments; it soon became the most popular (illus. 35–7).[6] Located on the southern outskirts of the Saxon metropolis where Napoleon had been defeated in October 1813, it was meant to celebrate the hundredth anniversary of the battle. Its unveiling in October 1913 was the last great ceremonial pageant of monarchical

35 Bruno Schmitz, *Monument to the Battle of Nations*, Leipzig, 1913. Postcard, *c.* 1920. Private collection.

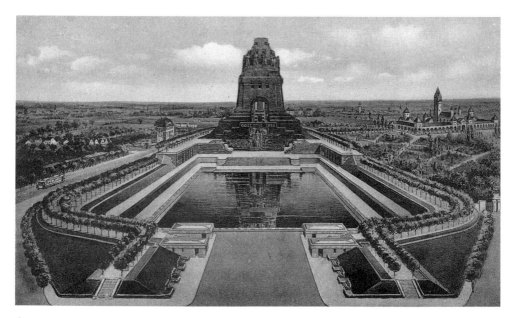

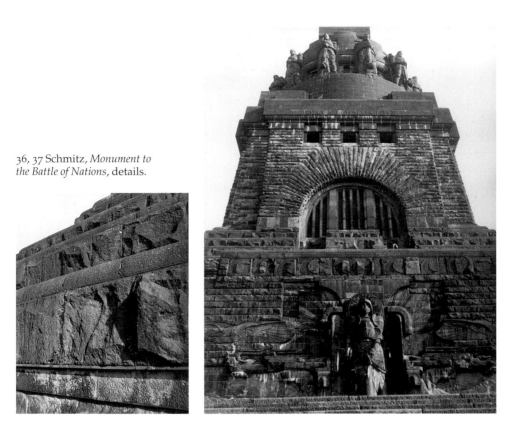

36, 37 Schmitz, *Monument to the Battle of Nations*, details.

Europe. The monument displays a massive, truncated, pyramidal structure consisting of dark, rough-hewn granite and sandstone blocks (illus. 36, 37). A heavy cupola with superimposed rectangular blocks covers a high mausoleum. Figures on a superhuman scale adorn the cupola and the chamber's interior. A closer analysis might reveal a curious mixture of apparently 'Germanic' primitive forms with thematic and stylistic impulses gleaned from giant ancient Egyptian and Assyrian sculptures.

Schmitz wished to create a great ceremonial complex surrounding the monument, one which would comprise a giant court of honour, parade-grounds and a great stadium. Although these plans were only partially realized (in the form of a great water basin flanked by two processional streets and a walled enclosure [illus. 35]), the monument even in its much reduced form became, during the intra-war years, a favourite meeting ground of Nazi and other right-wing organizations; moreover, it seems to have influenced the first Nazi plans for

the Nürnberg parade-ground complex. Soviet memorial archi-
tects were fascinated by the idea of an elaborate mausoleum
within a semi-conical structure and used the scheme several
times after 1945. The Leipzig memorial thus constitutes a link
between late Wilhelmine nationalistic art and post-1933 and
-1945 totalitarian memorials and their political pageantry, a
questionable mark of distinction by all means, but one which
somehow belies the logic of Wilhelmine monumentomania
and its penchant for large-scale political ceremonies.

These national and ancestral histrionics betrayed an insecure
nation whose fight for political and cultural primacy in Europe
increasingly separated it from Western rationalism. The cult of
the 'Iron Chancellor', Otto von Bismarck,[7] provides a perfect
example of this evolution, in the course of which historical
and biographical elements were used increasingly in the
creation of national and racial fables. Writing about the cult
of Bismarck, the eminent critic Karl Scheffler observed perspi-
caciously in 1919:

> One should not be misled by the pathetic initiatives
> which shortly before the war attempted to erect ever more
> grandiloquent monuments to Bismarck. One should not be
> deceived by all these attempts to elevate this eminent
> personality to the rank of a superhuman and supernatural
> phenomenon, to endow him with mysterious heroic traits
> and to apply to him designations like 'Germanic knight-
> hood', 'Siegfried' or 'Hagen'. All this shows that the
> attitude towards Bismarck had lost its directness and had
> become highly formalized. The monuments to Bismarck in
> the years before 1914 are not in reality dedicated to him;
> these are monuments which the nation erected for herself
> and which refer to Bismarck solely as a pretext.[8]

The Bismarck cult thus constituted the leitmotif of
Germany's national imagery and its answer to Parisian
democratic meritocracy. Its evolution towards ever more
mystic and rustic elements closely reflected the successive
stages of Germany's *Sonderweg* – its turn against Western liberal
values – which though discernible earlier, came to the fore
around 1890 and persisted until the catastrophe of 1945.

The Bismarck cult did not exist in a political vacuum.
Despite his political aggression, the Chancellor was a man of
some principle and did not expressly encourage the erection

of monuments to him during his lifetime. Nevertheless, he did nothing to discourage his monument-crazed entourage after 1890, when he was forced to relinquish the chancellorship. After that year, the Bismarck cult and its monuments reflected a subtle critique of Wilhelm II's political rule and his neo-Baroque court style,[9] although ironically the majority of people engaged in it remained loyal to the Emperor and deplored the rift between the two men (healed by a superficial reconciliation in 1895). The evolution of the Bismarck cult and monuments[10] would distance them from the allegorical court style to the realm of *völkisch* and Teutonic 'mythopolitics'.

The first phase – up to the end of the 1890s – was dominated by conventional statues. Not being of monarchical rank, Bismarck was depicted (with the sole exception of a late equestrian statue in democratic Bremen in 1910) as a standing figure either in uniform – as a military leader – or in court attire, with the Reich's constitution in hand. As each German city received an equestrian statue of Wilhelm I,[11] the problem of defining the relationship with his faithful protector (their relationship being similar to that between Queen Victoria and Disraeli) arose: Wilhelm was of higher rank, Bismarck was the greater man. This difficulty was generally solved by keeping the equestrian statue and standing figure separate. Only in a handful of monuments, such as the Hohensyberg monument near Dortmund, were the two shown together.

By the 1890s, the official, standardized, standing Bismarck figure had been joined by statues serving as biographical annotations and adornments. At Rudelsburg castle in Saxony, corps students sponsored a statue by Pfretzschner of the frivolous young Bismarck in a debonair seated pose (1896; illus. 38).[12] This was an unabashed, stylistically conscious reference to Parisian bronze statues and their peculiar modelling techniques. The stylistic borrowing served obvious ideological ends, with the Germans consigning lightness of touch to the French artistic sphere in a manner reminiscent of their preconceived ideas about French frivolity and licentiousness. The statue reminded the beholder that Bismarck had overcome juvenile licentiousness and had come quickly to the 'earnest things of life'. The Rudelsburg statue – setting aside its self-serving glorification of the German *Burschenschaften* and their lifestyle – thus assumed the function of a light-hearted

prologue to a great dramatic epic, an epic not of wine and merriment but of 'blood and iron'.

A prologue demanded an epilogue, and the latter was duly provided. During his forced retirement, after 1890 Bismarck lived on the Sachsenwald estate near Hamburg, ostensibly leading the life of a country squire. His forays into the adjacent woods – during which he was accompanied by his faithful dog – were signalled to increasing numbers of reverential visitors in a manner in keeping with modern PR. A sentimental picture of the 'old man of the Sachsenwald' made the rounds to almost every German home, showing the old Bismarck in civilian clothes, his sabre replaced by a walking-

stick, his dog providing a picturesque, domestic touch. Around 1900, this image was immortalized in three or four statues, the example in Berlin-Grunewald (1897) having recently been reconstituted (illus. 39). This lesson in popular iconography was not lost on the Soviets, who after 1945 enlarged their standardized Lenin repertoire with statues showing the lively, young – though not debonair – revolutionary and concluded with park figures of the ill, semi-retired Lenin sitting at his dacha near Moscow in the last year of his life.

The craze for bronze monuments devoted to Bismarck culminated in the great Berlin project by Reinhold Begas (1901), unveiled in the vicinity of the Reichstag (now transferred to the Tiergarten; illus. 40). A conventional statue of the Iron Chancellor was surrounded by French-style allegorical figures. It was soon evident that this type of monument, combining local and French influences in the neo-Baroque mould so dear to Wilhelm II, could not embody the specifically German Bismarck cult.

39 Max Klein, Bismarck in retirement on a stroll in the Sachsenwald, Grunewald, Berlin, 1897 (destroyed in 1945; reconstructed in 1996 by Harald Haacke).

In the final years of the nineteenth century, this cult took
on a new symbolism. A new material aesthetic in the areas
of both architecture (neo-Romanesque buildings) and 'national
monuments' associated rough, unhewn or only slightly
worked granite[13] with peculiar Germanic qualities like strength,
simplicity and uprightness, thus envisaging an anti-Western,
pre-civilized mythology. In a discussion about a projected
Bismarck monument in Delmenhorst (Bremen), a local critic
enthused, '. . . we shall erect a veritable altar from the granite
of our erratic boulders.' The granite was thus imbued with an
almost mystical earthiness.

Although there was nothing particularly German about the
granite itself – granite does appear, after all, almost every-
where in the world – German pre-Romantics and Romantics
imparted specific 'Germanic' qualities to this common stone.
Goethe spoke warmly about 'vaterländisch Granit' and pro-
posed the stone as a symbolically suitable medium for the
base of the patriotic Blücher monument in Rostock (1817). The
erratic boulders and dolmens in the landscapes of Caspar
David Friedrich echo a similar sentiment. As the nineteenth
century progressed, granite was often chosen in Germany as a
particularly appropriate material for plinths and bases.

In 1890, Julius Langbehn published his famous book
Rembrandt als Erzieher, which helped to legitimize the politics

of the Right. Langbehn's remarks about the qualities of granite were to exercise a fateful influence on it as a material suitable for monuments:

> The Greeks had a culture of marble, the Germans should have one of granite. Granite is a Nordic and truly Germanic stone to be found in rocks of Germanic and Nordic Scandinavia. It is strewn all over the North German lowlands; we find it there in the form of erratic boulders. Stein and Scharnhorst, Bismarck and Moltke – these are enormous boulders who serve as the political foundation stones of the German Reich.[14]

Langbehn's book – which appeared in the year of Bismarck's downfall and at the beginning of his cult – contained many

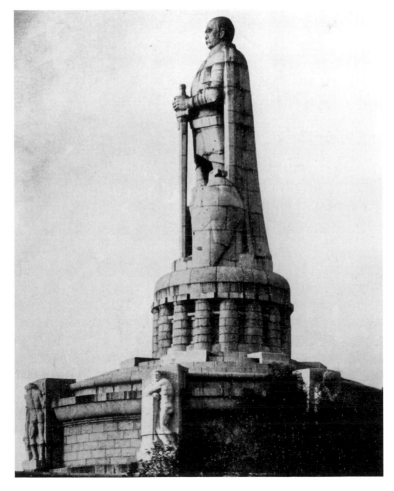

41 Hugo Lederer, Bismarck as Roland, Alter Elbpark, Hamburg, 1906.

völkisch elements which would later appear in Nazi ideology.

During the last years of his life, and increasingly after his death in 1898, Bismarck's image migrated from the realm of heroic politics to that of timeless mythology. Granite – a material which, unlike bronze, was not created by human beings – was considered better suited to expressing the Germanic aspects of his career. Shortly after 1900, Bismarck appeared in the northern cities of Germany and in Munich in the guise of Roland, a medieval personification of civic pride (illus. 41); the important elements were lightly dressed stone, tectonic volumes and reductive medievalism. The iconography of Roland, which mixed the pride of the northern Hanseatic cities with its own Reich mythology, only constituted a secondary element in the creation of the Bismarck myth, however.

It was a tower in Göttingen built on the eightieth anniversary of Bismarck's birth (1895) which inaugurated a new monumental genre: that of the so-called *Bismarcktürme*. Located on high hills or in places with panoramic views, these

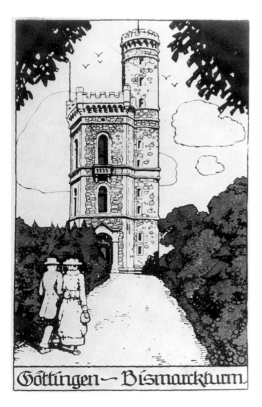

42 City architect Gerber, Bismarck tower, on the Hainberg near Göttingen, 1894/5. Illustration from a postcard of *c*. 1900.

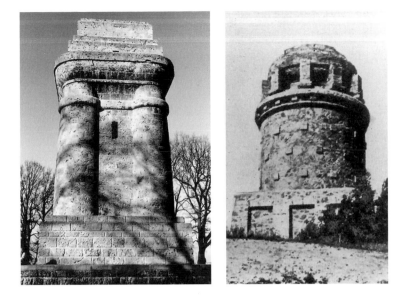

43 Wilhelm Kreis, Bismarck tower, Neusäss near Augsburg, 1903.

44 Wilhelm Kreis, Bismarck tower, Lössnitz near Dresden, 1907.

towers blanketed the Reich rather like the castles of the medieval period (illus. 42). The first ones had medieval formal echoes and assumed a useful function as touristic lookouts, provided as they were with internal stairs and platforms. After 1900, there appeared a new type of monument, a quadratic or conical block built of unhewn granite and field-stone with a gigantic urn – waiting to be lit on festive occasions – at the top (illus. 43, 44). These were meant to resemble Germanic funeral pyres and thus anchored the Bismarck cult in an ever more distant past. The pyres were lighted on Bismarck's birthday and the anniversary of the victory at Sedan, but also functioned as midsummer bonfires (illus. 45). These rites and forms had nothing in common with Wilhelmine state and court pageantry.

The history of one of the last planned Bismarck monuments, that in Delmenhorst,[15] clearly shows a trend towards an ever more primitivistic reductionism. Whereas the first proposal, by Peter Behrens, opted for a sort of Antique, altar-like structure hewn from rough stones, later versions espoused a low, Germanic stone altar with fire urns, with an alley flanked by erratic boulders showing the way (illus. 46). Some elements of this design appeared in the Nazi *Thingstätten* after 1933. The Bismarck towers and monuments were to be complemented by picturesque clumps of that most truly Germanic of trees, the German oak.

73

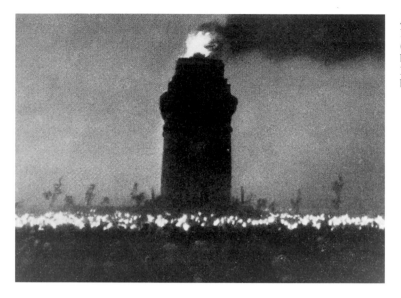

45 Wilhelm Kreis,
Bismarck tower
(with a midsummer
bonfire).
Photograph,
before 1914.

In 1911, a great architectural competition was held for the Elisenhöhe, a prominent, exposed hill overlooking the Rhine, which was to have a 'national monument' devoted to Bismarck. Although the First World War would impede its realization, the competition produced very interesting results. The winning project, by Wilhelm Kreis,[16] foreshadowed things to come. Although the interior decor of Kreis's mausoleum referred unabashedly to the Leipzig *Monument to the Battle of Nations*, on the outside it adopted forms modelled on the 'Germano-Gothic' Mausoleum of Theodoric at Ravenna in Italy. Here too, the historicist impulse looked back not to actual styles but to an imagined Germanic past. Later, Kreis would adopt very similar structures for his famous *Totenburgen* projects, which served as memorials to fallen soldiers of the Wehrmacht. In some ways, two specifically Nazi forms (*Thingstätten* and *Totenburgen*) were thus by-products of the Bismarck cult.

At the outbreak of the First World War in August 1914, five hundred Bismarck monuments of one kind or another existed in the German Reich. A certain pattern had been established. There were relatively few in anti-Prussian agrarian territories like Hannover or Bavaria. The Bismarck cult appeared as a socio-political integrative measure in regions subjected to rapid industrialization such as the Rhineland, the Ruhr, Westfalia or Saxony (where, astoundingly

enough, it helped to overcome separatism). In the Habsburg lands, the few Bismarck monuments were sponsored by nationalistic German-speaking circles critical of the vacillating policy of Vienna and eager for a kind of Anschluss.

No projects were completed and only some minuscule provincial monuments were erected after 1918. The all-embracing enthusiasm seems to have vanished almost overnight. The Nazis, who used Bismarck's name to attract the old conservative Right, had other priorities than to erect monuments to a realistic politician who espoused a policy of checks and balances. Instead, they named a battleship after him. Following an uncanny instinct, however, Nazi cultural policy retrieved from the wreckage of the Wilhelmine era, whose neo-Baroque aspect it abhorred, numerous primitivistic, rustic, neo-pagan Germanic elements. Although Hitler and Speer opted for a modified version of utopian French Revolutionary Classicism, they accepted some Germanic primitivistic strands and placed a high value on granite; the colossal arch planned for Berlin, for example, was to be built of that stone.

46 Curate Ramsauer, Project for a Bismarck monument made from erratic boulders, on the Bookholzberg near Oldenburg, 1922, drawing.

The evolution of both the style and the semantic content of the Bismarck monuments was thus channelled in an anti-urban, neo-pagan, anti-cultural and neo-primitivist direction. Like the Kyffhäuser monument and the Leipzig *Monument to the Battle of Nations*, the later Bismarck monuments strove for chthonic connotations, an illusion of timelessness based on a formal morphology likened to geological strata and the process of sedimentation. It was in connection with the granite of the Bismarck cult that the popular idiomatic expression 'politisches Urgestein' must have arisen. As had happened so often in the past, the Germans were in the uncomfortable position of having to respond to a particularly refined version of Western culture, like the one exemplified by the Parisian monuments of the Third Republic.

The French had watched the evolution of German monuments closely – in particular, the *Nationaldenkmäler* – erected after 1871; on the whole, they found them appalling.[17] It would of course be somewhat naïve to expect praise for monuments glorifying the Battle of Sedan or Germany's ascent to power from the vanquished. But the French rejection had deeper motives and touched on a number of important stylistic and typological problems. In his influential book about national monuments in Germany, the critic Eugène Poiré used a rhetorical comparison between the German monuments – with their rustic locations, semi-primitivistic forms and nationalistic, chauvinistic allure – and the internationalism and humanism of Parisian urban monuments, to underline the fundamental differences between the ethos of the Third Republic and that of Wilhelmine Germany. Poiré criticized both the German monuments' rural location and their architectural forms.

On the other hand, French conservative and nationalistic circles admired Wilhelmine patriotic pageantry and saw the need for similar mass-scale French celebrations. But even they preferred their own predominantly sculptural, semi-allegorical urban monuments to those of Wilhelmine Germany. When the last of the *Nationaldenkmäler*, the Leipzig *Monument to the Battle of Nations*, was inaugurated in October 1913, French art critics, journalists and political writers were unanimous in their aesthetic rejection of that 'barbaric' monument.

3 Memorials to the Great War

In an often quoted anecdote, an exasperated Lloyd George maliciously asked the British Commander Marshal Haig why the war of the trenches had not produced a single outstanding military commander – to be sure, he was referring to both sides of the conflict. Haig responded by asking the Prime Minister to name him at least one outstanding politician able to settle the conflagration. This anecdote aptly characterizes both the course of the war and the nature of the problems facing the committees and artists at work in the domain of public monuments after 1918.[1] Bloody but inconclusive trench battles like those of Verdun and the Somme put an end to any pretensions regarding the inherent romanticism of warfare and were difficult to glorify by means of traditional – especially allegorical – representations.

As things developed, only the victorious French took the decision to honour their phalanx of military commanders by means of public monuments – of course *post mortem*. Marshals Fayolle and Gallieni and General Mangin were represented as standing figures; Joffre and Foch were destined for equestrian statues which were not quite ready when war began anew in 1939. Revering Clemenceau as the 'Father of Victory', the French decided to place a vivacious statue of the 'Tiger' by François Cogné on the prominent though small Rond Point des Champs-Elysées (1932; illus. 47). The rough boulder base gave the forward movement of Clemenceau – not dissimilar to the thrust of the *Athena Nike* – a dynamic, ascending character, while the dense foliage of the trees around the statue paradoxically guaranteed a feeling of intimacy and seemed to amplify the work's rather small dimensions. This was perhaps the first monument to be based on a photograph: a famous snapshot from 1917 showing Clemenceau plodding through a gale on a visit to the Champagne front.

Two valiant allied monarchs – Albert of Belgium and Alexander of Serbia – were also honoured with monuments in Paris. The decision to erect monuments to military leaders was not taken lightly, but the traditional Republican reticence

of the Paris City Council was overcome by the accumulated pressure of the army, the government and the vociferous veterans' associations. Despite this powerful backing, these monuments somehow failed to become focal points for commemorative festivities.

That role was taken over by a new type of commemorative monument – the *Tomb of the Unknown Soldier* – unveiled on the second anniversary of the Armistice, 11 November 1920. The idea for the Tomb was of course a by-product of the process of democratization; not surprisingly, the first such project, albeit on a small scale and with a slightly differing character, seems to have been attempted in the United States in the 1890s. The unprecedented mobilization of mass armies and the quasi-anonymous character of the war and of many of the fallen soldiers made this a universally understandable and seemingly pertinent solution. The exact history of the idea and the course of events in the two years following the war that led to the establishment of the two pioneering monuments in Paris and London must be investigated with greater accuracy.[2] For our purposes, it should be enough to say that the selection

procedure and ensuing ritual transporting of the remains to their final destination in Paris played an integral role in the Tomb's symbolism and ontology. Three years later, another, then novel, concept, that of the eternal flame, came to be associated with it.

In France, both the public and the National Assembly were for a while undecided as regarded the placing of the Tomb. Left-wing groups advocated the idea of a tomb in the Republican Panthéon. In retrospect, the choice of the Arc de Triomphe de l'Etoile was the right one; the seemingly incongruous contrast between the triumphalist Napoleonic pathos of the Arch and the minuscule grave worked in the latter's favour. (Interestingly enough, the political divisions with regard to its location seem to have continued until the 1980s; in his first ceremonial act after his election in 1974, Giscard paid homage at the Tomb, while in 1981 Mitterrand went to the Panthéon.)[3] When accented by a great French flag, the Arch takes on the character of a temporary frame, thus amplifying the symbolic valence of the Tomb enormously. Another gripping effect is the view of the elevated flame from the Champs-Elysées on a sombre Parisian night.

The British decided to place their Tomb in Westminster Abbey. This decision seems to have been an unfortunate one, though its ideological premises are not difficult to understand and are certainly respectable.[4] By virtue of its location, the Tomb in London became just another slab or sepulchre – one which, in contrast to its French counterpart, was endowed with a long-winded inscription – in a crowded, semi-religious Pantheon of national heroes. Its symbolic rank was overtaken by a very different object: Sir Edwin Lutyens's *Cenotaph* in Whitehall (1920; illus. 48).[5] The *Cenotaph* originated as a temporary wooden structure inspired by the ornamented cenotaph erected on the Place de l'Etoile in Paris for the festivities of 14 July 1919. Having been remade in marble, this modest pylon managed to maintain the character and allure of an impromptu reference sign. There seems to be a deeper significance in the astounding fact that in official as well as popular usage, it is still known by its *terminus technicus*. In reality, the *Cenotaph* constitutes a double model, of a former provisional commemorative structure and – by virtue of its name – of an actual sepulchre. Its blankness, devoid as it is of any obtrusive religious or patriotic elements (this pertains

also to the laconic inscription *The Glorious Dead*) in some sense presaged later abstract or Minimalist monuments. By virtue of these traits and its – apparently off-hand but in reality very propitious – location, the *Cenotaph* acquired greater prestige than the Tomb in Westminster Abbey.

One further suggestion can be made here. In the 1920s and 1930s, the *Cenotaph* stimulated an astoundingly wide range of ritual and semi-cultic practices. I would like to mention especially the hundreds of written messages that were left at its base, often unaccompanied by flowers or wreaths. A somewhat farfetched parallel to the Wailing Wall in Jerusalem and a closer one to the rituals carried out before Maya Ying Lin's Vietnam Veterans Memorial in Washington, DC (after 1984) comes to mind. Despite some obvious reservations about this comparison, it seems appropriate to reflect deeply on the cultic implications of nonfiguration.

48 Sir Edwin Lutyens, *The Cenotaph*, Whitehall, London, 1920, during a commemorative ceremony in the 1920s.

VERDUN: REPRESENTING A HECATOMB

In 1920, the city of Verdun received in an act of homage from the admiring Netherlands the first bronze cast of Rodin's *La Défense*.[6] The history of this monument was complicated.

80

Rodin had submitted a plaster project with the first version of this theme as early as 1878 to a competition for a monument to the 1870/71 defence of Paris. In its final shape, the work ably combined pathos in the vein of Rude's *Marseillaise* with Michelangelesque dynamism. Yet despite these as yet unconventional traits, it still belonged to the special type of the allegorical monument dear to the early Third Republic. The theme demanded, as in all other monuments of this type, a location before a city gate – and that was duly provided. However adequately Rodin's monument might have expressed the resistance spirit of the city, lying as it did in the hinterland of the battle zone and touched only by artillery fire, he could not represent in any way the terrible reality of the battle in the hills before Verdun.

On 11 June 1916, a giant German shell destroyed a large section of a deep French trench complex. A dozen or more French soldiers waiting with bayonets at the ready for the order to leave the trench were buried by an avalanche of sand – only the tips of the bayonets protruded from the earth. Somehow the symbolic significance of this terrible event was soon understand, even though it was rather minor when compared with the number of war victims overall. Amidst raging battles, the trench was left as it was, and the buried bodies were left unexcavated. Shortly after the war, the American philanthropist George Rand sponsored a massive concrete structure to shelter this section of the trench. The *Trench of Bayonets*, a grisly stop on the Verdun tourist circuit, came into existence.[7]

The *Trench* was thus transformed from a vestige of trench warfare into a symbolic image of the human condition on the modern battlefield. Earlier epochs could still romanticize warfare, including the graves of soldiers. The new mode of warfare in ever deeper earth and mud, a terrible activity devoid of romance and chivalry, changed that dramatically. The *Trench* could, however, serve as an excellent, both real and symbolic illustration of soldiers gradually sinking into their graves. In front of it, three soldiers were buried on higher ground; not only the tips of their bayonets but also parts of their rifles showed through the sand. Thus, the process of sinking was represented in a terrible but poignant manner. The trenches after all blurred the boundary between the living and the dead.

Many literary descriptions – and also painted representations, such as Otto Dix's *War Triptych* (1932) – dwelt on the analogy between the trenches and graves. In some cases, bayonet tips took on a cross-like configuration, a shape made by chance but all the more symbolic and gripping as a result. This analogy was exploited – as we shall see later – in the war monument in central Munich, where marching soldiers were likened to rows of crosses in military cemeteries. A modified representation of marching soldiers sinking gradually into the grave was presented as late as 1982 in the Hamburg counter-memorial competition, 60 years after the *Trench of Bayonets*.

This was death by metonymy, not death by allegory. Metonymy replaced metaphor and allegory as the chief artistic instrument of progressive war memorials. Without this tendency, it would be difficult to comprehend the cult of the Unknown Soldier in its entirety.

The grim *Ossuary* at Douaumont in the very centre of the battle zone constituted the other important Verdun war monument (illus. 49). Designed by Louis Azéma and a group of collaborators, it was constructed in 1923–32 by non-government sponsors and veterans' associations under the leadership of the Bishop of Verdun.[8] The edifice consists of a long, barrel-vaulted hall at ground level that houses large stone sarcophagi containing the remains of fallen soldiers from different geographical sectors of the Battle of Verdun. A high, central lantern tower tops the hall, which from the outside has the look of military casemates. The tower, on the other hand, influenced slightly by Mendelsohn's *Einstein Tower* in Potsdam (1921), presents a symbolic combination of an obelisk and a cross in neo-medieval guise. Beneath the huge hall, vaulted ossuaries are filled with the bones and skulls of (supposedly) French soldiers; they can be viewed through small windows. German soldiers are buried nearby, but in the earth.

In imagining this hecatomb containing more than half a million soldiers, those responsible for its conceptualization developed a peculiarly grim dialectic of invisibility and visibility, representation and its disavowal, decorum and crass naturalism. They accorded a different treatment to German and French soldiers and indulged in the grisly procedure of showing skulls and bones with visible gunshot wounds and mutilations. On the outside, the *Ossuary* is surrounded by

uniform rows of crosses, some with names, some without.
A supreme personal accent planned from the outset – the
incorporation of the grave of Marshal Pétain, the French
Commander-in-Chief during the battle – was avoided only by
the course of history. Pétain was buried in 1951 on the prison-
island where he had served his life-long sentence for colla-
boration with the enemy. Leaving aside the sordid policies of
Vichy, one can see in this absence a deeper logic, that of the
unavoidable anonymity of mass battle and mass graves.

THE VANQUISHED AND THEIR DEAD

The lost war confirmed Germany's deep anti-Western preju-
dices. After 1918, there followed a period of political turmoil,
and the Germans had neither the desire not the ability to
translate their grief and bitterness into one nationally accepted
form of remembrance and mourning. Despite the electoral
victory of the Social Democrats and the parties of the Centre,
most of the country, rural areas in particular, remained pro-
foundly conservative. And it was the conservative groups and
the many veterans' associations which, almost immediately
after the war, embarked on a gigantic, though decentralized
and uncoordinated, programme of erecting war memorials.
When war broke out again in 1939, Germany was the country
with the highest number of memorials in the world. 'All

83

around the country,' noted the journalist Victor Auburtin in 1921, 'committees are astir, sites are being selected, and designs made; a golden age of genii, triumphal structures and lions seems to be in the making, yet this time not as monuments of victory, but as memorials for the dead.'[9] These words adequately capture the mood of the 1920s, yet Auburtin erred in one respect: the new memorial movement completely rejected neo-Baroque Wilhelmine triumphalism.

If there exists in stylistic terms a *differentia specifica* of the German intra-war memorial, it is an abhorrence of decorative elements and the bare and bulky, somewhat archaic or pseudo-Romanesque tectonic quality of the statues. This trend harked back to the last decade of the Wilhelmine period and was inspired by the sculptures of the great Adolf von Hildebrand. In his book *Ginster*, the left-wing critic Siegfried Kracauer gave an excellent description of the aesthetic approach of the conservatives after the demise of the Wilhelmine style. In the words of an architect describing his submission to a typical competition for a memorial cemetery cum monument:

> As regards my memorial, it was my firm conviction that the equality [of all soldiers] mentioned earlier, which is the highest essence of patriotism, is opposed to any kind of extra adornment . . . For this reason, instead of curved lines, I drew straight ones, and these are just as unwavering as the rows of our heroes . . . their measured equality culminates in the simplicity which tallies with the simple 'field grey' uniforms of our heroes. This perpetuates itself everywhere up into the complete monument with its equally long edges, which lacks a cornice, as fine profiles would be damaging to the war cube – in view of its purpose, it should remain bare.[10]

We meet in Kracauer's perspicacious account many of the later catch-phrases of the Nazi period (equality of all German soldiers, simplicity, uniformity of the 'field grey' look, uniform rows of marching soldiers), which – in a more accentuated form – were to shape such memorials as the famous Hamburg *76th Infantry Regiment Memorial* (1936) (illus. 137).

In the Catholic territories of southern and western Germany, the pressure of the Church led to a predominance of religious imagery in the form of warrior-saint figures. Countless medievalizing statues of St George epitomized

modern German knighthood, while many St Michaels were shown metaphorically slaying the dragon of Entente. More moderate circles used the image of the Pietà,[11] which allowed for a slightly nonconformist, Expressionistic tinge, as in Bernhard Hoetger's Bremen example (1922), which, though destroyed in 1933 by the Nazis, seems nonetheless to have influenced Sir Jacob Epstein's Trade Union Council war memorial (1958). In other regions, reductive forms of classicizing vintage competed with neo-Romanesque images of marching soldiers and riders or countless Prussian Iron Crosses.

Left-wing or pacifist proposals for new forms of war memorials remained isolated or unrealized – thus, the great architect Bruno Taut's proposal to erect an Expressionistic glassed-in reading room for pacifist literature as a war memorial in Magdeburg (1921)[12] exists only on paper. Neither the kneeling figures of grief-stricken parents modelled by Käthe Kollwitz for a Belgian war cemetery (1932) nor Ernst Barlach's expressive memorials located in church interiors (Güstrow, Magdeburg) gained wide acceptance. The only outstanding semi-avant-garde work to come to the attention of a wider public was Bernhard Hoetger's *Niedersachsenstein* (1923), located on a prominent hill near the artists' colony of Worpswede.[13] This project presented a mixture of Expressionistic, primitivistic (in the vein of Gauguin) and functionalist elements, while the location and a row of erratic boulders catered to the tastes of the *völkisch* Right. It is therefore not surprising that this curious memorial survived the Nazi denigration of 'degenerate' art, as Barlach's works did not.

Two greater war memorials with claims to a wider audience were erected in the mid-1920s by Centre-Right circles in Munich (in 1924 by Eberswalder, Wechs, Bleeker and Knappe [illus. 50–52]) and at Tannenberg in far-off East Prussia (in 1927 by Johannes and Walter Krüger; illus. 53). The Munich memorial, located in the famous Hofgarten in front of what was then the Army Museum, was a novel departure as it tried to combine an austere mixture of classicizing and vaguely Expressionistic elements. Its reductive classicism espoused the so-called 'heroic style' which foreshadowed Paul Ludwig Troost's unembellished Nazi architecture of the early 1930s. Bernhard Bleeker's monumental figure of a young soldier lying in an eternal sleep (illus. 50) exerted a great influence on many smaller war memorials. In this project, we find a subtle

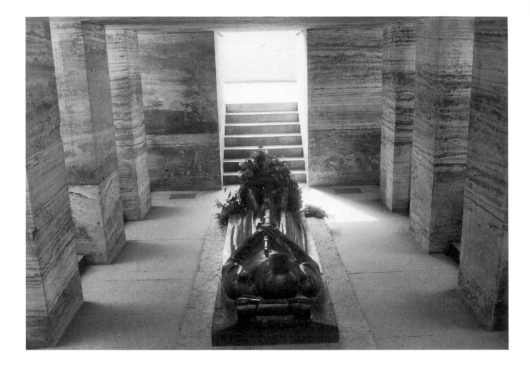

critique of the war – marching soldiers on a side relief (illus. 51) are confronted with a relief placed opposite them showing a similarly rhythmical depiction of the rows of crosses in military cemeteries (illus. 52). This detail was easily overlooked, unlike the figure of the young soldier, who went on to grace the covers of many nationalistic or militaristic brochures.

50 Ulrich Finsterwalder, Thomas Wechs, Bernhard Bleeker and Karl Knappe, Munich war memorial, Hofgarten, 1924.

In contrast, the Tannenberg monument, celebrating the victory of Germany's Eastern army over Russia in August 1914, was a wholesome and unabashed exercise in right-wing mythology (illus. 53). Inaugurated with a grand ceremony in 1927, it contained the tombs of twenty unknown German soldiers and was Germany's response to the French and British concepts of the tomb of a single unknown soldier. (Earlier attempts by Konrad Adenauer, then Mayor of Köln, to vary the British conception by placing the tomb of an unknown soldier near Köln cathedral had inspired only negative responses, though that building would have provided a nineteenth-century *Nationaldenkmal* aura.)

Nonetheless, this great polygonal structure, with walls and fortress-like towers modelled on the thirteenth-century Apulian Castel del Monte (erected at the behest of the mythical figure-

head of the German conservatives, Emperor Frederick II), was meant to give the impression of military triumphalism; the Battle of Tannenberg was after all Germany's great victory in a war characterized by stalemate and defeat. In 1934, the victor of Tannenberg, Field Marshal Paul von Hindenburg, was buried there on Hitler's orders, and the inside of the memorial was remodelled – following the relocation of the tombs of the unknown soldiers – along the lines of Nazi places of assembly.

There remained Berlin, the bustling political and cultural capital of the Weimar Republic, a city which also served as the capital of Prussia. Governed by Social Democrats, Berlin differed in its aesthetic and political stance from its conservative hinterland. In 1929, the Social Democratic government of Prussia decided to establish a central war memorial in Berlin which would reject both triumphalism of the Tannenberg

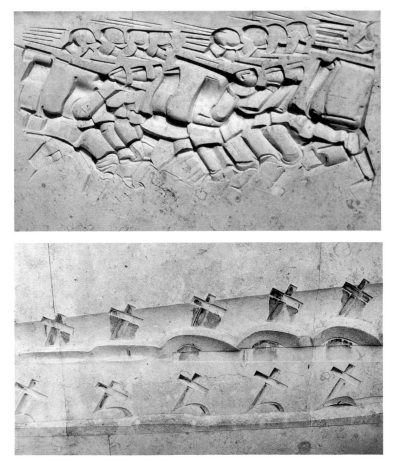

51 Knappe, Munich war memorial, detail showing relief of marching soldiers.

52 Knappe, Munich war memorial, detail showing relief of military cemeteries.

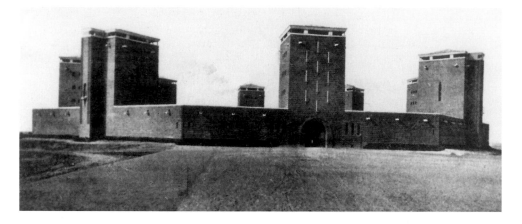

type and the Western solution of an unknown soldier's tomb. As a site, the authorities chose a famous classicizing guard-house, the Neue Wache, designed by Schinkel and situated on the Unter den Linden. The Neue Wache, with statues of Prussian generals positioned in front of it, had been the tradi-tional centre of the Berlin garrison's military pageantry.[14]

53 Johannes and Walter Krüger, Tannenberg monument, East Prussia, 1927 (destroyed 1945).

Despite this somewhat problematic choice, which excluded the remodelling of the building's exterior, leading architec-tural avant-gardists like Mies van der Rohe participated in the competition. It was won by Heinrich Tessenow, an austere, reductive classicist (and teacher of Albert Speer), who by creating a great, unified room completely changed the interior (illus. 54). Tessenow inserted a circular opening into the ceiling, thus gaining a dramatic source of light. Under this opening he posed a quadratic, altar-like block made of dark Swedish granite and crowned with a gilded wreath of oak leaves. The latter referred to the *corona civica* which the Roman Senate bestowed on a civilian or soldier who had saved someone's life in battle, but could also be interpreted in a solely military and Prussian (the oak leaves) way. The ambivalence was no doubt intentional. The interior of the Neue Wache was totally bare, without ornament or inscription. The black granite block had a stark simplicity and foreshadowed Minimalist solutions of our own time (Sol LeWitt); sometimes the light from above, setting the golden tones of the wreath against the sombre black, engendered an almost metaphysical atmosphere.

Although it transcends at first glance the chronological structure of this chapter, we shall continue our narrative with the Neue Wache as its chief subject; in a paradoxical way, the

vicissitudes of this memorial reflected up to the present day the debates and dispositions of the 1920s. After taking power in 1933, the Nazis placed a giant cross on the wall, hoping to use this opportunistic gesture to gain the support of the Church. Even more important was the introduction of an elaborate military ritual in 1935, which included the changing of the guard complete with a demonstration of the Prussian goose-step. The Neue Wache thus became a focal point for highly politicized state ceremonies conducted by leading figures of the Third Reich.

The Neue Wache was partially ruined during the war when a bomb hit it and disfigured the central dark stone block. When restoring the memorial in the 1950s, the East German authorities left the block in its ruined state – the wreath having disappeared in the post-war turmoil – thus creating by all accounts a gripping and imaginative symbol of the carnage of war. (A similar idea had been realized as early as 1946 in Warsaw, where the ruined colonnade above the *Tomb of the Unknown Soldier* was left unrepaired.) The statues of the Prussian generals, now considered politically untenable, were removed to less prominent locations nearby.

The affluent 1960s saw a Communist change of heart followed by a change of style. The memorial was refurbished in 1969 in a different vein; now the regime decided to take

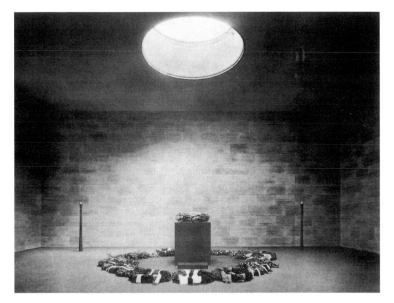

54 Heinrich Tessenow, Interior of the war memorial in Karl Friedrich Schinkel's Neue Wache, Unter den Linden, Berlin, 1931 (partly destroyed in 1945).

up the Franco-British conception of a unknown soldier's tomb, though not – owing to the burden of German history – in its classic form. The memorial was officially rededicated to 'Victims of Fascism and Militarism', and in a compromise solution, but without any of the usual rituals associated with the cult of the Unknown Soldier, the remains of a fallen Wehrmacht soldier and those of a German anti-fascist combatant were interred in the middle of the room. A large GDR coat of arms and revived Prussian-style military pageantry showed in an unintentional but instructive way that particular combination of Communist and Prussian motivations and motifs that characterized latter-day East Germany.

Although the East Germans were indeed edging closer to Western-style symbolism (the rejection in the 1920s no doubt being motivated by disdain for anything French), their didactic solution contained one fatal element: the unknown Wehrmacht soldier might have killed the anti-fascist, or vice versa. This worrying possibility in conjunction with the cheap and flashy design of the glass cube and the showy military parades before the memorial turned the Neue Wache into a particularly dubious set piece of official propaganda. After the fall of the GDR in 1990, all of these post-1969 elements were immediately removed or discontinued.

Since becoming Chancellor, Helmut Kohl had tried to promote – mostly in an infelicitous way – a peculiar brand of

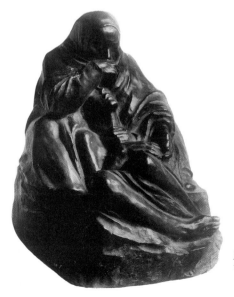

55 Käthe Kollwitz, *Pietà*, 1935/6, bronze

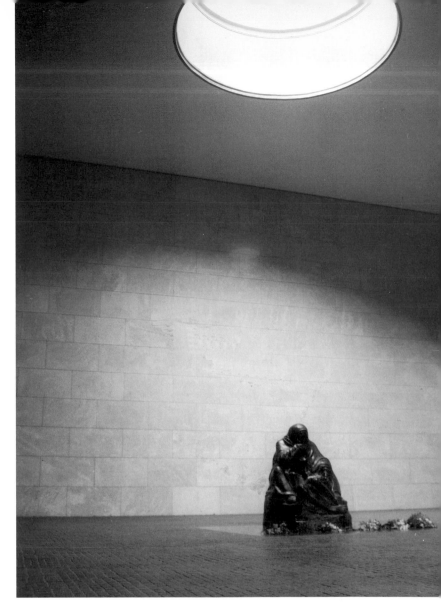

56 The Neue Wache memorial with the replicated bronze sculpture by Käthe Kollwitz, 1993 – the solution devised by Chancellor Helmut Kohl and realized by Harald Haacke.

symbolic politics. In early 1993, he dictated a new memorial concept for the Neue Wache, designating it as a memorial to the 'victims of war and the rule of oppression'. This less than precise phrase encompassed through semantic subterfuge both the victims of the Holocaust and – potentially – their executioners killed later in the course of war. Where once the black stone and glass cube had stood, Kohl decided to place a replica of a small bronze sculpture by Käthe Kollwitz showing a Pietà-like rendering of a mother with her fallen son (illus. 55, 56). Kollwitz had sculpted this motif in 1935 as

an act of remembrance for her own child. The Pietà motif had indeed played an important role in some German war memorials of the 1920s; thus, Kohl's decision seemed to take up the iconographic thread at the point where the artists of 1930 had abandoned it. But Kohl ignored the fact that Tessenow, and subsequently the East German Communists (who habitually opted for elaborate figurative decoration), had chosen a nonfigural solution as the only feasible option given the sheer scale and anonymity of the carnage of two world wars.

Other arguments were put forward, including a suggestion that the Pietà would offend Jews and atheists; art historians and connoisseurs deplored the mediocre results of the enlargement of what was originally a small sculpture. But one important point seems to have been overlooked by the general public and the experts alike. The tombs of the two unknown combatants were once again rendered anonymous through the removal of the inscribed tablets in the floor and the extinction of the eternal flame. By means of this unique decision, Germany finally severed all links with the tradition of the cult of the Unknown Soldier. On the other hand, the many angry protests against the memorial's new vagueness forced the Chancellor to agree to the creation of two supplementary tablets to be affixed at the entrance. (A persistent rumour has it that they were written by the then German President, Richard von Weizsäcker.) These list the various categories of the victims of Nazism and war, starting with those of the Holocaust and including such neglected groups as gypsies and homosexuals. As a result, today we are confronted with a somewhat clumsy, obviously forced exercise in political correctness. The one positive aspect of Kohl's vision lies in the new, predominantly civilian character of the Neue Wache – a tendency epitomized by the Pietà motif, the abrogation of military pageantry and the continued banishment of the statues of the Prussian generals.

4 The Nazi Monuments

When in 1942, in a rare moment of leisure amidst raging war, Hitler sketched a monument to the great composer Anton Bruckner (to be situated in Linz), the Führer vividly revealed his attitude towards monuments (illus. 57).[1] Since his days in Munich, Hitler had had a penchant for tall columns interspersed with the urban fabric. His inspiration probably came from Paris, though he needed these tall columns to decorate new urban complexes, not to enhance existing nineteenth-century structures. In 1938, he ordered the relocation of the Wilhelmine *Siegessäule* in Berlin and the correction of its faulty proportions – in a sensible move, he had the column heightened by one drum.[2] Hitler also planned to erect gigantic columns crowned by the Reich's eagle in Munich and Berlin.

If we return to the Bruckner sketch, one thing immediately becomes obvious: Hitler must have had deep misgivings about portrait statues of the traditional type. He preferred allegorical figures; in the case of the Linz project, this was to be a personification of Music. Two important facets of the Nazi attitude to monuments are apparent in his sketch: the dominance of architecture, and a recurrence of the allegorical stance of the nineteenth century, though in its earlier classicizing rather than its later eclectic guise. This tendency went so far that, with regard to the many reliefs or statues in the grand Berlin and Nürnberg complexes, Hitler often demanded that these be 'symbolic' in nature without specifying particular themes or motifs (illus. 58).

Contrary to popular belief, the Nazis only erected a few monuments. In quantitative terms, theirs was a minuscule effort when compared with the profuse production of statuary under Stalin. Of course, their regime lasted for a much shorter period of time, with the war curtailing and then preventing the realization of their projects. But the scarcity of monuments in the orthodox sense of the term also had other causes. To begin with, Hitler and his acolytes were strongly critical of Wilhelmine neo-Baroque pathos and bourgeois

57 Adolf Hitler,
Sketch for a projected
Bruckner monument in
Linz, 1942. Private
collection.

statuomania, which they saw as a preserve of both the old
monarchical order and an equally reprehensible democratic
meritocracy. The Nazi theoretician Alfred Rosenberg attacked
the Wilhelmine patriotic monuments of the Berlin *Siegesallee*
type on various occasions. For their own monuments, the
Nazis chose mostly architectural forms, though they used
them in an unorthodox way.

For the first Nazi Forum in Munich, on the Königsplatz
(1933–7), Hitler conceived the idea of 'martyrs temples'
(*Ehrentempel*)[3] which were to be placed on either side of the
square's long axis, flanking the two chief party buildings, the
Führerbau and the Verwaltungsbau. The two *Ehrentempel* were
to house sixteen sarcophagi of the 'martyrs' of the abortive
Munich Putsch in November 1923. Paul Ludwig Troost,
Hitler's first architect, devised an unusual approach for the
complex: both temples took the form of square, roofless atria,
with fluted pillars supporting a heavy cornice (illus. 59).
Inside the atria, two cavities contained the decorative metal
coffins of the fallen Nazis. This was an ingenious solution
to the need to present the 'martyrs' relics' during the many

festivities on the Königsplatz and to assure a semblance of physical contact with them – in a manner reminiscent of ambulatories in Gothic cathedrals.

The famous confrontation of the German with the Soviet Pavilion at the Paris 1937 World Exhibition (illus. 81) will be analyzed in the next chapter. Suffice it to say that Albert Speer's work unabashedly aspired to a *Denkmalcharakter* of its own, but only by means of architectural expressiveness. This tendency accentuated itself a year later, when Hitler and Speer designed a Great Arch for their new Berlin. Incredibly, this war memorial containing the names of all German soldiers fallen in the First World War would have been 150 m high

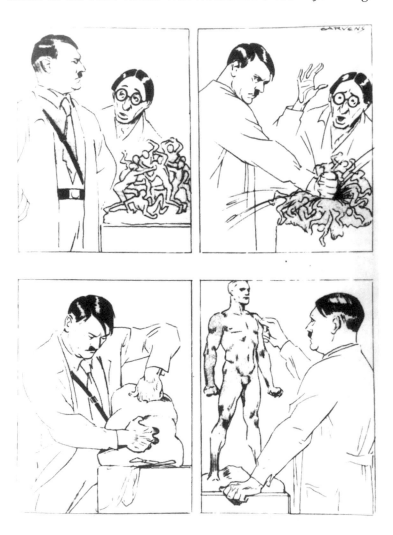

58 O. Garvens, 'The Sculptor of Germany'. Cartoon from *Kladderadatsch*, LXXXXVI/49 (1933), p. 7.

(illus. 60). Of course, the concept reflected Hitler's fascination with ancient arches, but it also showed his knowledge of the Parisian ones. Whereas the latter were integrated into the city structure, the Berlin Arch was to be one of four or five structures dominating the skyline of the new city: a novel, but certainly disquieting, idea (which, incidentally, was taken up in the Paris of François Mitterrand).

Hitler, as is well known, was most interested in architecture.[4] Grandiose complexes and the reconstruction of entire cities like Berlin and Munich were meant to symbolize the building of the new German Reich. In a manner which displayed some affinities with Boris Iofan's Palace of Soviets and, in an ontological sense, with Mitterrand's later *Grands Travaux*, the Nazi buildings and memorials set out a semiotic claim within the fabric of the city. Although they made generous use of sculpture, it served only as an external symbolic or decorative element,[5] as a visual or iconographic complement to an otherwise domineering architectural structure. None of Hitler's projects aimed at a solution in the vein of Iofan, whose Palace was meant to serve as the socle of a gigantic sculpture, despite the fact that the sculptures designed or modelled by Hitler's leading sculptors – Arno Breker, Josef Thorak, Adolf Wamper and Kurt Schmidt-Ehmen – were in themselves gigantic. Nevertheless, they were intended to merge visually with the walls, colonnades or porticoes of Speer's great buildings. They represented ideal types or professions – the warrior, athlete, nude woman or labourer – rather than noteworthy individuals.[6] These sculptures, even when free-standing, never seemed to act on their own, invariably reminding one of bas-reliefs. In fact, grandiose bas-reliefs lay at the core of the Nazi sculptural effort. The Hamburg *76th Infantry Regiment Memorial* – discussed in Chapter 9 – clearly showed a union of brutal geometric forms with superimposed bas-relief decoration (illus. 137). What is more, despite their professed acceptance of regional or folkloric modes in the vein of the so-called *Heimatstil*, the Nazis somehow failed to erect monuments espousing regional themes. Nor were they eager to create statues of their historical or ideological ante- cedents; as has been noted, no monument to Bismarck was unveiled during the Nazi era.

At the core of the Nazi aesthetic lay a yearning for semi-religious, cultic, scenographic effects, intended to enthral the

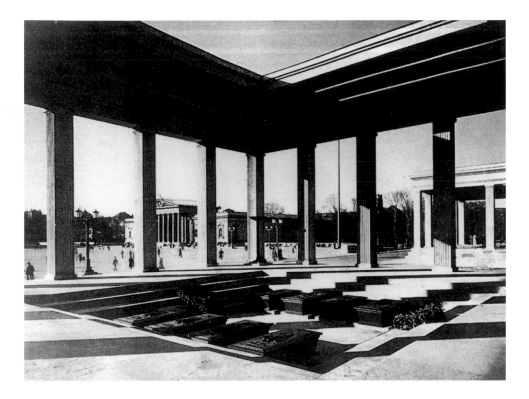

59 Paul Ludwig Troost, *Ehrentempel* for the Nazi victims of the 1923 Munich Putsch, Königsplatz, Munich, 1934 (destroyed in 1946).

crowds but variable and movable. Hitler saw himself as a *Pontifex Maximus* of the nation, with which he renewed his cultic bond in the annual Nürnberg *Parteitage*.[7] These gatherings served as a liturgical re-creation of Hitler's position, a position achieved not by isolation on a throne or high tribune, but by his moving through and with the crowd, 'face to face' with each participating German. Hitler himself, as his propagandists put it, was the living throne. His charismatic rule was not based – at least until 1939 – on monuments symbolic of his personal power, despite the presence of numerous Hitler busts in the interiors of state buildings. This marked a decisive difference from the symbolic gradation of Soviet power in the Stalin era, with its instruments of the Stalin cult and the countless stereotypical Lenin monuments. Stalin, a stiff orator devoid of charisma, achieved his god-like position by a diametrically opposed strategy[8] based on a calculated estrangement both from crowds and from the public in general. When in the course of the war Hitler withdrew to the *Hauptquartier* bunkers, the bond between him and the German people weakened.

97

Besides their penchant for great, symbolically laden building complexes, the Nazis were forever on the look-out for adequate grounds for parades, festivities or giant theatrical productions. In addition to the well-known Nürnberg complex and the great planned north–south axis in Berlin, one should mention the grounds around the Olympic stadium there and the Königsplatz in Munich with its series of Nazi buildings. In all these areas, sculpture played a subservient role, decorating walls or flanking entrances. The so-called *Thingstätten*[9] – amphitheatre-like structures which served as places for oratory or rhapsodic 'Germanic' productions – evolved, as we have seen, from some concepts inherent in the earlier Bismarck memorials. They were almost totally – with the exception of the Berlin *Thingstätte* – devoid of sculptural decoration. In a case of astounding continuity of aesthetic thinking, the great Bertolt Brecht pinpointed this weakness when, in 1952, he drew up a kind of socialist *Thingstätte* for the Buchenwald *KZ* memorial which should have been complemented by great sculptures of the camp's inmates.[10]

The Nazi art historian Werner Rittich defined monumental sculpture as a 'symbol-giving accent with an ornamental subfunction' in the service of architecture.[11] The monument honouring Mussolini,[12] planned since 1937 for an oval square on Berlin's 'east–west axis' (illus. 61), is a good example of this tendency. In Berlin, Speer and Breker attempted a re-creation of Italian flair and classicism both by reference to Italian models (one might mention Charles Moore's Postmodern

Piazza d'Italia in New Orleans as a later example of this tendency) and by a reversion (hitherto overlooked) to the eighteenth-century tradition of Berlin enclosures and colonnades. A two-storey columnar monument was planned to rise up in the centre of the square, echoing in a calculated historicist ploy the Bolognese free-standing monuments of famous jurists from the late Middle Ages. It was to be crowned by a statue of Readiness by Breker. However, Breker's figure had no specific connotation in relation to Mussolini, and many contemporary observers were convinced that its final destination would be the *Reichsparteitag* grounds in Nürnberg. The colonnades and the overall structure did succeed in their evocation of an Italian aura, however.

MONUMENTS TO LABOUR

61 Albert Speer and Arno Breker, Model for the planned Mussolini monument in Berlin (destroyed).

The mythologization of industrial labour was an important constituent of the Nazi Weltanschauung and – on a more pragmatic level – served as one of its favourite propaganda ploys. No wonder the National Socialists also cultivated a field which is normally thought of as a preserve of leftist cultural politics, that of monuments devoted to labour or the working class. In conjunction with the Nazi penchant for and

cult of all types of 'sacrifice', nude figures of youths or men with melancholic gaze and in pensive mood, adopted from war memorials, thus stood for the 'victims of labour' (a theme which had been formulated at the end of the nineteenth century). What is more, figures of miners or steel-workers conceived in the realistic mode of the 1800s were – following a heroizing adaptation – placed before the entrance gates of factories or mines. These were mostly small-scale monuments, a type which straddled the dividing line between monuments as such and decorative public sculpture. There can be no doubt that the realism of nineteenth-century art proved itself to be eminently adaptable in this domain. Thus, the works of the important Augsburg sculptor Fritz Koelle forcefully demonstrate the meanderings of artistic forms and motifs amidst the pressures of conflicting ideologies.[13] Koelle used Meunier's type of the socially conscious worker in the 1920s for miners' memorials which in some way reflected the struggles and industrial unrest of the period. Having gained Nazi protection in the 1930s, Koelle endowed his small monuments with Nazi pathos. In the late 1940s, he adopted a sweeter, more folksy Socialist-Realist manner, with which he tried to endear himself to the fledgling East German Communist system.

The Nazis took up the theme of a great 'Monument to Labour', a somewhat utopian idea formulated for the first time in Paris by Rodin, Dalou and Bouchard.[14] Rodin's project of a great tower – despite the fact that it had never been realized – had enjoyed some publicity. It also seems probable that Vera Mukhina's provocative 1937 hammer-and-sickle group in Paris inspired the Nazis to work out gigantomanic plans of their own in 1938/39. In the words of a Nazi publication: 'The Third Reich will create the absolutely greatest monument to Labour. It will be a gigantic structure made of stone and bronze, almost three storeys high . . . The Monument will show a worker surrounded by figures of a scientist, a peasant, a soldier, an artist, a craftsman and a mother with a child on her arm.'[15] Needless to say, this unrealized concept had a strong nineteenth-century flavour.

In a similar way, the roots of a better-known though also unrealized project hark back to Art Nouveau. The Viennese artist Josef Thorak, until 1938 Hitler's favourite sculptor (later replaced in that role by Arno Breker), designed an *Autobahn-*

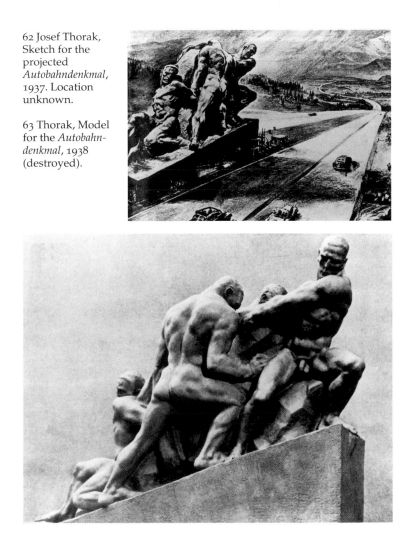

62 Josef Thorak, Sketch for the projected *Autobahndenkmal*, 1937. Location unknown.

63 Thorak, Model for the *Autobahndenkmal*, 1938 (destroyed).

denkmal in 1937, a great sculptural monument glorifying the construction of Hitler's famous motorways. Contrary to common belief, the *Autobahnen* had no overriding strategic or practical importance; they were conceived from the outset as a propaganda device whose monumental and aesthetic qualities were paramount. Thorak had the idea of symbolizing the effort of motorway construction as analogous to titanic labour (illus. 62, 63). He placed a sloping socle in the middle of a motorway, contrariwise to the mountain slope on which it was located, thus achieving dynamic architectonic tension. Looking closely at the toiling figures, we might discern a curious mixture of Michelangelesque and Rodinesque impulses.[16]

Although edging towards muscled Nazi brutality, these figures are still endowed with residues of nineteenth-century pathos.

The ideological message of this project must be analyzed carefully in view of the contradictions between form and imagery which are clearly visible in the work. There is something pathetically Sisyphean in the superhuman travail of these primeval labourers who symbolize a technically advanced enterprise of the twentieth century. On the other hand, their labour has a collectivist ring. Its primitive mode might evoke analogies with pharaonic Egypt and the construction of the Pyramids by slave labour. Thus, a commentary by the noted Nazi critic Kurt Tank carefully charted a middle course between interpretational pitfalls: 'The fact that five men [in fact four] are trying to heave a gigantic, unhewn stone with all their strength is not the most important thing . . . These men belong together, they are not isolated, nor are they slaves . . . These are men united in their labour . . . They do it for their country.'[17]

TOTENBURGEN – CASTLES OF THE DEAD

In the 1930s, the German War Graves Society (*Volksbund Deutsche Kriegsgräberfürsorge*), under the guidance of its leading architect Robert Tischler, erected a series of monuments made of lightly dressed stone that commemorated the battlefields of the Great War.[18] These monuments often assumed the appearance of small fortifications or pseudo-medieval castles (Hünenburg, Petrisoru, Bitolj, Quero) situated on high hills or cliffs; inside, small memorial rooms or chapels contained tablets, inscriptions or epitaphs (illus. 64). In a certain sense, these monuments continued a late Wilhelmine primitivist strand issuing out of the Bismarck cult discussed in Chapter 2. Although the War Graves Society managed to keep a certain distance from the Nazis, enabling it to continue its work after 1945, these memorials suited the nascent Nazi aesthetic very well. What is more, sometimes they were fitted into larger fascistic structures. This was the case with Tischler's Annaberg monument in Upper Silesia (1936–8), which commemorated a 1921 battle between Polish insurgents and German *Freikorps* (illus. 65); it was incorporated into a *Thingstätte*. Tischler's memorials, which in a certain sense also echoed the Hindenburg monument at Tannenberg, had a rusticity and

64 Robert Tischler,
Totenburg, Bitolj,
Slovenia, *c.* 1936.

65 Robert Tischler,
Memorial of the
German Freikorps,
Góra Sw. Anny
(Annaberg),
Poland, 1936–8
(destroyed in 1945).

simplicity of design that could serve different memorial purposes. Thus, his last monument (a variant of the Annaberg one) commemorated Rommel's *Afrikakorps* at El Alamein in 1955 – with heavily anti-British overtones.

In the opinion of the Nazis, the victories of the Wehrmacht demanded larger, more awe-inspiring structures than Tischler's small or medium-sized memorials. The old conservative architect Wilhelm Kreis, who in his youth had elaborated the primitive Bismarck-tower type and who in 1911 at Elisenhöhe had already conceived a monument to Bismarck which in a way prefigured Tischler's structures, was called upon in 1941 to design a new type of memorial to commemorate the victories of Hitler's army. Kreis's projects received the popular – though in a certain sense unofficial – designation of *Totenburgen*.[19] While elaborating them, he reverted both to his early works and to elements of the Leipzig-type 'national monuments'; hence their locations on high hills and the similar treatment of the stonework. The *Totenburgen* were strongly imbued with a darkly pseudo-Romantic spirit proper to Nazi mythology. They had important tasks as regards the projection of the image of the new Großdeutsches Reich:

> These monuments are more than just war memorials . . . they embody the sense of a great historical change. Placed on the cliffs overlooking the shores of the Atlantic, directed against the West, they shall symbolize the liberation of Europe from British domination. The austere, noble simplicity of the war cemetery near Thermopylae symbolizes the German adoption of ancient Greek culture. The massive, high, tower-like structures erected on the gigantic plains of the East will show how Germanic order has tamed the chaotic forces of the Eastern steppes . . .[20]

The task Kreis faced was by any standard a daunting one: to achieve an acceptable local context, he was often forced to use semiotically cognizable local architectonic forms such as the kurgan for the Ukraine and southern Russia, the temple for Greece, or mastaba-like structures for Egypt (illus. 6, 67, 88). At the same time, the monuments had to display a certain uniformity of appearance and purpose. Kreis succeeded to an extent, though the serial illusion might be, at a second glance, less due to the similarity of forms than to his brilliant sketching technique.

66 Wilhelm Kreis, *Totenburg* on the English Channel, 1942/3.

67 Kreis, *Totenburg* in Africa, 1942/3.

In contrast to the general evolution of Nazi architecture, the *Totenburgen* were not provided with ceremonial parade-grounds. Only the kurgan-like *Totenburg* on the Dniepr (illus. 88) was to be provided with a gigantic mausoleum, 100 m high and 150 m wide – dimensions which were to echo symbolically the wide-open spaces of the East where politico-cultic ceremonies were to take place. The uniform aura of the *Totenburgen* gained an additional symbolic value after El Alamein and Stalingrad, when the Nazis concentrated all their efforts on defending the mythological 'Fortress Europe'. In 1943 and early 1944, the *Totenburgen* were popularized in a way which sought to connect them to fortified outposts of a Europe from which 'British plutocracy and Bolshevism' had both been expelled.

An often reproduced photograph of Nazi art shows the *cour d'honneur* of Speer's *Reichskanzlei* in Berlin. The entrance is flanked by two famous bronze figures by Arno Breker, *The Party* and *The Wehrmacht*, the first holding a torch, the second wielding a sword. These statues served as subservient allegorical components of architecture. In 1941, Breker created a new variant of the NSDAP allegory, which he called, in a direct cross-reference, *The Torchbearer* (illus. 68). At that late hour – sometime in 1942 – plans were formulated to enlarge the statue to around 30 m and erect it as a free-standing monument somewhere on the north–south axis in Berlin.[21] It seems probable that the Nazis then contemplated – as the Soviets had done a decade earlier in their Palace of Soviet projects – the creation of a Nazi counter-monument to the Statue of Liberty in New York. The reference in the Berlin monument was to be – by virtue of the torch symbolism – even more direct than in the Moscow projects. In themselves, these attempts of two totalitarian systems to counter the message of the Statue of Liberty testify to the strength of this democratic emblem in an epoch as yet unaware of the commercial potential of symbols.

68 Arno Breker,
The Torchbearer, 1941.

5 The Communist Pantheon

The events of 1989–91 and the fall of Communism and its monuments have generated the rather superficial impression that monuments in both a political and an artistic sense lay at the centre of the Communist art programme. The truth is slightly different. Despite their prominence, Communist monuments served primarily as visual symbols of power. Ideological education for the masses through art was provided by means of films, posters, illustrations and narrative paintings. The Communist didactic impulse showed surprising similarities with French academic theory of the seventeenth century; the visualization and analysis of virtuous, exemplary or heroic deeds in narrative settings was the overriding objective for both Charles Le Brun and the Soviet academicians. Statuary art could not attempt to achieve these ends because of its obvious narrative limitations, but this impediment could be overcome by the creation of various types of public monuments. In 1918/19, it seemed that things would develop in this direction in the new Russia.

FROM THE REVOLUTION TO 1930

The public monuments of Paris provided an excellent thematic model for Lenin and for Anatoli Lunacharsky, his chief cultural advisor. Both men knew and liked Paris and had a soft spot in their hearts for some elements of bourgeois Republicanism. The plans which they formulated in early 1918 with regard to public monuments seemed a determined attempt to copy and outdo certain elements of Parisian statuary, particularly with regard to its claim to a universal didacticism. They were no doubt taken in by the fact that the French had also erected monuments to Shakespeare, Dante and Garibaldi – that is, to personages of universal esteem who had no obvious connection with Paris or France as a whole.

Another influence on Lenin was Tommaso Campanella's great politico-religious utopia, 'The City of the Sun'. In this city, statues of great men appeared in conjunction with inscriptions

extolling ethical and judicial rules meant to exert a pedagogical influence on the inhabitants. Two translations of Campanella were published in Russia in the fateful year of 1918. Lenin seems to have been drawn less to images than to the written or inscribed word; he would select inscriptions for projected monuments, occupying himself with the arduous task of composing suitable phrases for numerous commemorative plaques.

A decree published by the Council of People's Commissars on 12 April 1918 ordered the removal of tsarist monuments (even so, many were spared) and the preparation of large-scale models for new monuments, which were to be subjected thereafter to the judgement of the 'masses'.[1] In the summer, Lenin and Lunacharsky drew up an extensive list of around 50 monuments for Moscow and St Petersburg (then Petrograd) and chose the artistic avant-garde as their main partner in the realization of their programme.[2] However, Vladimir Tatlin and his colleagues showed some hesitation, and the exasperated Lenin went so far as to compare them to 'saboteurs'. Lenin's stubborn insistence that the monuments should be ready on the first anniversary of the October Revolution in November 1918 was a great problem. Lunacharsky, by contrast, seems to have preferred a gradual approach; he suggested that every Saturday should be devoted to the unveiling of one statue and that the subsequent evening should see a theatrical celebration of the subject's life.

Although they were forced by sheer necessity to draw on a wider group of artists, as is clear from the fact that some monuments display a definite Art Nouveau touch, the cultural authorities could not keep to Lenin's original schedule. Only ten or so monuments were inaugurated in Moscow and St Petersburg in the week of the first anniversary; Lenin orchestrated the Moscow unveilings while Lunacharsky did the same in St Petersburg. In the end, around 30 monuments were erected in Moscow and around fifteen in St Petersburg, while some 40 remained in the model stage. In Moscow, seat of the new government, their role seems to have been greater than in St Petersburg with its predilection for exuberant urban décor and street theatricals.

The monuments in question – mostly giant heads or busts on socles but also statues or bas-reliefs – were made of non-durable materials like plaster of Paris, clay, plywood and

cement. Only those acclaimed by the 'masses' were executed in more permanent materials, such as bronze, marble or stone, later on. At the heart of the Communist impulse to create public monuments lay a unique and very laudable democratic notion, though the process by which the selection was to be carried out was not specified, and ultimately it did not take place at all. Neither Lenin nor Lunacharsky – not to mention the 'masses', who vandalized some of the models – were satisfied with the aesthetic and iconographic results. Thus, in St Petersburg only one monument, dedicated to the German socialist Lasalle, was realized in a durable material.

Both Soviet leaders had chosen to evoke a number of left-wing antecedents, including Marx, Engels, Marat and Robespierre, but also Spartacus, Brutus, Rousseau, Voltaire, Blanqui, Owen, Saint-Simon, Babeuf and Fourier. That list, with its strong representation of utopian thinkers, was closed by Danton, Jaurès and Garibaldi and, after their murder in 1919, the revolutionaries Liebknecht and Luxemburg. The ranks of Russian peasant-leaders, revolutionaries and opposition thinkers (Razin, Herzen, Bakunin, Plekhanov) were joined by a number of actual or would-be regicides (Ryleev, Pestel, Khalturin, Zhelabyov, Perovskaya). This disproportionate representation no doubt constituted a veiled reference to the historical legitimacy of the execution of the Tsar and his family in July 1918. In Moscow, the group was joined by great writers like Tolstoy or Dostoyevsky. The tsarophile Dostoyevsky could not provide an ideological or personal model for the Soviet revolutionaries, but Jaurès, Garibaldi and Danton stood for a more moderate brand of politics. Thus, Lenin adopted the broad, undogmatic approach pursued in Paris by centrist Republicans, but limited it – if we exclude the writers he specified – to progressive politicians. The reaction of the population also had a historicist ring – one night, the enemies of the Revolution overturned the statue of Robespierre.[3] A similar thing would no doubt have happened in Paris.

This little-known action – analyzed chiefly in laudatory articles which feigned ignorance of the role of Paris as model – astounds by its very scope, thematic acumen and democratic aura. To invoke a sadder note, it is in some way emblematic of the course Russia (and the Soviet Union) took after the Revolution: a furious, incredibly bloody start, full of

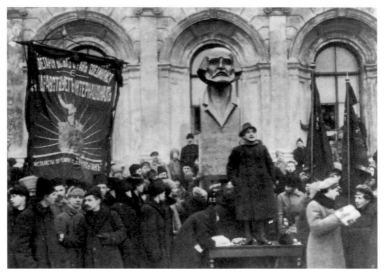

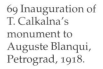
69 Inauguration of
T. Calkalna's
monument to
Auguste Blanqui,
Petrograd, 1918.

dynamism and the best of intentions, striving to achieve and
surpass in a couple of years that level of civilized development
which Western countries or cities like Paris had achieved
organically over decades. There followed disappointments,
failures and a dramatic reversal to the traditions of Byzantium.

The majority of temporary Communist monuments showed
heads or busts and were executed in a semi-Cubist idiom with
strong Futurist elements. In this they reflected a peculiar phase
of pre-war Russian avant-garde art – namely the so-called
Cubo-futurist mélange of 1912–14. Some works attempted an
Art Nouveau stylization, while a handful reiterated nineteenth-
century Realist modes.

The models and busts executed in 1918–20 have not sur-
vived. No comprehensive documentation seems to exist (these
were, after all, years of grim civil war), and photographs are
often blurred. However, one monument has survived which –
perhaps intentionally – refers back to Cubo-futurism (illus. 69,
70). The Soviet sculptor Lev Kerbel's giant bust of Karl Marx
in Karl-Marx-Stadt in East Germany (since 1990 Chemnitz
once again), erected in 1971, is a reasonable example of this
sculptural mode. The backdrop provided by the wall with the
slogan 'Working men of all countries, unite' rendered in many
languages also constitutes a veritable pastiche of the slogans
carried in the Moscow and St Petersburg May Day parades and
demonstrations of the Revolutionary period. Thus, Kerbel's

70 Lev Kerbel, Karl Marx monument, Karl-Marx-Stadt (today Chemnitz), 1971.

bust – certainly the best political monument ever erected in East Germany – owed part of its success to a calculated historicist return to the traditions of Soviet Revolutionary art, including its Cubist aspect.

The great artists of the avant-garde were somewhat sceptical regarding this particular statuary action, being drawn more to utopian projects like Tatlin's *Monument to the Third International* (1920). Nikolai Punin, an artist who – as we shall see – rejected public monuments of the conventional type, enthusiastically welcomed Tatlin's tower of 'spiral forces', which attempted to circumscribe, in a visualization of Hegelianism, the Revolution's internal dynamics.[4] It is a moot point whether Tatlin's project could be categorized as a public monument. His idea provided a Revolutionary response to the Eiffel Tower (and to its visualizations by Robert Delaunay) as well as to German Expressionist utopian projects of the 'alpine architecture' type. Its ultimate influence can be discerned in the intra-Soviet debate about the Palace of Soviets in the 1930s. But by then, it had become obvious that Tatlin's tower had a global symbolism, whereas the public cults of Stalin conformed only to the later idea of 'socialism in one country'.

A characteristic phenomenon of the first decade of Bolshevik rule in Russia – and one which seems to have impeded somewhat the erection of 'normal' public monuments – was the visual concept of 'monumental propaganda'. This concept

111

embraced the varied painted and sculpted decorations for the new festivals (on 1 May and 7 November) or celebrations devoted to the Red Army's victories. Although such decorations were made of nondurable materials (mostly wood and plywood) as a rule, they often alluded to the figure-cum-socle type of monument. Their demise in the 1930s was due to Stalin's classicism.

Nikolai Kolli's unrealized project (1918) for a monument to the victory of the Red Army over General Krasnov is an excellent example of a project meant to straddle the categories of ephemeral 'monumental propaganda' and full-fledged public monuments (illus. 71).[5] What is more, it was the first fully abstract political public monument in the world. This piece consists of a black pedestal from which rises a white stone, splintered at the top by a red wedge. A peculiar word play was intended here, since it had been by means of the red (*krasnij*) wedge that the 'bands of Krasnov' had been defeated. Kolli's project was deftly plagiarized by El Lissitzky in his

71 Nikolai Kolli, Project for a monument commemorating the victory over General Krasnov, 1918. A. V. Schusev State Research and Scientific Museum of Architecture, Moscow.

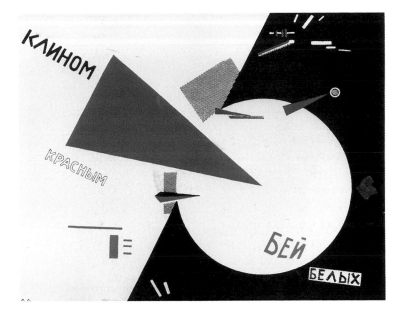

72 El Lissitsky,
*Beat the Whites
with the Red Wedge!*,
1920, poster.
Private Collection.

famous poster *Beat the Whites with the Red Wedge!* (1920), which showed a white circle (for the White Guards) being pierced by a red wedge, thus broadening Kolli's play on words (illus. 72). But the sequence of transformations and ripostes did not end here. In the fall of 1920, the famous avant-garde artist Malevich and his students erected a plywood monument to the October Revolution in Vitebsk which depicted a circular form splintered by a wedge.[6] An inscription likened the latter to a ray of light shining through the darkness. In 1921, Walter Gropius developed this symbolism further by creating a symbolic lightning flash composed of concrete wedges as part of his Expressionist monument to the working-class victims of the Kapp Putsch in Weimar.[7] All of this provoked a veiled response from the Right. Between 1922 and 1924, Kandinsky – at heart an anti-Bolshevik – produced a series of obvious derivations of Lissitzky's composition in which the red wedge was exchanged for yellowish or (satirical) pink carnations. In his theoretical treatise 'Vom Punkt und Linie zur Fläche' (1925), Kandinsky went to great pains to link wedge forms with the colour yellow (which he believed to be psychologically irritating); this was, no doubt, a veiled attack on Bolshevik symbolism.[8]

Commenting on the meagre results of Lenin and Lunacharsky's monumental plans in Moscow and St Petersburg,

the avant-gardist Punin expressed the opinion that public figural monuments were in reality incompatible with the deeper principles of the newly established social system.[9] In the early Communist era, no individual heroizing was needed, either of personages from the past or of contemporary figures. Many artists and writers as well as older revolutionaries of the 1920s shared Punin's views. Between 1924 and 1930, the great poet Mayakovsky vehemently attacked both the semi-religious mausoleum cult of Lenin (which was opposed by his wife Nadeshda Krupska and revolutionaries like Trotsky) and heaped abuse on the 'bronze crap' of projected Revolutionary monuments. In 1924, after Lenin's death, Mayakovsky pleaded: 'Please, no Lenin in bronze!' Brecht's poem about the carpet-weavers of Kujan-Bulak who, instead of honouring Lenin with a bust, decided to allocate the money for sanitary improvements in their village, was a later echo[10] – since it was written after 1933 – of this point of view. But Stalin, strongly drawn to oriental forms of adulation, decided to promote and use (for his own political purposes and as a stepping-stone

73 Vladimir Shchuko and Sergei Evseev, *Statue of Lenin at the Finland Station*, 1927.

74 Sergei
Eisenstein, Lenin
giving a speech,
from the film
October, 1927.

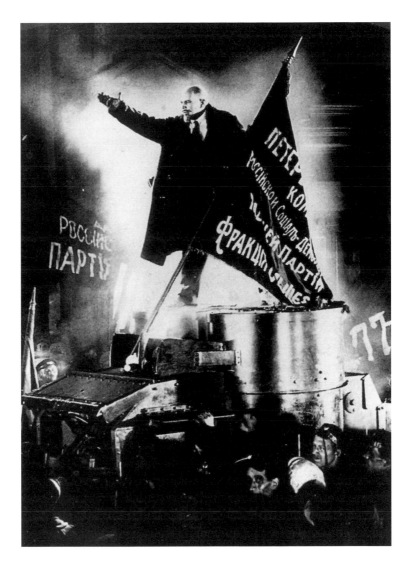

for his own mythology) an ever-growing state cult of Lenin.[11]
In 1925, a government decree about the '. . . correct manufac-
ture of busts, bas-reliefs and pictures showing V. I. Lenin'
entrusted to a newly created 'Committee for the Immortaliza-
tion of Lenin's Memory' the supervision of the nascent Lenin
memorial industry. Characteristically, public monuments were
not expressly mentioned, and only a handful were erected
before 1932. By then, the avant-garde had been dispersed and
the older generation of Bolsheviks – less drawn to cultic forms
– were being subjected to ever more vicious purges.

Emblematic of the transitional period of 1924–32 was the Lenin mausoleum on Red Square in Moscow, where a cubic, semi-Constructivist structure provided an outer shell for the realization of an idea going back to pharaonic Egypt (Howard Carter's discovery of the Tomb of Tutankhamun in 1922 might have provided inspiration here).[12] A similar cleavage is apparent in Vladimir Shchuko and Sergei Evseev's prominent Lenin memorial in front of the Finland Station in St Petersburg (1927; illus. 73). This figure of Lenin was the first to assume what become a characteristic haranguing pose, with the outstretched arm (a kind of *ad-locutio* gesture) which was to become the trademark of innumerable provincial Lenins. The plinth consists, interestingly enough, of scaled cubes crowned by the cupola of an armoured vehicle's turret. Lenin had addressed the Revolutionary crowd from just such a vehicle after his arrival in St Petersburg in April 1917 after years of exile. The form of the plinth displays distinct affiliations with both Constructivist sculptures and Malevich's 'architectons'.[13]

Popular posters and films (illus. 74) had propagated the image of Lenin addressing the crowd from the armoured vehicle; both image and vehicle seemed to prefigure the October Revolution. But the significance of this monument transcended the bounds of an on-the-spot re-enactment of an important historical event. The first major monument of the first head of the new socialist state showed Lenin on an armoured car. This car was to serve as the poignant symbol of the new, technical civilization which the Soviets had pledged to build and which would replace the symbols and trappings of the old system – including the equestrian statues of Russia's tsars. The Petersburg monument was logically erected at the end of the first Revolutionary decade, which had seen the overthrowing of most monarchical riders.

This first great Lenin monument (if we do not take his mausoleum into account) was, in artistic terms, also the best. What followed after 1930 belonged more to the category of standardized objects – the workings of the State Committee had borne their respective fruits. Nonetheless, Lenin did preserve, in his imagery and monuments, some vestiges of revolutionary dynamics. Stalin, on the other hand, assumed an isolated, unmovable pose, hieratic if not god-like. Lenin was, after all, presented as part of the historical process, while Stalin preferred to see himself as its epitome.

Since the end of the 1920s, the idea of a great Palace of Soviets had occupied the minds of Stalin and his closest entourage.[14] In a brutal exercise of political triumphalism, the grand Moscow church of Christ-the-Saviour (1882) near the Kremlin was demolished in 1931 to provide a site for it. The invocation of the Church, of the central tenets of religion and salvation, no doubt provided an additional negative stimulus. The first three rounds of the international architectural competition (1930–3) brought a politically motivated defeat for the Western European and Soviet architectural avant-gardes. In 1933, when an incredible fourth round resulted in the choice of a recessed tower structure designed by Boris Iofan, the political leadership intervened and demanded that '. . . the upper part of the palace should be crowned by a great Lenin statue in such a way that the building would constitute the pedestal of the figure.'[15] There followed a series of projects by Iofan and his colleagues Shchuko and Gelfreikh, each with slightly different stepped tower structures crowned by a gigantic statue of Lenin. By 1938, the huge foundations had been excavated and an elaborate metal scaffolding had been constructed, when suddenly the pace slowed. Stalin had changed his mind and, without acknowledging it publicly, had come to the conclusion that a project devoted solely to the glory of Lenin would challenge his own fast-growing cult. Using the political and economic problems of these years as a plausible pretext, he halted construction. The scaffolding was dismantled in 1941 and used in the construction of anti-tank barricades for a Moscow threatened by German panzers. Being a master of the double game, Stalin kept ordering new variants of the palace project till the end of the 1940s. By 1948, Iofan and his group had produced twenty or so versions, each with a Lenin figure at the top. For twenty years, a gaping hole could be seen in central Moscow, a reminder of the scuttled project. It was filled in 1961, when a gigantic outdoor swimming pool was opened to the public. As a hot-water spa open during the severe Russian winter, the pool invoked by subterfuge a certain quasi-sacral aura. Under Yeltsin, history came full circle, with the church being reconstructed in a questionable blend of historic elements and nouveau-riche taste (1997).

There is no doubt that Stalin's idea postulated a new direction; it demanded a fusion between figural and architectonic parts. As such, it ushered in a new epoch in Soviet architecture characterized both by an academic classicism and by a subordination of sculpture to the demands of architectural ensembles (though in the Palace of Soviets, from a typological point of view, the building assumed the role of pedestal). A similar tendency also marked the attitude towards political monuments of the other terrible totalitarian regime, Nazi Germany. Both regimes seem to have made a distinction between prestige objects – which attempted to combine sculpture and architecture and which opted for extraordinary, grandiose solutions – and political monuments and smaller sculptures destined for subsidiary government buildings and the provinces, which were standardized as a rule. Thus, each official Nazi building had to have a small bust of Hitler on a socle opposite the entrance, while each Soviet town from the mid-1930s on had to possess a public monument showing either a seated or a standing Lenin. Half-figures of Stalin graced the assembly halls of government buildings, his public monuments appearing infrequently before 1945. The locations for Lenin statues were also stereotypical: in front of Party buildings or railway stations. The Russian part of former East Prussia – where no Communist statues were pulled down after 1991 – still possesses a complete, graded provincial infrastructure of Lenin monuments.

Thus, there existed in the provinces a system of special symbolic gradation, a system which catered to visual expectations. Moscow was different; it was the capital of socialism and on its way to Communism (even in Brezhnev's cynical times, the media kept referring to it as the 'first Communist city' of the world). It had the right to choose the atypical, the grandiose, like a 320-m-high building topped by a 100-m statue of the beloved Vladimir Iljitch. Some of Moscow's prerogatives in the symbolic domain extended to the capitals of the republics, in particular Kiev and Minsk (though, interestingly enough, not to what was then called Leningrad).

The formal genesis of the gigantic, well-known, but too hastily ridiculed Palace of Soviets project has never been analyzed properly. One premise is fairly obvious: it repeated, though in a totally different idiom, the utopian dimensions of Tatlin's *Monument of the Third International*. It seems plausible

that the aim was to attain, following Tatlin, the status of a 'counter-monument'. Whereas for Tatlin, the main referential building was the Eiffel Tower (which in his eyes was a purely technical structure), Iofan's project had another aim: to surpass not the dimensions but the distinctiveness and ideological gravitas of the Statue of Liberty. Since the turn of the century, the New York statue had functioned as the central symbol of the American dream as well as of American power. In Kafka's *America*, for example, the new immigrant perceives her to be equipped with a frightening sword.

The majority of Iofan's proposals show Lenin with one hand rhetorically outstretched in the aforementioned *ad-locutio* pose, but in at least three variants he raised his hands in a way quite similar to the gesture of the Statue of Liberty (illus. 75). Both figures seem thus to entertain a kind of gestural dialogue – an idea prevalent in political cartoons which show personified countries acting on a small globe. As Marina Warner has

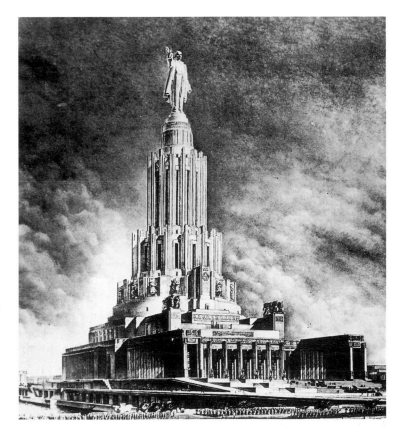

75 Boris Iofan, Vladimir Shchuko and Vladimir Gelfreikh, Detail of project for the Palace of Soviets, Moscow, 1934. A. V. Schusev State Research and Scientific Museum of Architecture, Moscow.

observed about political personifications,[16] the female form tends to be perceived as universal, while the male is shown as an individual, though Iofan was using Lenin to express a generalized concept. In a 1933 version, proposed by Iofan before the ukase of Stalin had intervened, the Palace was to be topped by a small figure of a worker holding a shining red star. Not so Lenin; it was obvious that he did not need any light symbolism, no red star, no torch. His person in and of itself would serve as a symbol of the world-wide luminosity and relevance of his ideas.

That the Statue of Liberty exerted an almost obsessive influence on the first generation of Stalinist architects and monument makers is evidenced by the fact that a direct – one might even say confrontational – paraphrase of it surfaced in Iofan's 1939 Soviet Pavilion for the New York World's Fair, the torch having been transformed into a shining red star. In a project for the Red Army Theatre in Moscow (1939/40), the reference to the New York figure was even more pronounced (illus. 76).

The strange history of the Lenin-topped version of the Palace of Soviets did not end there. Iofan's earlier versions

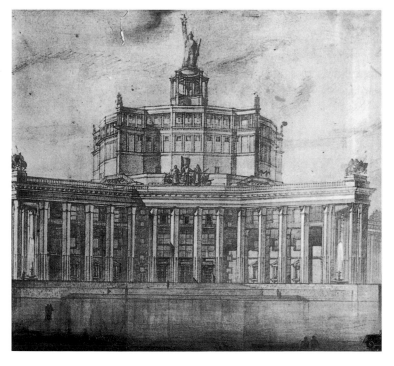

76 Karo Alabian, Project for the Red Army Theatre, Moscow, 1939/40. A. V. Schusev State Research and Scientific Museum of Architecture, Moscow.

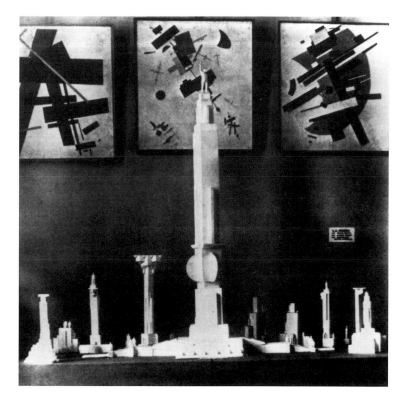

77 Kazimir Malevich, 'Architectons' and pictures in the 1932–3 exhibition '15 Years of Art in Soviet Russia' in Leningrad.

showed strong similarities to some of the 'architectons' created by Malevich around 1931/2. Malevich had started his series in the mid-1920s as a means of analyzing architectural configurations of a semi-abstract, cubic and volumetric type. After 1930, the 'architectons' received a more decorative form, in some cases approximating free-standing columns, as if Malevich was accommodating himself to nascent Stalinist aesthetics. In 1932, he showed a group of his latest 'architectons' in a prestigious official exhibition in Leningrad (illus. 77); the one in the centre of an exhibition photograph seems like a direct forerunner of Iofan's 1934 proposal.[17] Although we know that Iofan had contact with Malevich's students,[18] the exact nature of the relationship remains shrouded in mystery.

This somewhat astounding coincidence had wider consequences. When Iofan was asked to design the Soviet Pavilion for the Paris Exposition Universelle of 1937, he created a structure which also displayed obvious links with Malevich's 'architectons', though this time he chose as his model the more austere shapes of the late 1920s. A preparatory drawing

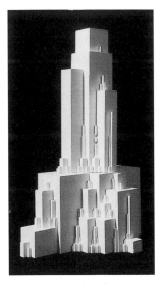

78 Kazimir Malevich,
Gota (an 'architecton'), 1923.
Musée Nationale d'Art
Moderne, Paris.

79 Boris Iofan, Preparatory sketch for the
Soviet Pavilion at the 1937 Exhibition
Universelle in Paris, 1936/7. A. V. Schusev
State Research and Scientific Museum of
Architecture, Moscow.

(illus. 79) clearly demonstrates the influence of Malevich (illus. 78), whose cubic shapes had been modified into symmetrical terraced pylons.[19] In the final version, some Art Deco softening crept in, especially as regards the profiled cornices (illus. 83). Seen from the side, the Soviet Pavilion looks like a pedestal for the famous group of the worker and the collective farmer by Vera Mukhina, a composition which blended Russian folkloristic realism with the dynamism of Boccioni's Futurist sculptures. At a height of 25 m, Mukhina's sculpture made up almost half the height of the Pavilion. But Iofan nonetheless carried the day in his visual contest with the Nazi Pavilion, which the crafty French organizers located just opposite, only 90 m away (illus. 80, 81).[20] Despite its height, Speer's elongated structure with pilasters, crowned by a clumsy eagle, provided a feeble response to the much lower, but somehow more vertical and dynamic Soviet work. The enraged Nazi critic who detected in the Soviet Pavilion a 'barbaric formalism'[21] was thus – despite his vitriolic tone – not far off the mark, anticipating in some way the later evolution of Stalinist aesthetics. The Soviet Pavilion could be classified as representing the public monument type, while the Nazi one – despite the giant eagle and some muscular athletes at the base (illus. 82) – was predominantly architectural

80 View of the site of
the 1937 Exhibition
Universelle, showing
the 'confrontation'
between the
Soviet and German
pavilions.

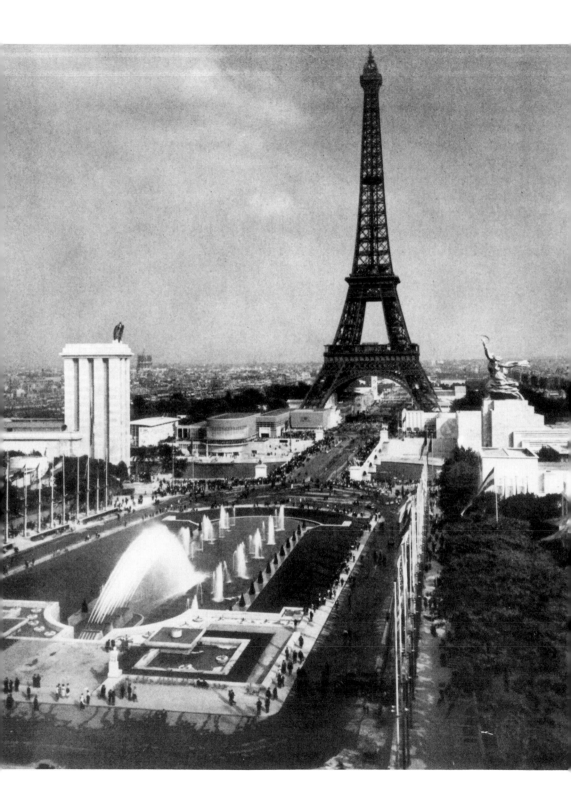

82 Josef Thorak, *Comradeship*, figural group in front of the German Pavilion at the 1937 Exhibition Universelle.

81 Albert Speer, German Pavilion at the 1937 Exhibition Universelle.

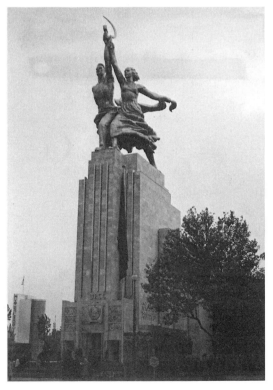

83 Boris Iofan and Vera Mukhina, Soviet Pavilion at the 1937 Exhibition Universelle, Paris.

in nature. Paradoxically, the Paris Exhibition brought about a posthumous last triumph of Malevich and of avant-garde residues over purely totalitarian architecture.

SOVIET MEMORIAL COMPLEXES AFTER THE WAR

Few monuments commemorating the victims of Nazism and praising the final victory were erected in the immediate postwar years. The feeling of relief was universal, but exhaustion and the stultifying ravages of war effectively stifled any triumphalist notions in the West. Britain and France, which both possessed rich and varied traditions of politico-military monuments, were not in a markedly victorious mood. The real victors, the Americans, bewildered by the magnitude of the challenges still facing their country, had no plans for this type of monument. They had, to start with, no distinct tradition of government commissions in the area of political monuments on which to build.

The other superpower, the Soviet Union, exhibited a diametrically opposed approach. As stated in a sarcastic Hungarian anecdote, the ferocious Turks were much to be preferred to the Russians, since they, at least, did not demand rituals of gratitude for having subjugated Hungary. This crude oversimplification does characterize an important facet of the Soviet approach. The nations of Eastern Europe were coerced into 'voluntarily' erecting countless monuments expressing their gratitude to their Soviet liberators. That type of monument, which started to appear in 1950/51, was generally schematic, consisting of a medium-sized obelisk with a red star[22] and a statue of a soldier holding a flag in front of it; in later decades, a T-34 tank would often appear on a socle. Sometimes – but not as often as might be expected – a sort of cemetery-appendix would appear in the form of a dozen or so officers' graves. (Both the number of Soviet military cemeteries and that of separate, personally identifiable graves is astoundingly low given the Red Army's losses.) The Russians had, when acting on their own, a penchant for memorial complexes with mass graves meant to serve both memorial and propagandistic purposes.[23]

A memorial complex designed by I. Melchakov and J. Mikunas was erected already in September 1945 in East Prussian Königsberg (after 1946 Kaliningrad), which the Russians had

taken only a few months before. For the Soviets, Königsberg constituted the westernmost outpost of the inner Soviet empire: this is why they chose it for their first large war monument. The complex astounds by its grandeur: a half-circular wall measuring 140 m, flanked by two statues (*Storming Soldiers*, *Victory*) and an obelisk surrounded by generals' busts and soldiers' mass graves.

In 1945–6, proceeding along the lines elaborated in Königsberg, the Soviets erected great commemorative complexes in Berlin and Vienna, two cities they took in 1945 but had to share with their Western allies. These urban centres constituted the most advanced outposts of the outer Soviet empire; the complexes built there were meant to glorify the wartime sacrifices and victories of the Soviet army but also to signal – by drawing on the notion of frontier camps – Russia's claim to govern a large chunk of Europe. Thus, in Berlin three great memorial complexes were situated close to the border between the Soviet and the three Western sectors, as if guarding a particular portion of this dividing line. These were the Schönholz memorial complex in the north, the Tiergarten in the centre of the city and the Treptow park complex in the south. The incredible speed with which the Viennese monument was erected on the Schwarzenbergplatz (illus. 84) – it was unveiled just four months after the city was taken, on 19 August 1945 – shows clearly the propagandistic significance the Russians attached to erecting such complexes in no time amidst ruins, famine and the disruption of ordinary life. Both the Berlin monument in the Tiergarten district and the Viennese one were conceived as scenographic complexes replete with walls and colonnades, the aim being to provide a focal point and backdrop for politico-military ceremonies. Both complexes disregarded somewhat the urban structures around them. This tendency found a legal and symbolic expression in the fact that after the final partition of Berlin in 1948, which left it in the Western sectors, the Tiergarten memorial enjoyed a kind of extraterritorial status until the city was reunified in 1990.

Designed by Lev Kerbel, the Tiergarten complex (1945/6; illus. 85) had been erected with ironic finesse at the end of the visual axis provided by a pompous Wilhelmine *Siegesallee* with its string of Hohenzollern dynastic busts and statues.[24] If this placement implied a symbolic revenge for the defeats

84 S. Jakowlew,
M. Intizarjan, Soviet
war memorial,
Schwarzenberg-
platz, Vienna, 1945.

85 Lev Kerbel,
Soviet war
memorial,
Tiergarten, Berlin,
1945/6.

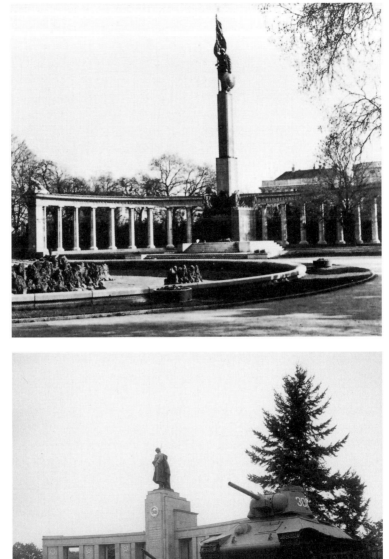

Russia had incurred at the hand of the Kaiser's army in the First World War, other symbolic strands referred to more recent events. Extracting marble fragments from the ruins of the nearby Reichskanzlei of Albert Speer, the Russians indulged in the symbolic act of reusing the enemy's material. Nearby loomed the partially ruined buildings of the Reichstag, which the Soviets – despite their contempt for parliamentary democracy – had always accepted as the prime architectural symbol of modern German statehood. Photos from 1946 and 1947,[25] taken at a moment when the trees of the Tiergarten had been eradicated by bombs and fires, show a curious superimposition of the Reichstag and the monument and raise the suggestion of a deliberate counter-monument. The complex was closed off by free-standing arcades in the centre of which a giant plinth – astoundingly similar to the one used in the 1937 Soviet Pavilion in Paris – provided a support for the figure of an advancing soldier. In the foreground, two T-34 tanks, placed symmetrically on two slightly lopsided socles, provided the main visual attraction. In 1946, this was a novel and interesting idea which in some later versions gained even more gestaltist qualities when the tank seemed to overcome – like a lion on the move – the steep tilt of the socle. The countless repetitions of the 1960s and 1970s littering the Soviet Union and Eastern Europe turned this motif into a banal, much-ridiculed cliché. (In all fairness, one has to remark here that the British apparently were the first to hit upon the weird idea of placing a tank on a socle. Such a monument was put up shortly after 1918 in front of the British Museum by the National War Savings Committee, though this clumsy realization – as evidenced by the woodcut of Frans Masereel [illus. 86] – seems to have brought discredit to the idea in the West.)

The similarly arcaded Viennese monument on the Schwarzenbergplatz had a more pronounced outpost symbolism though of a different type. (In 1813/14, Prince Schwarzenberg had led the Austrian army against Napoleon together with the Russians, a fact which the historically conscious Russians did take into account.) Whereas the Berlin soldier's dynamic pose seemed to symbolize the main axis of Soviet expansion – which was to start with West Berlin – the Viennese one stood stiffly, as if defensively, on guard at the very limits of the new empire. Russian policy in Vienna and in Austria was of course more

86 Frans Masereel, The Tank Memorial erected *c.* 1918 by the National War Savings Committee in front of the British Museum, London. Woodcut from Arthur Holitscher, *Der Narrenführer* (1925).

restricted. Supporting a flag with one hand, the Vienna soldier clutched a medieval shield with the Soviet coat of arms in his other hand. The iconography of the Byzantine military saints (Dimitrios, Theodore) provided inspiration here. (Already in 1941, a proposal for a monument to the defenders of Moscow showed a Christian knight in the act of slaying a dragon with a gigantic sword before a medieval, Kremlin-like wall. The only socialist symbol consisted of a tiny red star inserted into the knob of the sword.)[26]

This overt reference to the neo-medieval imagery of knighthood was amplified in the famous Treptow complex in Berlin (1945–9), on which the sculptor Evgeny Vuchetich collaborated with the architect Iakov Belopolskii (illus. 87).[27] The *Monument to the Battle of Nations* at Leipzig (1913), much esteemed by the Russians since it commemorated their own soldiers fallen in the great battle against the French, provided a model. It also inspired the placement of a mausoleum at the end of the complex. The dominant 'kurgan' at Treptow might recall Slavic pagan burial mounds and thus strike another chord in the repertoire of historic allusions. We are less at ease when we discover pronounced similarities with Nazi cemetery

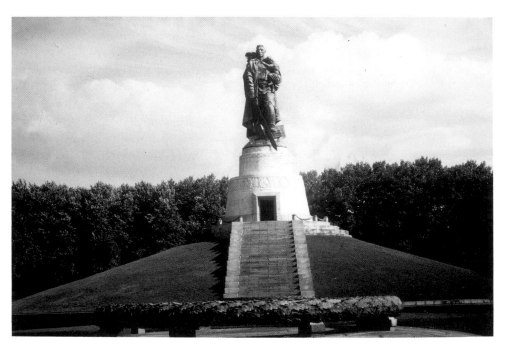

87 Evgeny
Vuchetich and
I. B. Belopolskii,
Soviet Memorial
Cemetery, Berlin-
Treptow, 1945–9.

88 Wilhelm Kreis,
Project for a
Wehrmacht
Totenburg on the
banks of the Dniepr,
drawing, 1942/3.

projects, such as the funerary mound drawn by one of Hitler's
architects, the esteemed Wilhelm Kreis, to commemorate the
1941 crossing of the Dniepr by German troops (illus. 88).[28]
Although the similarities between the architectural aesthetics
of both regimes are well known, this particular connection
still appears somewhat embarrassing. A fusion of Christian
and neo-pagan ideas also lay behind the conception of the
Leipzig memorial.

Treptow embraced a range of solutions inspired by Christian iconography. The sorrow-laden granite 'Motherland' figure was modelled on the Pietà, while the kneeling soldiers evoked mourning Gothic knights. The 'kurgan' was crowned by Vuchetich's famous statue of the Soldier-Liberator clutching the saved Child, a composition which abounds with analogies to the iconography of St Christopher and St Michael. A further visual allusion was provided by the gigantic sword in the form of a cross. Thus, the Russians pre-empted the crusade metaphor which appeared in Eisenhower's memoirs devoted to the campaign of 1944/5. Last but not least, a distinct classicizing streak is discernible in the lesser decorative elements. On one of the stelae flanking the ceremonial way, the industrial effort of the Soviet Union during the war was symbolized by a direct transposition of the hallowed Beaux-Arts theme of Roman matrons offering jewellery and precious vessels to their threatened state.

If we set the neo-pagan and classicizing aspects aside, this neomedievalism can be explained by Stalin's wartime turn towards Eastern Orthodox patriotic traditions. Because of this, the influence of these memorial complexes proved to be limited. In the 1950s, the Soviets refrained from exporting forms tainted by hidden Eastern Orthodox influences to Eastern and Central Europe. Their later memorial complexes eschewed this particular strand of medievalizing imagery.

RESISTANCE PATHOS AND THE REALITY
OF THE KZ'S

In the first post-war decade, the new socialist countries and the Soviet Union were faced with the need to pay homage to the victims of war and racial persecution. Stalin decided that Russia did not have to concern itself with the task of commemorating the civilian victims of war. Against the background of the mounting anti-Semitism in the Soviet Communist Party and the purges after 1948, the mere mention of the Holocaust and of the need to commemorate Jewish suffering could lead to accusations of 'Jewish nationalism and anti-sovietism' with all the imaginable consequences. Thus, in an orchestrated campaign around 1950, Stalin's police destroyed almost all provisional memorials and commemorative plaques which the surviving Jewish communities had erected spontaneously in

the first post-war years. No other monuments were erected to the more than one million Jewish Soviet victims in the Soviet Union until 1991, though in the 1970s and 1980s Jewish victims were co-commemorated at *KZ*'s, or execution places (as in Latvia).[29] The sole prominent exception was an oblique memorial in the Babi Yar gorge near Kiev (*c.* 1975) whose erection was forced on the hesitant authorities by the popular response to Evgeni Yevtushenko's famous poem (1963), which deplored the absence of even a modest commemorative plaque. Monuments to other Soviet civilian victims started to appear at the end of the 1960s. Even then, political considerations were paramount: thus, in an act of lexical trickery the authorities selected from among the thousands of Russian, Ukrainian and White Russian villages destroyed by the Nazis that of Khatyn in Byelorus and erected a gigantic memorial complex there (1969).[30] Its sole purpose was to overlay semantically, and thus sow confusion about, the sombre aura of nearby, identically named Katyn, where over five thousand Polish officers had been murdered by the NKVD in 1940. After an ill-advised wreath-laying by Nixon in 1972 aroused protests in the West, the Soviets toned down this propagandistic subterfuge without abandoning it completely.

For historical and political reasons, Poland and the newly established German Democratic Republic could not ape Stalin's inhuman disregard for Jewish and other civilian victims. Yet, their first attempts to commemorate the Holocaust and to create *KZ* memorials seem in retrospect to have been singularly flawed. In a certain way, both countries subscribed to the then current mode of thought; until 1965 or even until the 1970s, the sombre singularity of the Holocaust (the term was not yet in use) was scarcely comprehended in Europe and the United States. It was seen as a kind of peculiarly vicious super-pogrom, comparable to other historical persecutions and massacres. Moreover, the defeat of Nazism and the establishment of the State of Israel seemed to provide the story of persecution with a kind of happy ending. Thus, a (mostly superficial) pathos of resistance superseded the commemoration of mass-scale death and civilian suffering. Today, of course, we see things differently.

In the immediate aftermath, both the heroic Jewish uprising in the Warsaw Ghetto (April 1943) and all aspects of the

KZ experience were commemorated by means of existing artistic formulas pertaining to triumphal political monuments. The monument by Nathan Rapoport commemorating the Ghetto Uprising (1948) skilfully blends realistic rustic details with an overall 'lutte-à-outrance' pathos very much in keeping with the Parisian statuary of Rude and Antoine Bourdelle (illus. 89).[31] The only explicit non-combatant reference to Jewish suffering and the Holocaust is a smallish bas-relief on the back of the monument showing, though in allegorical guise, Jews on a death march. Located on too wide a square in the midst of the former ghetto, the project reminds

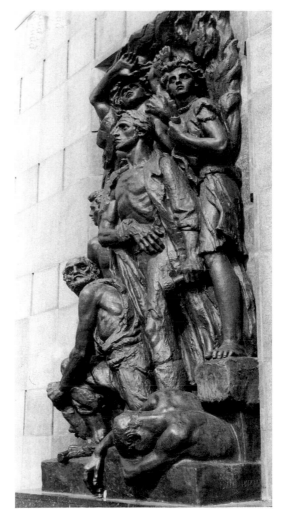

89 Nathan Rapoport, *Memorial of the 1943 Uprising in the Warsaw Ghetto*, Plac Bohaterów Getta, Warsaw.

one of a forlorn island. To paraphrase Musil's essay about public monuments, it does not commit a faux pas, but certainly strikes an inappropriate, pathos-laden tone which tends to obscure the Holocaust's deeper significance. This notwithstanding the fact that Willy Brandt chose it as the place of his historic genuflection in December 1970. Two other monuments in the vicinity commemorate places where Jewish-German fighting took place during the Uprising. The so-called *Umschlagplatz*, from where three hundred thousand Jews were herded onto trains bound for Auschwitz, was commemorated before 1988, when an expressive, abstract monumental complex was finally erected, but only with a minuscule inscribed tablet.

The one-sided commemoration of the Ghetto Uprising as a *pars pro toto* for the Holocaust constituted a historical distortion and a political and psychological error. In the 1940s and 1950s, this led to conflicts with anti-Communist Poles who loudly complained that the Warsaw Uprising of 1944, with its anti-Soviet tinge, had been passed over in silence. After 1960, the dwindling of the Jewish community and a combination of old grass-root and new Communist anti-Semitism led to a kind of implicit Polish appropriation of Jewish suffering. The 1960s saw the erection of the majority of *KZ* memorials but also official pronouncements (1968) which tried to obscure (though not to negate) the Holocaust's singularity. This process was thankfully reversed, starting in the mid-1980s, by means of a series of conflicts, also with the Polish Catholic Church and the dubious Cardinal Glemp.

In the DDR, the noted sculptor Fritz Cremer finished (1958) – after protracted changes and conflicts with the political authorities – the central figural group showing the march of *KZ* inmates at the Buchenwald memorial complex near Weimar. This complex, the main commemorative project of the Communist authorities in East Germany in the 1950s, was never superseded. Although Buchenwald had been liberated in April 1945 by American troops, the inmates, led by a group of Communists, had managed to free themselves a day earlier, thus providing the new German state with a handy myth which featured in propaganda about anti-fascist resistance.[32] Quite early on, a false note had been introduced into the discussions about Buchenwald, and this was to influence the memorial complex's iconography.[33]

Cremer's central group of marching prisoners displays all the dynamic pathos of workers at a demonstration marching behind a prominent red flag (illus. 90). The high memorial clock tower behind the figural group – composed of rustic-classicizing forms in fact quite similar to those of Nazi architecture – displays a prominent inscription: *1945*. The complex is thus primarily devoted to the liberation of the camp and not to the suffering of the inmates. What is more, the great tower

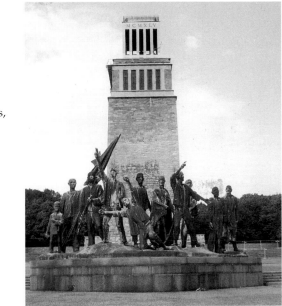

90 Ludwig Dieters, Hans Grotewohl (architects) and Fritz Cremer (sculptor), Buchenwald Concentration Camp memorial, Buchenwald, 1954–8.

91 'Avenue of the Nations', part of the Buchenwald Concentration Camp memorial.

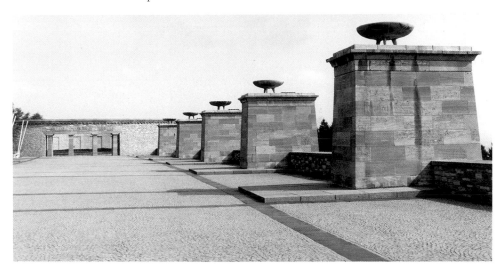

was located near a former *Bismarckturm*, which had been pulled down after 1945: such a continuity of architectural dominants seems at variance with the spirit of the place. Other parts of the memorial complex, like the Avenue of the Nations with its eighteen pylons topped by fire urns (illus. 91) and the ring of mass graves with their funnel-shaped hollows, show disquieting similarities to Nazi Nürnberg-style pathos.

When discussing the erection of this memorial at an early stage (in 1952) with Bertolt Brecht, Cremer received the following incredible piece of advice (duly written down by Brecht in his *Arbeitsjournal*):

> I suggest to erect here an amphitheatrical theatre scene in stone and to place, on the slope near the Old Camp, an odd number of giant figures representing the freed KZ-inmates looking towards the south-west where there are still territories to be liberated.[34]

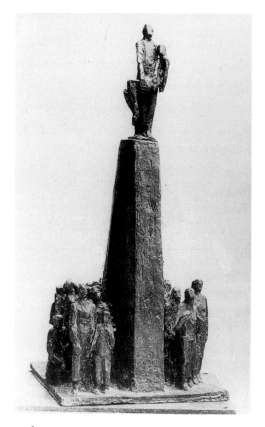

92 Will Lammert, Project for the Ravensbrück Concentration Camp memorial, 1955/6. Lammert Collection, Berlin.

The great dramatist was a noted moral cynic who never really reflected on the Holocaust or the Stalinist purges. Here, he was indulging his passions for theatrical scenes and unconventional monuments. Nonetheless, he should have known that on the grounds of architectural iconography alone the erection of an amphitheatre-like structure resembling Nazi *Thingstätten* was out of the question. Despite the abandonment of this foolish scheme, Brecht's second idea – that of referring to the adjacent 'unliberated' territories of the Bundesrepublik – took root. On a clear day, it is possible to see the Franconian lands from that very slope of the Ettersberg. The liberated inmates march southwards, to free adjacent German territories from the clutches (as Communist propaganda in the 1950s termed it) of Adenauer's 'neofascism'.[35] One should keep in mind these dubious premises when looking at Cremer's expressive figures, which resemble a type favoured by the great painter Karl Hofer.

Some of the memorial and burial obligations towards the murdered *KZ* inmates were fulfilled only after the political changes of 1989; the last urns of ashes, stored in a former SS depot, received a decent burial as late as 1997. But these unfortunates had not had the privilege of 'liberating themselves' and joining the ranks of the Communist anti-fascist aristocracy.

In 1956, the West Berlin authorities decided to place Reginald Butler's *Monument to the Unknown Political Prisoner* (about which more later) on a hill overlooking the frontier with East Berlin. Thus, in the 1950s both German states projected or erected political monuments whose message aimed at the 'liberation' of the other side's subjected population and which attempted, directly or by implication, to visually transcend the nearby frontier. Irrespective of the political cynicism of the Buchenwald project, this was a very interesting development.

A somewhat pathetic note was also sounded in Will Lammert's unrealized project for the central monument at the Ravensbrück *KZ* near Berlin (1955/6; illus. 92). The figure on the high pylon – though conceived as a variation of the Pietà – expressed by virtue of its placement and the rhythmic subordination of the smaller figures surrounding the base a semi-triumphal, marching dynamism. The march forward thus constitutes the leitmotif of the early *KZ* memorials in

East Germany. The inmates were being led to a better future, this time under the dictatorship of the proletariat.

COMMUNIST PUBLIC MONUMENTS, 1949 – 89

If Communism's main failing was that quantity did not translate into quality, the same observation might be made in the domain of monuments. The percentage of original or even laudably quixotic solutions is very small, although the opposite is true when one gauges the statues' influence on the public imagination, which was effected solely through their massive presence.

With the Communist parties of Eastern Europe firmly entrenched (1948/9), there came the task of paying homage to their overlord, the great Stalin. More than half of the new Communist countries dedicated great palaces or avenues to him (East Germany, Poland, Romania) and were thus absolved from the duty of erecting a great statue. Czechoslovakia and Hungary preferred to erect great statues (a solution which in the end proved less costly).

The Czechoslovakian Communists decided to place their Stalin monument on the green slopes of Letná Hill overlooking the Vltava, a spot which could be seen from all over Prague. Between 1926 and 1932, the First Czechoslovak Republic erected a somewhat constructivist national monument (designed by Jan Zázvorka), which housed a Tomb of the Unknown Soldier and a national Pantheon, on Vitkov Hill at the opposite side of the city. After 1948, this site was used by the Communists as the burial place of their leaders. The Stalin monument thus confronted its symbolic urban counterpart across the river.[36]

Letná Hill is situated right on the axis of Prague's Old Town 'Paris Street', which had once been the most prestigious thoroughfare of the 'bourgeois city'. What is more, the Stalin monument was shortly to provide the starting point for the building of a new quarter of Stalinist architecture in the northwestern part of the city. By virtue of its urban placement, the Prague monument served as a prime example of Stalinist dialectics (based on a crude Hegelianism) of the negation and overcoming of old forms and continuation of some of their aspects en route to a new, superior synthesis. The monument, designed by the sculptor Otakar Švec and the architects

138

J. Štursá and V. Štursová, was praised at its inception in 1950. It was unveiled in a subdued atmosphere in 1955; the Stalinist system was already on the wane.

This project focused on a thirteen-m-high statue of Stalin, the apex of a wedge-like structure on whose sides marching figures representing the workers, peasants, intelligentsia and armed forces followed their leader, to one side the Czechoslovaks, to the other the 'Soviet Nation' (illus. 93). With his hand thrust into his coat in Napoleonic fashion, Stalin looked imperiously towards the city centre. When illuminated at night by floodlights and flanked by fire urns, the figures gained a grisly vivacity (illus. 94). Paradoxically, their night-time appearance revealed that despite its apparent brutal clumsiness, the monument possessed a well-balanced structure, the subordination of the supplementary figures to Stalin having been achieved by means of subtle compositional intervals. Thanks to the gigantic scale, the project was very

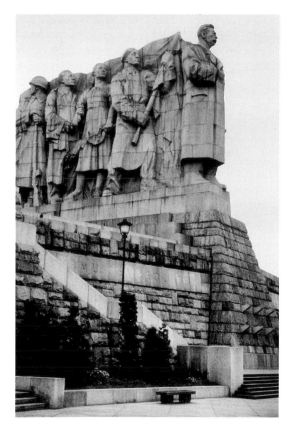

93 Otakar Švec, Stalin monument, Letná Hill, Prague, 1952–5 (demolished in 1962).

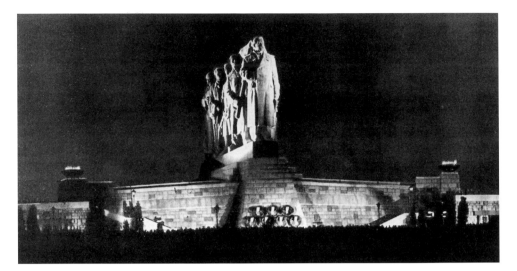

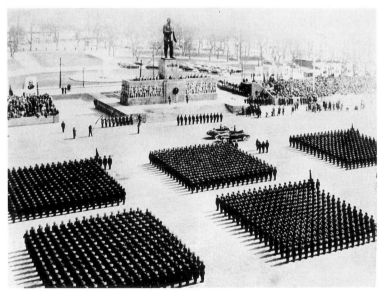

94 Švec's Stalin monument in Prague floodlit at night sometime in 1955.

95 Sandor Mikus, Stalin monument, Budapest, 1951, during a military parade in spring 1956.

impressive when seen from a distance. The Stalin monument was dismantled in 1962. The two workers who lost their lives while dismantling the dictator's head were thus literally his last victims.

The dogmatic group around Matyas Rakosi which ruled Hungary before 1956 was certainly the most loyal and subservient to Stalin of all the Communist élites. The grandiose Stalin statue they decided to erect in central Budapest, designed by Sandor Mikus (1951; illus. 95),[37] was realized in forms which

bordered on political exhibitionism. The monument was not only meant to constitute a panegyric to the great leader but was also intended to serve as a tribune for the Hungarian leaders from which they could address mass meetings or view May Day parades. That particular statue-cum-tribune combination appeared in isolated cases in the Soviet Union, mostly in the Caucasus (Lenin monument at Yerevan, Stalin monument at Gori), but when applied to a formally independent country it acquired a different meaning. In a literal way, Stalin patronized his Hungarian protégés. To add insult to injury, some of the bronze used for the Budapest statue had been melted down from 'bourgeois' monuments of the pre-1945 period. Its destruction on the day after the Hungarian Uprising therefore had an even deeper than usual significance, being accompanied by especially vivid acts of public denigration (illus. 96).

Outdoor Stalin statues were not very numerous, even in the Soviet Union. It seems probable that the dictator himself had decided to accord to the countless standardized Lenin statues the rank of a normal state cult while reserving for himself some extraordinary monuments to be built in the future. The scuttling of the grandiose plans for the Palace of Soviets with a gigantic Lenin figure at the top might be interpreted anew in the light of Stalin's unstated determination to surpass Lenin and, in time, outdo him. Assuming a kind of semi-immortality, the dictator was loath – even as a septuagenarian – to specify his designs. A clue might, however, be gleaned from Beria's decision to provide a pompous architectural mantle for the small hut in Gori where Stalin had been born, an unabashed reference to Bethlehem. Where the ever stronger semi-religious components of the Stalin cult might ultimately have led must remain a matter of conjecture. As a final gesture, in 1953 his embalmed body was laid to rest next to Lenin's in the Kremlin mausoleum only to be taken away and buried in a normal grave in 1961. The de-Stalinization process started by Khrushchev's famous secret speech in February 1956 heralded the end of the great leader's cult – already on the wane – and the gradual dismantling of Soviet and East European Stalin statues, save for those in Albania and the few in China.

In the 1960s and 1970s, the Eastern Bloc settled down to normality. In the Soviet Union, one should mention the great

military commemorative complexes like the one at Volgograd (until 1963 Stalingrad). The fact that this monument praising Russia's greatest and most heroic victory was erected twenty years after those in Berlin, Vienna or Königsberg shows vividly the primacy of external propagandistic aims over questions of internal policy; Volgograd was situated in the deep hinterland, while the other sites documented the new limits of the inner and outer empires. In Volgograd, the figurative parts of the giant memorial complex present a peculiar mixture of stylization in the manner of Antoine Bourdelle and Expressionist and classicizing influences (the giant Nike with the sword). The heroic statues are very conventional, and the repetitive nature of their imagery is evidenced by the fact that one of the main groups (*Comradeship*) presents striking similarities to the same theme in Norman M. Thomas's *Coast Guard Memorial* in New York's Battery Park (*c.* 1960). The New York monument, ironically enough, is – *horribile dictu* – a derivative of the theme as shown in a famous Nazi triptych by Wilhelm Sauter (1936).[38] Aside from that interesting, but after all marginal, observation, one is forced to say that few monuments or complexes worthy of any mention were erected in the Eastern Bloc, though the statuary output was very great.

Poland and the German Democratic Republic constituted a case apart in this somewhat uniform and uninspiring picture. In Poland after 1958, architecto-sculptural competitions for the *KZ* complexes produced abstract or semi-abstract solutions with outstanding expressive qualities. An official monument devoted to Communists killed in the 1945–8 struggles with the national opposition, created in the Pieniny Mountains by Wladyslaw Hasior (1966),[39] used elements from Pop Art imposed on a constructivist iron structure which was meant to emit solemn, organ-like noises when it moved in the wind. The same artist tried to combine Tinguely-like iron structures with fire urns in 'Fire Birds' at Koszalin (1980; illus. 97),[40] but his monuments, though sponsored by the state and endowed with a political pretext, could as well be thought of as decorative public sculpture.

In the 1950s and 1960s, the DDR had to face incessant competition with West Germany. Sometimes this pressure exerted a positive influence on the arts. In the late 1950s, Hermann Henselmann, a brilliantly opportunistic architect who had already travelled from the Bauhaus to Stalinism and back, hit

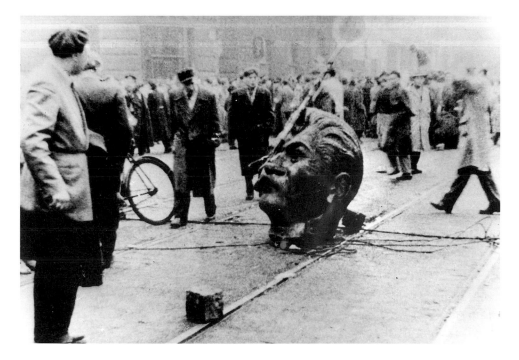

96 Head of Mikus's toppled statue of Stalin being reviled in a Budapest street, 24 October 1956.

upon the idea of building (in order to impede the erection of a Stalinist skyscraper) a modernized version of Tatlin's tower, conceived as a TV 'Tower of Signals', in the centre of East Berlin; its reflector lights would be directed at the unbelievers in West Berlin. At the base of Henselmann's tower, a shrine would exhibit the manuscript of Marx's *Das Kapital*.[41] This fascinating concept was, however, modified step after step by the Party bureaucracy, ending up in the mid-1960s as the purely technoid, clumsy TV tower near the famous Alexanderplatz.

Around 1970, East Germany seemed to combine – as the only socialist country – a stable political system with an excellent economic growth rate. The ultimately illusory confidence of that short period found its expression in two major commemorative monuments. The Lenin monument in East Berlin (1970; illus. 98)[42] was the work of the Russian sculptor Nikolai Tomsky. Tomsky showed an expressive Lenin in red granite with a small flag at the rear; the combined silhouettes rhythmically doubled the shape of the apartment blocks behind. This was in every sense a gripping metaphor of socialist construction issuing out of the revolutionary process. The effect was greatly amplified by an overall frontality and a careful

143

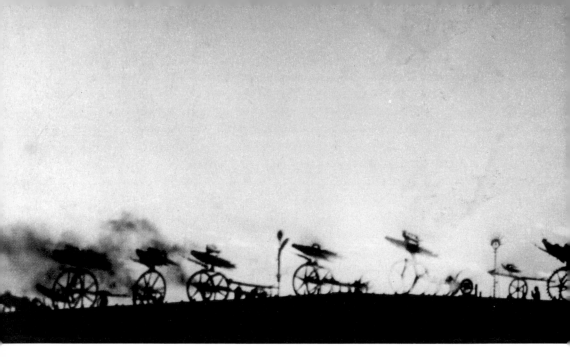

blending of simplified sculptural forms with the architectural environment. It is therefore not surprising that a paraphrase of Tomsky's monument erected in 1977 in Kiev, the *Monument to the October Revolution*, which opted for a large entourage of figures, constituted a dismal failure in artistic terms. The demolition of the Lenin monument in November 1991 on the orders of West Berlin politicians is still resented in the East on both aesthetic and sentimental grounds.[43]

The other major monument of that period survived the post-1989 demolitions. In the southern district town of Karl-Marx-Stadt (until 1953 and after 1990 Chemnitz), a great bust of the city's new patron by Lev Kerbel (1971; illus. 70) closely reflected, as has already been shown, the revolutionary Cubism of the years 1918–21.

After the mid-1970s, the political climate in the DDR changed fundamentally. Together with the rest of the Eastern Bloc, the state slid deeper and deeper into a political and economic crisis. The offensive optimism vis-à-vis the Federal Republic was gone; a defensive, half-hearted dogmatism vied for primacy with ever stronger strands of traditional thinking, including a remarkable Prussian renaissance. The most visible consequence of the latter development was the re-establishment of a dislocated equestrian statue of Frederick the Great on Unter den Linden, carried out on 6 December

97 Wladyslaw
Hasior, 'Fire Birds'
(monument in
honour of
Pomeranian
combatants),
Koszalin, Poland,
1980.

1980. On that same day, East German troops were planning, together with their Soviet comrades, to invade the Poland of Lech Walesa and Solidarity. Thankfully, the invasion was called off, but the frightening conjunction of the pompous re-establishment of a statue of the man who had destroyed the eighteenth-century Polish state with the spectre of an imminent bloody invasion poignantly illustrates the sinister possibilities of symbolic politics inherent in public monuments. Nobody seems to have noted this coincidence until now.

The cultural processes which accompanied the crisis of East Germany were varied in nature; they also had a civic-regional aspect comparable in certain respects to developments in West Germany. Thus, one rank below the level of political or historical public monuments, public figurative sculptures surfaced showing small, often humorous narrative scenes. In the 1980s, this strand was enriched by surreal motifs. The genre's outstanding characteristics were the placing of figures in pedestrian zones at eye-level and their amusing intimacy.

Astoundingly enough, this tendency influenced the last important Communist monument erected before 1989, namely the Marx-Engels memorial designed by Ludwig Engelhardt (1986) in East Berlin (illus. 99). The first plans for such a monument had been formulated as early as 1950. It was to be

145

98 Nikolai Tomsky, Lenin monument, Berlin, 1970 (demolished in 1991), with the added inscription *Keine Gewalt* (No violence).

located – in a triumphalist ploy – in place of the dismantled great neo-Baroque equestrian monument to Wilhelm I. Later plans changed the location somewhat, envisaging an elaborate complex composed of a high-rise government tower block (in a certain sense conceived along the lines of the Palace of Soviets) with a tribune and a great statuary monument to the two thinkers in front of it. Then, planning was halted. In 1958, Hermann Henselmann introduced his utopian tower project, which of course implied a break with conventional statuary solutions. The authorities' indecision lasted until the end of the 1970s, when they approved Engelhardt's scaled-down, purely sculptural group. Plans to place it before the newly built Palace of the Republic were scrapped in favour of an unobtrusive spot amidst greenery at the back of the building. This decision, taken by otherwise hard-line

99 Ludwig
Engelhardt, Marx-
Engels memorial,
Marx-Engels-
Forum, Berlin,
1986, with the
famous graffito
inscription *Wir
sind unschuldig*
(We are innocent),
May 1991.

WIR SIND UNSCHULDIG

Communists, echoed the creeping de-ideologizing of the 1980s. The realized work shows the two thinkers standing or sitting demurely on a low, almost undiscernible pedestal. They are available to anyone to touch,[44] and children were permitted to play around them – a trademark of public sculpture. The former self-assurance of the theoreticians of the proletariat was gone, as if anticipating the fall of the system. The sculptor evidently knew the genre of seated monumental figures which flank passers-by on narrow streets.

A kind of intimist plea for respect – a reticence to use the rhetorical forms of grandiosity – is evident in Engelhardt's work. Interestingly, its popular reception – the irreverent East Berlin vox populi dubbed it 'The Pensioners' – took these visual suggestions into full account. Nobody ever attempted to vandalize the monument. After the historical watershed of

147

1989, it was endowed with a graffitied inscription which achieved media celebrity overnight: *Wir sind unschuldig* (illus. 99).[45] The melancholic, defensive quality of the monument aptly characterized the last lethargic years of East European Communism.

1989 AND AFTER

Few reports, television programmes or book covers devoted to the momentous events in East Europe in the autumn of 1989 and in the Soviet Union in 1991 and after managed to do without a photograph of a vilified, moved, dismantled or carelessly cast-aside Communist statue.[46] The removal of these statues has become (much more than in their original role) the prime visual symbol for an historic change of regime. No doubt the propensity of our media-led civilization for incisive, symbolically charged acts has been decisive in this regard. The pulling down of a statue is telegenic and provides the welcome illusion of symbolically condensing a much longer historical process. In Theo Angelopoulos's magnificent film *Ulysses' Gaze* (1995), for example, a giant discarded statue of Lenin being shipped slowly down the Danube provides a melancholic leitmotif.

A number of creative photographers have recently taken up the theme of the fall of the Communist monuments. Their best photos (for example, the German series by the Israeli photographer Judah Altmann taken in 1991/2 [illus. 100]) tend to confirm our observations regarding Pierre Jahan's 1941 Paris photographs. Both the process of destruction, displacement and dismantling, which pits human beings and technical appliances against silent, pathetically immobile statues, and the subsequent acts of storage or disposal of broken parts are eminently photogenic and have a surrealistic tinge. The sight of seemingly timeless monuments entering new semantic contexts and the process of history in unexpected ways is thought-provoking to say the least.

In marked contrast to the events of the Hungarian Uprising of October 1956, during which the spontaneous destruction of the statue of Stalin played a very important role, no similar event occurred during the transformations of 1989 and after. The destruction of Felix Dzerzhinsky's statue in Warsaw in November 1989 came about as an administrative act after the

148

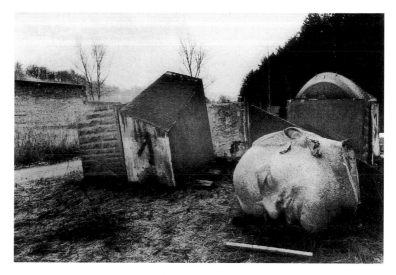

100 Judah Altmann, Photograph of Nikolai Tomsky's demolished Lenin monument in a depot in (West) Berlin, 1991/2.

new Solidarity government was firmly holding power. (The only destruction of a statue of sorts that acquired paramount political significance in 1989 was, sadly, that of the *Goddess of Democracy*, the wood-and-plaster variant of the Statue of Liberty erected by Chinese students in Tiananmen Square). Neither the fall of the statue of Enver Hoxsha in Tirana (20 February 1991) during the demonstration which toppled the Albanian government nor the dismantling by Yeltsinite officials (aided by the population) of the Dzherzhinsky statue on the second day of the anti-Gorbachov coup in Moscow (22 August 1991) possessed a significance even approximately approaching that of the Budapest iconoclasm. Yet, taken as a whole the removal of the statues can be said to characterize the fall of Communism.

In reality, the removal of Communist public monuments in the former Eastern Bloc began gradually and somewhat hesitatingly after the opposition had gained power. There were few acts of spontaneous destruction but many attempts at defacement. These included the scrawling of graffiti and throwing of red paint, the latter a somewhat redundant gesture in semantic terms.

A special category worthy of more detailed analysis includes the many attempts to arrange Happenings or artistic actions with the monuments serving as focal objects or backdrops. In one prominent example, the Polish Conceptualist Krzysztof Wodiczko[47] used slide projections to transform

149

Tomsky's East Berlin Lenin into a Polish shopper in the act of taking a cart filled with cheap Western electronic products out of a West Berlin shop (September 1990). Lenin was subjected to this poignant metaphor of the West's economic victory just one year before his dismantling. The same monument was defended by Eastern intellectuals in 1991 by means of an inscription using a slogan of the 1989 anti-Communist opposition, *Keine Gewalt* (illus. 98), but this symbolic turning of the tables failed to convince the responsible administrators from West Berlin. In January 1992, the Bürgerinitiative Lenin-denkmal, an association devoted to defending the Lenin monument, which had tried without success to save Tomsky's work, conducted a most unusual ceremony. Its adherents placed a number of stones taken from the debris of the dismantled monument (the major sculptural part having been removed to a depot) on a cart and carried them in solemn procession to the Berlin cemetery of Friedrichshain, where a number of prominent revolutionaries and Communists are buried. These 'stones of a wise man' were placed, perhaps in a subconscious reference to Jewish ritual, on the graves of Rosa Luxemburg and Karl Liebknecht.[48] The monument's empty site was adorned in the course of 1992 with a number of symbolic elements (illus. 101): biblical verses deploring the destruction but also an outline of the shadow of the Lenin figure. Left-wing demonstrations and ritual January processions to Friedrichshain habitually start at the former Leninplatz. No other dismantled monument east of the Elbe has inspired such symbolic actions.

The removal of Communist monuments was thus not a spontaneous process and swiftly became the preserve of local bureaucracies. In marked contrast to Communist times, decisions were normally taken at regional and city level, central governments being preoccupied by other pressing problems. It is still too early for a synthetic view of this process, especially as it is ongoing, though Dario Gamboni (1997) has provided us with an admirable outline of the main events and their symbolic ramifications. In the former Soviet Union and in Russia proper, the level of sympathies or ongoing Communist structures or affiliations can be gauged quite accurately by the extent to which statues of Lenin have been preserved. In itself, this is a hopeful indication that Russia has become more decentralized and democratic. No Lenin statue seems to have

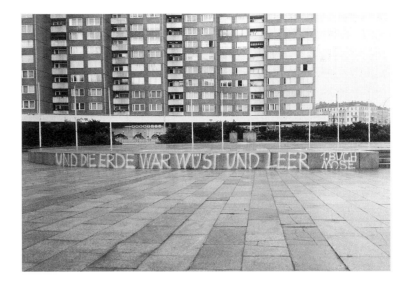

survived outside the former Soviet Union, although a majority
of the monuments devoted to Marx are still standing. In Poland,
the most difficult question proved to be differentiating between
burial memorials to the Soviet Army (these were of course
preserved) and monuments whose sole purpose was to glorify
the purported liberators (most of these were demolished).[49]

One thing is fairly obvious: artistic considerations – as
evidenced by the demolition of the outstanding Berlin Lenin
memorial – played a minor, if not an altogether non-existent,
role. Some fairly horrible Soviet war memorials survived in
East Germany and will continue to do so, being protected
by the clauses of the Soviet-German Treaty of 1990. The history
of the demolitions abounds in mistakes, comedy, quirks and
even occasional reinstatement.

The fate of monuments after the decision to remove or
demolish them is not without interest. Some bronze monu-
ments have been – to refer once more to the sardonic
euphemism of Pétain's 1941 decree – 'reintegrated into the
circuit of industrial production'. But the material value of
bronze is now much lower than it used to be. Thus, it is not
surprising that the leading Polish artistic foundry in Gliwice
is taking back all undesirable monuments it once produced
and storing them in the hope of creating the nucleus of a
factory museum. Two sculpture parks should also be men-
tioned. A German stonemason in Gundelfingen in Bavaria
purchased some twenty statues and busts and (interspersed

151

with his own products) installed a 'communist sculpture yard' whose main attraction was the surreal placement of four different statues on a single socle (illus. 102). In a more planned and structured way, the Hungarians designed the Szóbórpark, a sculpture park on the outskirts of Budapest, where around 60 Communist monuments are grouped around an ironic pastiche of a typical Soviet red star composed of flowers. Didacticism prevails at the entrance, where a large plaque quotes a verse from the famous poem by Gyula Illyes, 'A Sentence on Tyranny', which condemns 'bombastic and deceitful statues'.[50]

Only in Russia have discarded figures been left on the ground; the demarcation between neglect and conscious denigration is often hazy. The Moscow statue park near the Tretyakov Gallery, known as the Temporary Museum of Totalitarian Art, adopted such a principle, exhibiting standing as well as overturned or mutilated figures. This is a kind of *Depot de mémoire et oubli* (a reference to the paradoxical title of a 1992 installation by Anne and François Poirier which paraphrased the monumental vestiges of history and which was located, in fine symbolic style, on the site of the then still ruined Kaiser Wilhelm monument in Koblenz).

Many unoccupied socles remain. In Riga (Latvia), the Soviet monuments were pulled down soon after the reattainment of independence, but some of the pedestals were left on

102 Four monuments brought together on one large pedestal, a picturesque and somewhat surreal solution found in the 'Sculpture Yard of Communist Monuments', Gundelfingen (Bavaria), in 1997.

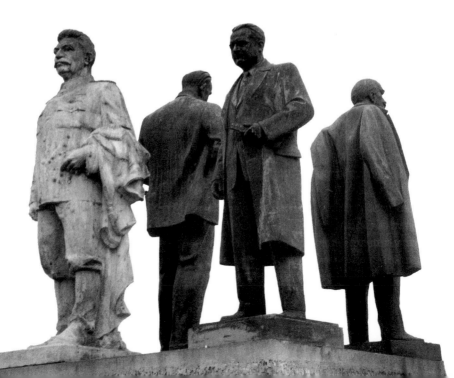

purpose. In the fall of 1994, an international competition was organized with the aim of finding suitable sculptural replacements.[51] This action seems to have been plagued by a lack of clear directives. What is clear is that the new sculptures are meant to belong to the genre of public art and not to that of public monuments. That in itself constitutes an important watershed, signalling more poignantly than mere iconoclastic acts can do the end of a system of public representation.

6 In Quest of a New Heroic Form

The Second World War was scarcely over when the erection of a signal public monument indicated a new direction. The Milan architectural bureau BBPR (established in 1932) decided to commemorate one of its members (Banfi) who had died in a German concentration camp with a monument consisting of a white cubic armature. At the outset intended as a private act of homage, the work was enlarged to encompass and express last respects for all of the Milanese victims of the *KZ*'s. Placed in the centre of Milan's pathetic Cimitero Monumentale, the work shocked by its deliberate contrast with the nineteenth-century sepulchral monuments already in place and with local examples of Fascist monumentalism (illus. 103).[1]

In the middle of the grate, a translucent glass cube exposed a primitive metal pot – similar if not identical to the ones used in prisons and concentration camps – containing blood-soaked earth from Mauthausen and encircled by a piece of barbed wire. The monument was thus structured on the principle of contradictions: a semi-constructivist structure, erected on a base in the symbolic shape of a Greek cross, contained a modern reliquary. The latter's austere form con-trasted with Italy's latent Baroque culture of death, apparent in the glass sarcophagi of many a church. In place of com-memorative plaques, tablets fastened by wire to the grid endowed the Milan monument with an air of informality. A kind of architectural model – alluding to BBPR's avant-gardism – thus served as a monument. Its antecedents, overlooked until now, included Giuseppe Terragni's famous Casa del Fascio in Como (1934), one of the great buildings of function-alist architecture. In Como, Terragni had hit upon the novel and somewhat paradoxical idea of placing in the office of the Fascist Secretary – the power centre of the whole province – a kind of modern ossuary replete with the relics of the first heroic years of Fascism.[2] A great vertical showcase fastened to a brutal cement pillar, whose supplementary function was to symbolize the vertical power structure of Italian Fascism, displayed the bloodied clothing and other memorabilia of

154

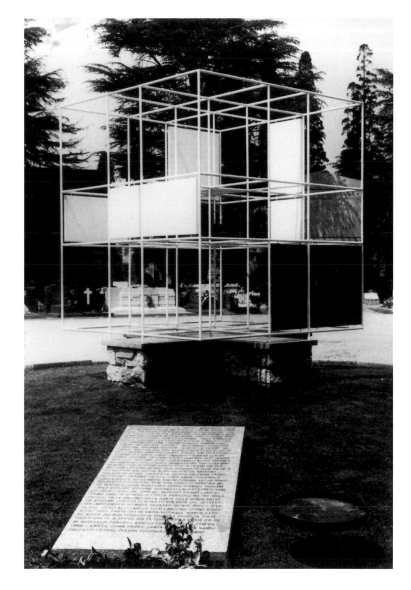

103 BBPR Group, *Monument for the Victims of the Concentration Camps*, Cimitero Monumentale, Milan, 1945–55.

Fascist *squadristi* killed or wounded in the street riots of 1920/22. The BBPR architects imitated both the contrast between different materials and that between modern-day reliquaries and the rational language of engineering, but turned them inside out, a process emblematic of Italy's post-Fascist transition.

The commemorative monuments of the decades after the war could scarcely follow such complex lines. Yet, the ideas inherent here were to shape the public sculptures and monuments of the West in the last quarter of the twentieth century.

155

Despite some isolated forerunners, it was only in 1951 that the West adopted abstract forms for public monuments. The widespread feeling that traditional forms of state pageantry had become irrelevant certainly helped to tilt the scales in that direction. In 1951, the *Monument to the Victims of the Berlin Airlift* was unveiled near Tempelhof Airport in West Berlin (illus. 104),[3] its three concrete prongs symbolizing the three vital air corridors which had linked the blockaded city in 1948/9 with the Western Zones of Germany.

Also in 1951, Republican political circles, using funds supplied by the CIA, put forward the idea of an international competition for a monument to an unknown political prisoner. The then Institute for Contemporary Art in London, under the noted art critic Sir Herbert Read, agreed to act as a 'front'. The monument was 'to pay tribute to those individuals who had dared to offer their liberty or their lives for the cause of human freedom';[4] despite this seemingly universal formula, it was quite obvious that the action had a circumstantial anti-Communist tinge.[5] The preferences of the organizers were clearly for abstract or semi-abstract solutions. After 1945, abstract painting had assumed the role of an ideological antidote to Soviet and East European figuration. The competition was conceived as a kind of multi-functional ideological weapon, furthering the ethos but also the forms of the West. This went so far that – in order to keep all options open – no location was specified, a most unusual situation for a public monument.

In January 1953, following a gigantic competition with over 3,500 (!) entries, the young British sculptor Reg Butler was awarded first prize.[6] The majority of the projects which made it to the final round espoused abstract (Gabo, Pevsner, Calder, Hepworth, Max Bill) or semi-abstract solutions. Butler's winning model showed a tall, cage-like metal structure ensconced on a three-legged platform endowed with a tall pole, the whole construction fixed to a rock-like base. Butler had elaborated the final version in dozens of preparatory sketches and models, starting with the drawing of a figure – no doubt that of the Unknown Prisoner – standing in an urban setting on a

kind of gallows (illus. 105). The prisoner figure gradually dis-
appeared through a process of analogy with the outline of the
crucified Christ and then with the Cross itself (illus. 106, 107).
In the final project, a semblance to the Cross is still there, albeit
only when viewed from a certain angle (illus. 108). The three
spectators who watch the now empty platform constitute a
blatant reference to Easter symbolism, with the rock with
its Christian connotations also in place. The complex metal
structure, leaving aside its accidental similarity to early TV
antennae, evokes a bewildering spectrum of shapes. Is it a
watch-tower, a cage, an execution platform or a grid serving

104 Eduard Ludwig,
*Monument to the
Victims of
the Berlin Airlift*,
Tempelhof Airport,
Berlin, 1951, floodlit
at night sometime
during the 1960s.

157

105 Reg Butler, 'Sketch for a monument to *The Unknown Political Prisoner*', 1951/2, pen and ink. Pittsburgh Museum of Art.

108 (*opposite*) Butler, 'Final maquette for a monument to *The Unknown Political Prisoner*', 1951–2, bronze sheet and wire on stone base. 1950s photograph.

106 Butler, 'Preliminary maquette for a monument to *The Unknown Political Prisoner*', 1951/2, bronze sheet and wire on a plaster base. Private collection.

107 Butler, 'Sketch for a monument to *The Unknown Political Prisoner*', 1951/2, pen and ink. Pittsburgh Museum of Art.

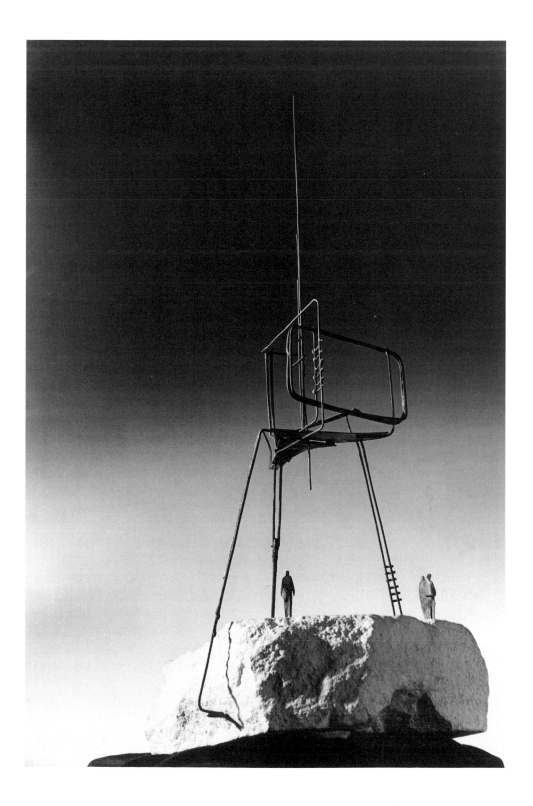

as a support for an obliterated cross? All of these associations make some sense as regards the theme. No doubt, this visual polysemy appealed to the jurors.

Butler was the first sculptor to stage a public monument which referred to modern scenographic ploys and settings. He imagined a corridor hewn out of the rock which would lead the eager visitor directly underneath the platform; for others, a distant view of the 40-m-high structure would have to suffice. Butler thus permitted the beholder a double function: from afar, as the viewer of a theatrical scene, and from nearby, as one of the mourners looking for the absent prisoner. That absence provided the drama in progress with a poignant symbol and narrative sense and resolved the difficulties and figural ambivalence inherent in the formula of the Unknown Prisoner by endowing it with a metaphysical aura proper to the topicality of the Unknown Soldier. The majority of the other proposals did not escape that dilemma successfully; they showed a somewhat simplified human figure enclosed or encircled by cages, grids, razor-sharp objects or other symbols of imprisonment and oppression (illus. 109).

Another major project which opted for a setting with viewers, designed by Fritz Koenig, showed a circular, walled-off den with the prisoner fastened inside to a cage-like structure (illus. 110). Five figures outside the enclosure viewed his predicament. A comparison with this garrulous, literal symbolism highlights the visual and synthetic qualities of Butler's solution. Paradoxically, the rock, with its Christian references, seemed an asset to the urban placing of the monument. Quite quickly, the Americans, in conjunction with the German politician Ernst Reuter, found a suitable location in Berlin, the city which straddled two ideological systems.[7] This choice grew logically out of West Berlin's anti-Communist bearings. The city already possessed the anti-Communist air-lift memorial, but monuments to victims of Nazism and the Holocaust were sadly lacking. Butler's was to be placed on a high hill, the Humboldthöhe, a stone's throw from the boundary between East and West (illus. 111). The place chosen lay opposite the East Berlin district of Pankow, where the entire party élite then lived. As such, the location was a masterly provocation: on the boundary of the two systems, a semi-abstract towering structure was to commemorate Eastern political prisoners. To add insult to injury, a supplementary

160

109 Karl Hartung, Model for the monument to the Unknown Political Prisoner, 1952, plaster. Nachlass Karl Hartung, Bad Bramstadt.

110 Fritz Koenig, Model for the monument to the Unknown Political Prisoner, 1952, plaster. Fritz Koenig, Landshut.

concept devised by the West Berlin Senate postulated the creation of a crypt beneath the monument to record the names of political prisoners (1957). It was obvious that Butler's project was meant to constitute a kind of counter-monument to the pathetic Soviet memorial complex in Berlin-Treptow, a concept already apparent in 1953 in Ernst Reuter's deliberations. Despite its acceptable anti-Communist premise, a kind of moral blindness (the aesthetically alien Treptow monument had after all functioned as part of a cemetery complex) had crept in on the Western side.

161

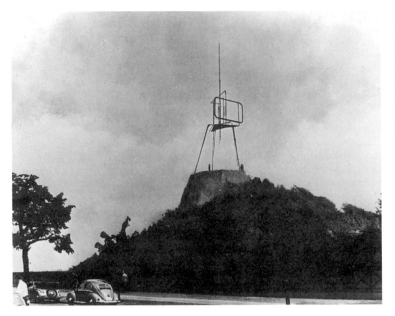

111 Reg Butler, 'Working model for a monument to *The Unknown Political Prisoner* on the proposed site (the Humboldthöhe, Berlin)', 1957, photomontage. Private collection.

Technical (the Humboldthöhe was equipped with a shelter) and financial problems delayed the project's erection until 1958; the acute political and military crisis sparked that year by Khrushchev's Berlin ultimatum[8] led to the scuttling of all plans in the spring of 1960. By that time, East Germany had completed the Buchenwald memorial, which attempted to project its symbolic message across the border: a revenge of sorts.

Butler's project broke new ground both in form and in its popular reception. It met with widespread hostility both from the Left (for ideological and aesthetic reasons) and the old Right (for aesthetic ones); a Hungarian political émigré vandalized the London exposition model, while popular cartoons highlighted the similarities to TV antennae. Speaking in the House of Commons, Winston Churchill found scathing words for Butler's concept. The storm subsided quickly, however.

Butler seemed to have sensed the range of artistic possibilities available in the early 1950s. In his early figural studies, he incorporated motifs from Moore and Bacon; the final figures of the watchers evoked a Giacometti-like stylization.[9] The symbolic polyvalence of the structure, which evolved through its successive planning stages, showed the logic of the abstracting process in an impressive way by obliterating overt

162

references to a human figure, a cage and a cross and yet some-how still echoing those shapes. The process of designing thus itself became part of the monument's polysemy. By creating a theatrical scene without a hero, Butler involved both narrative and symbolic moments and fused them into a powerful whole.

FLAG-RAISING SOLDIERS

It is now a well-known fact that the famous photo taken by Associated Press war photographer Joe Rosenthal of American Marines raising the Star-Spangled Banner on Iwo Jima in February 1945 belongs to the species of post-battle mise-en-scènes (illus. 112). The first flag raised on Mt Suribachi, amidst fierce fighting on the morning of 24 February, was considered too small. As a result, Rosenthal accompanied a second flag-raising group later in the day. As the enemy had withdrawn, Rosenthal asked the Marines to impersonate a kind of tableau vivant and took a series of snapshots.[10] (The official Soviet photo of the hoisting of the Red flag atop the Berlin Reichstag, supposedly in fierce combat on 30 April 1945, was also taken two days later in more peaceful circumstances.) Whether by chance or by design, Rosenthal created a wonderfully balanced, taut, diagonal composition. The steady, ascending progress of the soldiers, who, in fulfilling a symbolic act, at the same time face invisible danger, exerts a strong emotive appeal. The sharp ending on the right, a compositional and emotional caesura, while not containing the dynamics of the group subjects the flag-raising to the framing strictures of multi-figural compositions. The aesthetic appeal of this famous photo derives from its pronounced two-dimensionality and the abstract balancing of compositional forces, notwithstanding the illusion of snapshot vivacity.

Nine years after this famous pseudo-snapshot was taken, the US Marine Corps unveiled, at Arlington National Cemetery near Washington, DC, a commemorative monument to its fallen combatants conceived by Felix de Weldon (illus. 113). On a base almost three m high, giant bronze Marines measuring an incongruous ten m try to ram a flagpole into the ground. Because the figures' disposition was modified, the result is less than fortuitous; a sardine-tin-like tightness welds the group together, resulting in a mediocre sense of rhythm. The

overall dryness of the composition contrasts with a proto-Baroque exuberance of detail and the crass naturalism of the uniforms. Each morning, a real flag is hoisted up the pole; each evening, it is ceremoniously taken down. The contrast between the reality of the piece of cloth and the bronze makes the whole arrangement – with real Marines standing before the monument – seem even more incongruous and staged. The contrasts embodied in this example of sculptural bad taste suggest paradoxical Pop Art effects in the making.

In 1968, at the sombre apogee of the Vietnam War, Ed Kienholz created his mixed-media installation *The Portable War Memorial* (illus. 114).[11] The flag, so honoured on Iwo Jima and in the Arlington Cemetery, was by then being burnt or otherwise demeaned by the manifold enemies of the war and the Establishment. In Kienholz's memorial, five headless soldiers with helmets fixed to their bodies attempt to ram an American flag into a garden table, thus re-enacting two models, the photo and the Arlington monument. In the background,

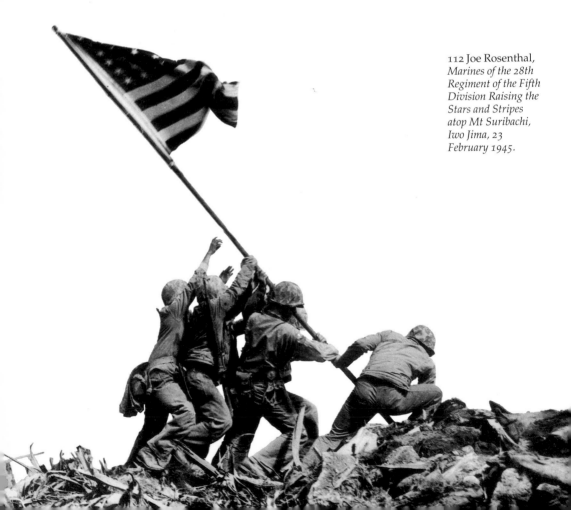

112 Joe Rosenthal, *Marines of the 28th Regiment of the Fifth Division Raising the Stars and Stripes atop Mt Suribachi, Iwo Jima, 23 February 1945.*

the famous Uncle Sam of recruiting posters gives his blessing. An inverted cross is affixed to what Kienholz himself termed 'a blackboard tombstone' inscribed with the names of 475 nations or states extinguished as a result of war. The inscriptions are in graffiti style with room for further names; for that purpose, slate pencils are affixed below. No doubt Kienholz was the first to hit upon the idea – some twenty years before Jochen Gerz's Harburg column, about which more will be said later – of inviting the viewer to inscribe an opinion or name on the monument. On the right, a garden-café table, chairs and a Coca-Cola dispenser are depicted before a combine-painting showing a couple in front of a fast-food stand. This part of the monument appears empty; the unknown future was still a clean slate. Yet, looking closely, we discover there a tiny suffering figure. Human misery is thus to be found not only in war but also amidst the affluence of modern civilization.

Kienholz's work, a refined Pop-Art agglomerate, was clearly intended to send up patriotic motifs and icons. The *Portable Monument* should be read, as the artist himself suggested, from left to right. It lends itself to a number of oppositions, beginning

with straightforward symbolic inversion (the cross upside-down), then proceeding through the mixing of high and low, and ending with the fundamental opposition of war and 'life as usual'. There are playful oppositions like the hidden similarity of the patriotic singer Kati Smith on the left to the dog listening to 'his master's voice' on the right. But after a while, our attention goes back to the effort of the soldiers ramming the flag into the table in an action epitomizing supreme military heroics. Painted a glossy gold colour, they seem to allude to the pseudo-monuments of the Baroque, golden 'living statues'. But what they are raising turns out not, despite appearances, to be the American flag at all. The flag has been stitched onto a support which provides a frame of sorts. It is thus not the flag itself, but an image of the flag. This detail reflects the ontological structure of Kienholz's monument. By virtue of its purported portability, it seems to satirize the *Pathosformel* of ordinary war monuments. The lines of reference go further; after all, portability is appropriate to a type of 'private monument' in the vein of Marcel Duchamp's *Boîte en valise*.

The astounding proliferation of graphic, cinematic and sculptural replicas and rehearsals of the Iwo Jima scene in America during the 1950s and early 1960s might also have generated the slightly surreal notion of portability. In its central segment, Kienholz's piece satirizes a war memorial

114 Ed Kienholz, *The Portable War Memorial*, 1968. Museum Ludwig, Köln.

which in itself was a blown-up version of a staged battle photo. The line of mise-en-scènes thus continues, with each step being retraceable through an analysis of the images. And with each step, the mere idea of a patriotic war monument espousing heroic action becomes more and more ludicrous. This was the message as the 1960s ended.

PARIS UNDER GISCARD AND MITTERRAND

The meritocratic statuomania of the Third Republic had spent itself after the First World War. The melting-down of over a hundred Parisian statues twenty years later had sounded the death knell for the idea of an open-air Pantheon. Although Paul Claudel coined a touching epitaph – 'Un Paris mallarméen se peupla tout à coup de socles dédiés à l'absence' – few contemporaries seemed to deplore these ravages. Thus, the great art historian Louis Réau could even laud – without incurring any protest at all – the Germans for having done at least 'one good thing' for Paris as the capital of modern art.[12] Though the models of the monuments had survived the war,[13] no recasting was ever attempted, the few mediocre replacements being chiselled out of poor and porous stone. Some of the empty socles continued to languish, while others were destroyed to ease the circulation of traffic or provide more parking spaces.

In the mid-1970s, the first stirrings of a changed attitude towards the Belle Epoque and of a new historicism generated a renewed interest in both the Third Republic's legacy and new monuments. The suggestion of Maurice Druon, Pompidou's much-maligned culture minister, to resume the practice of homages to great men was put into practice somewhat half-heartedly in the form of a series of figures of the Republic's Second World War commanders (Juin, De Lattre de Tassigny, Leclerc) and the First World War Marshal Lyautey. In itself, this meant a resumption less of the cultural and educational focus of the early Third Republic than of its controversial intra-war homages to commanders in the First World War. In artistic terms, the results were decent but singularly uninspired.

The Mitterrand government, after 1981, enlarged this somewhat narrow focus by fostering – amidst perpetual bickering with the Parisian authorities presided over by Jacques Chirac

– a new attempt to create statues of great politicians and thinkers. The task was entrusted to a special governmental commission with the inevitable strictures of bureaucratic travail ensuing forthwith. Uncontroversial figures like François Mauriac, Léon Blum, Robert Schumann and Pierre Mendès-France – all represented in an unspectacular, realistic mode – faced the Parisian public from atop diminutive socles.[14] There were also signal failures, however. An appalling statue of Sartre, sculpted by Roseline Granet after the famous photo showing him walking almost like a hunchback, was placed in the forecourt of the Bibliothèque Nationale (1987). It shows the pitfalls of transposing visual trademarks into a three-dimensional, plastic medium. A statue of President Pompidou by Louis Derbré (1984), rigid and seemingly inflated, assumed the questionable, charismatic looks of Mao Zedong (illus. 115). Worse still, a well-meant and laudable attempt by the great cartoonist TIM (Louis Mitelberg), debuting as a sculptor, to honour the famous Captain Dreyfus failed dismally (1986; illus. 116). TIM chose a particular narrative moment – namely the dramatic ceremony when Dreyfus was stripped of his

115 Louis Derbré, *President Georges Pompidou*, Jardin des Champs-Elysées, Paris, 1984.

116 TIM (Louis Mitelberg), *Captain Dreyfus*, Place Pierre Lafue, Paris, 1986.

military rank and his officer's sabre was broken – by showing him presenting his broken weapon in mute protest. The actual moment is charged with high drama and psychological tension, but the visual impact of the gesture is flawed, since Dreyfus's head, in keeping with TIM's drawing style, is narrow and elongated and seems to hide behind the mutilated sword. Thus, the pose is equivocal at best, and the Giacometti-style porous bronze amplifies the figure's oddly emaciated air. The work's present location on a minuscule square in a residential neighbourhood (placement before the Ecole Militaire was successfully opposed by the French Right) is – considering Dreyfus's pathetic gesture of protest – particularly meaningless.

Only one outstanding monument resulted from the twenty or so official commissions (by all standards the largest effort in the area of public monuments in the West after 1970): Albert Féraud and Marc Landowski's *Homage to Marshal Koenig and His Troops*, unveiled in 1984 at the Porte Maillot (illus. 117). Instead of erecting one more conventional statue of a great commander, Féraud and Landowski opted for an elaborate abstract representation of the Bir-Hakeim battle (1941), encompassing veiled references to Uccello's famous San Romano triptych but also showing a familiarity with pre-1914 Cubist (Léger) and Futurist (Boccioni) styles.

In general, abstraction has been a hallmark of public sculpture – as opposed to monuments – since the 1960s, though the dividing lines are becoming more and more blurred. The Porte Maillot monument defies these habitual associations by its convincing metonymy of combat, suggesting a semi-narrative representation of battle. This formal connection might even claim a kind of historic legitimacy in view of the proven bellicosity of the Italian movement. The assemblage of tubular, armour-like forms appears astoundingly homogenous and forceful, though it keeps a low profile on a smallish escarpment. After a controversy remarkably similar to that surrounding the *Vietnam Veterans Memorial* in Washington, DC, veterans' associations forced the reluctant artists[15] to insert a menhir-like stone with a profile portrait of Marshal Koenig. Despite this flawed addition, this is one of the most outstanding Western war memorials created since 1945.

Seen in retrospect and taking their reception into account, it is clear that these new statuary homages did not carry much weight in either the realm of official cultural policy or that

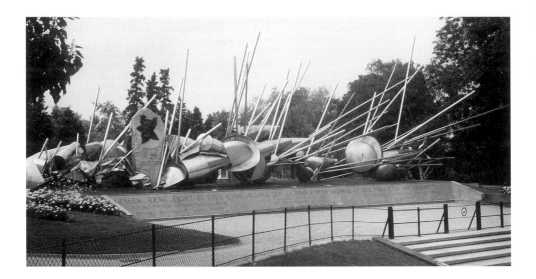

of popular Parisian itineraries. Only the statue of Dreyfus managed to attract some attention by virtue of provoking once again the latent anti-Semitic reflexes of the French Right. It would be a moot exercise here to speak at great length about the importance of the Parisian *Grands Travaux* undertaken by Mitterrand. The towers of the Bibliothèque de France, Spreckelsen's Great Arch and the less-than-felicitous Louvre Pyramid were, however, given appearances which have something in common with abstract sculptural forms and which lend themselves to a semiotic appropriation transcending the boundaries of an 'architecture parlante'.[16] In a certain sense, these edifices constituted the new public monuments of Paris – in the tradition of the prima facie abstract, but on a popular level supremely figural, Eiffel Tower.

The great celebrations of the Bicentenary of the French Revolution in 1989, which without a doubt constituted the apogee of Mitterrand's virtuoso *politique-spectacle*, resulted in very few public monuments, and those are of insignificant artistic and public stature. The contrast to the Republican programme of the Centenary celebrations of 1889 and 1892 could not be greater. The predominance of other celebratory forms reflected the changed mood of the times. Thus, in 1989 the well-known Korean video artist Nam June Paik created on official commission five figure-like video installations as public monuments to Voltaire, Diderot, Olympe de Gouges, Robespierre and Rousseau. These were shown at the Musée

117 Albert Féraud and Marc Landowski, *Homage to Marshal Koenig and His Troops* (Bir-Hakeim memorial), Porte Maillot, Paris, 1984.

118 Jan Dibbets, *Arago-Méridien*, one of 135 bronze plaques inserted into the pavements of Paris, in 1994, to create an imaginary line (this one is in the Palais Royal).

d'Art Moderne de la Ville de Paris. Dismantled the following year save for the Olympe de Gouges, this work was a deliberate travesty of the Third Republic's sculptural programme with some new revolutionary (Robespierre) and feminist (de Gouges) accents.[17]

A reconstitution of the Third Republic's dismantled Paris monuments is still deemed impossible or unnecessary. The action of the Dutch Conceptualist Jan Dibbets (1994) in honour of the great French astronomer François Arago chose as its starting point the empty socle of the latter's statue (the monument having been destroyed in 1942). Dibbets decided to create an 'imaginary monument' proceeding along an imaginary line – none other than the meridian which Arago himself had traced through Paris (illus. 118). Bearing only the inscription *Arago*, 135 minuscule bronze plaques were installed in accessible and less accessible places, in pavements, streets or squares. They are, of course, easy to overlook and constitute, as the French are now fond of saying, a 'lieu de mémoire' strewn over the entire city, creating an imaginary line.[18] Thus, in a paradoxical way the memory of the Third Republic's Parisian statuary programme lingers on.

7 Invisibility and Inversion

In the mid-1960s, the widespread feeling that the status of the political public monument had been rendered meaningless resulted in a new art form: monuments which tried to attain invisibility as a way of engendering reflection on the limitations of monumental imagery.[1] This end was to be attained within the framework of a comprehensible and retraceable artistic process.

Cultural stereotypes and public instinct had until that time considered visibility as an essential prerequisite for the existence of public monuments, conceived as they were to rise prominently above the ground, proudly erect (hence the many phallic associations), sometimes even – like the omnipotent Statue of Liberty – towering on the horizon. An invisible monument implied the negation of 2,500 years of visual experience. As a result, the introduction of this new category seemed a prelude to the final abolition of the monument in its traditional guise.

In 1916, Apollinaire published his autobiographical *Le Poète assassiné*. After the public murder of the poet Croniamantal, his adherents discuss the idea of erecting a commemorative statue, but then discard the idea as being totally outmoded. They hit upon the concept of erecting 'une statue profonde en rien' in the form of a subterranean structure in the forest of Meudon (where, incidentally, Rodin had his atelier until 1917). The hole in the earth was sculpted to resemble the outer form of Cronamiantal until it was 'replete with his spirit'.[2]

By means of this proto-Surrealist proposal, Apollinaire had joined the ranks of the critics of Parisian statuomania, dissociating himself also from his former aesthetic idol, Rodin. Some aspects of this novel idea were taken up a decade later by Picasso when faced with the task of designing a monument to his deceased friend. Picasso's *Wire Construction or Monument to Apollinaire* (1928–34), which was intended as a public commemoration, was described by the artist in terms which referred directly to that part of the *Poète* as an

. . . abstract sculpture which would give form to the void in such a way as to make people think about the existence of it . . . I am going to do something which corresponds to the moment described in the 'Poète Assassiné' and that means a space with a void.[3]

But the official Parisian committee for an Apollinaire monument thought that Picasso's work might enrage conservative public opinion and blocked his proposal. The exasperated artist finally honoured his friend with a bust of one of his own former mistresses, Dora Maar. By virtue of its blatant personalization, this version, unveiled in 1959, displays a Surrealist tinge, though no doubt one of a lighter kind.

When faced with the task of erecting a world war memorial inside Berlin's Neue Wache, Heinrich Tessenow had contemplated a totally novel solution (we have considered its realized form already). One of his friends recorded his saying that he would like to create an '. . . abysmal hole, a dark cavern covered only by bronze cross beams'. Such a hole would have been '. . . the only adequate expression for this war and its millions of victims'.[4] This stark symbol would have confronted the viewer with the idea of abysmal carnage and the still open questions generated by the war. What is more, by virtue of its placement underneath the circular opening in the ceiling of the memorial room, the hole would have become part of an axis linking the symbolic opposites of heaven and hell. In contrast, however, to the discreet symbol of Brancusi's *Endless Column* in the *Tirgu Iu War Memorial* (1938), Tessenow did not offer any eschatological dimension at all. In the 1930s, it was too early for such a radical solution. His simple but brilliant idea was to resurface 40 years later, combining aspects of grave symbolism with that of hollow, undefinable space.

In the 1960s, it was the turn of the leading Pop artist Claes Oldenburg to take up and modify Apollinaire's genial idea. Oldenburg's *Proposed Underground Memorial and Tomb for President John F. Kennedy* (1965) envisaged a gigantic statue of the murdered President placed upside-down in the ground (illus. 119). The statue was to have the same dimensions as the Statue of Liberty.[5] Seen in retrospect, Oldenburg's project was not devoid of a certain ambiguity: there is no doubt that he envisaged a memorial approach, but he used the project as a preparatory stage for a series of artistic objects whose aim was

119 Claes Oldenburg, *Proposed Underground Memorial and Tomb for President John F. Kennedy*, 1965, drawing.

to abolish the notion of the political monument as such. As regards the commemorative framework, Oldenburg referred deftly both to the popular iconography and intrinsic meaning of the Statue of Liberty. The events in Dallas were interpreted as turning the American Dream on its head. In short, they constituted its subterranean negative.

In 1965, Oldenburg was also on the verge of elaborating and publicizing a series of projects for out-of-scale everyday objects, blown up to megalithic proportions and inserted as mock-heroic monuments into the urban fabric.[6] He started with an object provocatively designed as a replacement for an existing monument, namely the 1967 *Proposed Colossal Monument to Replace the Washington DC Obelisk — Rotating Scissors*. Later, he proposed and realized totally independent objects (*Lipstick*, *Clothespin*). Whereas the buried and inverted Kennedy monument did its best to negate the Statue of Liberty through a truly antipodean procedure, the sculptures of the latter series proclaimed the need to establish a new category of public sculpture that transcended the traditional definition of the political monument.

Before he turned exclusively to making independent objects, Oldenburg tried once more to develop the earth-hole motif. In *Placid Civic Monument* (1967), the ironic strands inherent in the

174

Kennedy project were discarded. On 1 October 1967, a group of municipal grave-diggers employed by Oldenburg dug a hole in the lawn behind the Metropolitan Museum of Art in New York. After documenting the action, they filled the hole up again. Oldenburg expected – erroneously, as we know now – that in due time official triumphalist war memorials would be erected, and with this action he intended to protest against both the Vietnam War and its future celebrations. In his view, the hole was to serve as a negative of a prospective socle. By covering it up, he transcended the purely negative form of his Kennedy monument. Joining together the structurally related concepts of a negative form and a grave, he proceeded to annihilate them both. Oldenburg's compelling logic was to be sorely absent in the case of the gigantic hole project submitted in 1995 to the Berlin Holocaust competition.

In 1981, it was the turn of the West German artist Timm Ulrichs – who habitually chooses himself as the subject of his art – to take up the idea of a subterranean monument. He projected a special monument-grave for himself, which was first exhibited in Bergkamen and ultimately located, in the late 1980s, in an artistic necropolis near Kassel (Habichthöhe). Ulrichs inserted a cast of his body into the ground with the head pointed downwards, thus repeating Oldenburg's Kennedy project; the soles of his shoes were at ground level, fixed from below to a thick, translucent glass plate. After Ulrichs's death, the monument was meant to accommodate his ashes – a notion testifying to a peculiarly Protestant obsession with cremation and somewhat difficult to imagine in practice. Ulrichs expressly chose the motif of the shoe soles as the main catalyst for inducing the viewer to engage in a kind of philosophical reflection on life in general and the artist's life in particular. No doubt he was aiming – without expressly acknowledging it – at making an 'imprint' and 'leaving his mark', metaphorical connections with outstanding personalities. Ulrichs proclaimed that

> . . . having the monument – i.e. the bottom side of the shoes – at his feet the beholder will understand that this antipodic empty form relates to the living image like death to life.[7]

His somewhat pedestrian philosophizing on the strictures and imprints of life shows all the signs of a derivative version of an idea which had once been novel and illuminating.

The key concepts envisaged in these artistic actions were invisibility and negative form. As such, they show certain connections with strands of the philosophical-aesthetic debate on the Holocaust as it developed during the 1970s and 1980s. The catastrophe was increasingly discussed in terms of a 'black hole', the very anti-matter of culture and civilization. A figurative visualization seemed out of the question after 1970. The particular logic of the debate led to the idea of circumscribing the empty space in human civilization, a kind of void with abstract bearings. Circumscribing but not depicting the Divine had been a key concept of the iconophobes of Byzantium. Now, it returned as a way of delimiting the empty space left by a whole civilization which had perished in the gas chambers.

In its extreme form, this stance surfaced during the ill-fated Holocaust memorial competition of 1994/5 in Berlin. One of the entries envisaged a giant hole in the earth – to be excavated at the very centre of the city – measuring 80 by 60 by 50 m.[8] The sheer size of the hole and its location would have transcended any notion of providing a 'negative model', however, making it instead an exercise in gigantomaniacal land art. Other proposals and realizations had a more modest character. Thus, in the abortive competition for a Jewish memorial on the Börneplatz in Frankfurt, a whole range of proposals (1986) centred on the idea of an empty, semi-ruinous or ruined space at the heart of a modern conurbation. To counter the false triumphalism of the Buchenwald monument discussed earlier, a separate monument for the Jewish inmates, designed by Klaus Schlosser and Tine Steen (1993), recreated the ground plan of a barracks by means of an excavation covered with stones.

The most recent artistic developments have included interesting modifications of the 'black hole' idea. The plan of the famous Basque sculptor Eduardo Chillida (1995) to excavate a great regular hole in the 'holy' mountain of Tindaya (Fuerteventura, Canary Islands) under the guise of a 'Monument to Tolerance'[9] derives only in part – contrary to the opinions of most critics – from the current fascination for negative forms. Chillida sees the 'black hole' as the most adequate symbol of the predicament of modern humanity, but in an optimistic dénouement plans to drill two corridors from the rectangular hole (one vertical, one horizontal) to

ground level, so that spectators at the bottom will be able to see the 'light of the sun and that of the moon' as universal symbols of hope. Thus, without acknowledging it, Chillida is aiming towards a symbolic cosmological effect in the tradition of Boullée's interior for the projected Newton cenotaph (1784).

In an exemplary way, the idea of a 'negative-form' monument appeared in the so-called *Aschrott Fountain Monument* in Kassel, designed by Horst Hoheisel (1988; illus. 120, 121). This monument has a twisted, darkly fascinating history which demands to be presented in some detail. In happier times (1908), a local Jewish manufacturer had offered a pyramid-fountain to the city of Kassel, intended as a conventional piece of Belle Epoque urban décor without any particular aesthetic or thematic pretensions. In 1939, local Nazis destroyed the 'Jew's Fountain'; during the war, the basin was filled with earth and planted with flowers. Local inhabitants dubbed it – not without metaphorical reason – 'Aschrott's grave'. This episode of Nazi terror could hardly stand for Jewish martyrdom, the Nazis having rather harmed Kassel itself, but the paradoxes of this change of form and function illuminated in a deeper way the consequences of the disappearance of the Jews from German life. In 1988, Hoheisel, a local artist, realized a classic 'negative form' monument. As he put it:

120 Horst Hoheisel, Conceptual sketch for the new Aschrott Fountain in Kassel, 1987. Collection of the artist.

121 Hoheisel, *Aschrott Fountain Monument*, Rathausplatz, Kassel, 1988.

I have designed the new fountain as a mirror image of the old one, sunk beneath the old place in order to rescue the history of this place as a wound and as an open question ... I have rebuilt the fountain sculpture as a hollow concrete form after the old plans and for a week displayed it as a resurrected shape at City Hall Square before sinking it, mirror-like, twelve meters deep into the ground water.

The pyramid will be turned into a funnel into whose darkness waters run down ... there a hole emerges which deep down in the water creates an image reflecting back the entire shape of the fountain.[10]

One more related, very recent type of monument links the concept of a 'negative model' with a demonstration of seemingly paradoxical dysfunctionality. With this group, we enter the burgeoning area of installation art.

In 1995, a monument commemorating the burning of books by Nazi students in Berlin on 10 May 1933 was inaugurated on the very spot before Berlin University where that dreary ritual had taken place. Micha Ullman created a subterranean rectangular room whose walls are covered by empty shelves. The only viewing access is provided by a small, thick glass panel (illus. 122). When viewed through this somewhat opaque device, the white shelves and floor merge to suggest a less than definable space, though on closer inspection the room's limits are visible. A minuscule bronze tablet inserted into the pavement some distance away provides us, in Minimalist fashion, with the name of the artist and title of the work – but nothing more.

Symbolism of a similar kind is espoused by the British artist Rachel Whiteread's 1995 project for a Holocaust memorial in the very birthplace of modern anti-Semitism, Vienna.[11] The planned monument – after many deliberations and delays, it will finally be erected in 1998 – will show a concrete cubicle exposing on its outer walls books turned with their backs inwards. No functional access of any kind (despite a symbolic door) will lead to the interior of the cube; the book collection thus signalled will not be capable of being perused nor the interior visited. Despite its outward appearance, this will be an empty library, its void echoing the disappearance of the People of the Book. The books of the Jews might have survived, but their legitimate owners and readers are no more.

178

122 Micha Ullman, *Empty Library*, monument commemorating the burning of books by the Nazis on 10 May 1933, Bebelplatz, Berlin, 1995.

Inaccessibility and inversion rites will be used to create a 'negative' (in the photographic sense) of the trappings of contemporary civilization.

The Viennese monument is to be located on the historic, albeit somewhat cramped, Judenplatz, where a synagogue stood until its destruction in a vicious 1421 pogrom and where a statue of the great Lessing (*Nathan the Wise*) provides – with its historic background of persecution, later illusions of acceptance or assimilation and, ultimately, failed philo-Semitism – a marked contrast to Whiteread's non-figural cement cubicle. The weak aspects of her project are the facts that it evidently grew out of a non-Holocaust-related 1993 public sculpture project in London (*House*)[12] and that, architectonically speaking, it will encapsulate itself forbiddingly against its surroundings. Its undisputed semantic advantages do not necessarily translate into aesthetic ones. Whiteread's project also implies a demonstrative rejection of Alfred Hrdlicka's supremely figurative *Monument against War and Fascism* on Vienna's Albertinaplatz (1988–91).[13] The latter monument has masterly parts, but is marred by a chaotic overall composition. It is thus not surprising that by mid-1997 it was the choleric Hrdlicka who found himself at the head of the growing ranks of Whiteread's Viennese critics.

In both the Berlin and the Vienna projects, one can discern strong connections with the new genre of installations as practised by Christian Boltanski or Ilya Kabakov. Boltanski's

179

Missing House installation in Berlin (1990) also evoked the idea of a negative form: on adjacent fire walls of a house destroyed in 1945, the artist placed signposts listing the names and professions (both Jewish and non-Jewish) of its former inhabitants.[14] The gaping hole of the non-existent house illuminated at night by reflectors contrasted with the texture of memory reduced to a mere list of names. Kabakov's works share with Boltanski's the desire to create small, closed universes – that is, installations with minuscule visual openings to the outside world, at least in the sense that their small windows or slits cannot be used for reciprocal visual communication.

If one were inclined to claim a certain Surrealist parentage or affiliation for the Apollinaire and Ulrichs projects, and an installation background for those of Ullman and Whiteread, then the work of the West German Jochen Gerz looks to be an extension of the Land and Conceptual Art of the 1970s. Then and later on, Gerz participated in a series of actions meant to commemorate Germany's unsavoury past. Two of his works gained international renown: the *Harburg Column against Fascism and Racial Hatred*, erected by him and his wife Esther in 1986 in Hamburg-Harburg, and the memorial at Saarbrücken Schloßplatz, laid out in 1990–93 by Gerz and a group of young art students.

The *differentia specifica* of Gerz's endeavour lay in a peculiar conception of the artistic metaphor. The linkage with idiomatic rites led the viewer to re-enact the 'encompassing' metaphor while exploring the artistic structure of the object. In the Saarbrücken monument,[15] Gerz took as his point of departure a documentational initiative concerning former Jewish life in Germany. He collected, with the help of Jewish German councils, the names of all Jewish cemeteries – both existing and destroyed – until he reached the number 2,146. Then, he and his aides removed an equal number of cobbles from the pavement of the castle forecourt in Saarbrücken, carved the name of one of the cemeteries (illus. 123) and a date on each stone (the day that information had been received by him) and reinserted it with the inscription facing downwards (illus. 124). Thus, a part of the pavement of the Schloßplatz was reset as a symbolic, invisible assemblage of Jewish cemeteries. Visitors to the forecourt may or may not realize that they are walking on symbols of destroyed cemeteries. They

123 A cobblestone with the name of a former Jewish cemetery in Germany and the date it was received by artist Jochen Gerz inscribed on it. The cobblestone, with 2,145 others, was used to pave a lane in the forecourt of Saarbrücken castle.

124 Jochen Gerz and Projektgruppe Mahnmal, HBK Saar, *2,146 Stones – Memorial Against Racism*, forecourt of Saarbrücken castle, 1990–93.

may experience a certain uneasiness and may wish to avoid direct physical contact. This is impossible, however, as some of the stones beneath their feet have no inscription at all. There is no way to know the difference, no way to avoid contact.

Gerz has described invisibility both as an intellectual challenge and as a kind of pragmatic protective measure against eventual neofascist defacement. He and his collaborators seem to have been divided as to the necessity of installing explanatory plaques in the area; the artist himself preferred booklets, interviews or other forms of communication. Both the Christian Democratic opposition in the regional parliament and some Jewish groups objected to the

memorial because of its paradoxical nature and its unprece-
dented refusal to be seen. For some Jewish intellectuals, the
acceptance of this particular form implied compliance in a
symbolic effort to 'bury the past'.[16]

The invisible Jewish memorial at Saarbrücken combines a
bewildering range of intellectual premises. If one keeps in mind
the traditional double meaning of the German word *Denkmal*,
it certainly constitutes one of the most thought-provoking
monuments of its kind. We have already encountered one of
its symbolic premises, inversion towards the earth, in earlier
examples. Invisibility as such seems a veiled reference to the
Jewish prohibition of images. Although each stone stands for
one whole cemetery, the assemblage might be seen to reflect
the Jewish practice of throwing small stones onto graves.
But the cemetery context is difficult in a psychological sense,
since we have to march, willy-nilly, over the necropolis
symbols. Thus, we might succumb to the literal meaning
of the metaphorical phrase '. . . der Boden sollte unter den

125 Jochen and
Esther Gerz,
*Harburg Column
Against Racial
Hatred and Injustice*,
Hamburg-Harburg,
1986–93, after the
second lowering
in 1988.

Füssen brennen.' No doubt a kind of catharsis is envisaged as the next step.

A separate element is introduced by the symbolism of the place. The cobbles constitute a part of the pedestrian thoroughfare leading to the main entrance of Saarbrücken's Baroque castle. During the Nazi period, the building housed the local Gestapo headquarters; in the forecourt, thousands of Saarbrücken Jews were assembled to be herded onto trains going to the extermination camps in the East. That the building is now occupied by the democratic government of the region does not alleviate the burden of past crimes. Nonetheless, Gerz tried to stress the universality of his message and disclaim a specifically local memorial context by saying that his primary aim was to 'adequately express absence'.

Last but not least, it seems worth recalling that Gerz and his aides started their action of inscribing cobblestones on government property in 1990 without any official permission – an action which, in contemporary Germany, constitutes a transgression of the building code. Though duly legalized later, their activities thus bore the imprint of another artistic phenomenon of the 1960s, the Happening.

Gerz's 1986 *Harburg Column against Fascism and Racial Hatred* also contained Happening-related aspects. At the famous Documenta 6 at Kassel (1977), Walter de Maria had displayed *Earth Kilometre* as a token of the potential of conceptualized Land Art. Starting from a small, coin-like brass plug, the viewer was invited to imagine a long steel rod which pushed into the earth's crust for the distance of one km. No doubt this peculiar idea (presented on a smaller scale during the Munich Olympics of 1972) provided the decisive stimulus for Gerz's Harburg memorial (illus. 125).[17]

Gerz's square, lead-covered column ten m high was erected in front of the local City Council building. For Gerz, the lead covering offered the chance to display the ambivalent relationship between the German past and present. Conditioned by weather and the presence or absence of sunlight, the lead coverings presented either a semi-bright metal reflection of present-day society or the dull opacity of Nazi horrors. But more important than this duality was their role as reflectors of social viewpoints. Members of the public were expressly invited to state their attitudes towards the column by making inscriptions in the lead. The coverings were not, however,

conceived as tables of pious wishes and decent sentiments. Gerz planned for and accepted the fact that right-wing or pro-Nazi smears would appear; in fact, he felt that they would be necessary to represent all points of view. Each inscriptional act activated a special, though hardly discernible, sinking mechanism, and so, on 10 November 1993, after seven years, the column was completely buried in the ground.

On the place where it once stood is a plate which proclaims *Nothing can in the long run replace our own protest against injustice*. In Harburg, Gerz demonstrated that the monument as a vehicle for articulating social values might be expendable after all. A small window offers a side view of the sunken column. The mausoleum effect is aesthetically appealing and in some way continues the series of subterranean monuments analyzed in the preceding pages. It is not very pertinent to the monument's intrinsic message, however.

Gerz on the whole prefers immaterial messages to material ones. Traditional political monuments, but also the public sculpture of the 1970s and 1980s, failed as far as he was concerned to elicit a larger communal debate. One does not, however, have to possess prophetic faculties to foretell the pitfalls of Conceptual Art in this particular domain. Even if endowed at the outset with rigorous intellectual premises, it is always in danger of succumbing to democratic conformity and banality.

Gerz's endearing belief in democratic, electoral and participatory elements (we should recall here Lenin and Lunacharsky's initial readiness to submit political monuments to the judgement of the masses) is in a certain way tinged also by the Happenings of the 1960s and by Beuys's activities after 1980, though his actions avoid crass visual effects. They will have to face the test of time solely on the basis of the pertinence of their symbolism.

BLACK FORMS AND THE HOLOCAUST

Sol LeWitt's *Black Form Dedicated to the Missing Jews* is in many ways emblematic of 1980s thinking about the Holocaust. Though not intended in the classical functionalist sense as a monument, the work's underlying raison d'être devolved from the public sphere. Designed for a sculpture exhibition in Münster (1987; illus. 126),[18] it was placed in the middle of an

elaborate Baroque palace courtyard. Thus, the black cube was positioned in a place traditionally reserved for equestrian monuments and where an equestrian figure of Wilhelm I had stood before the Second World War. This situation bestowed on the cube the aura, if not the function, of a pedestal – with no figure to support. The cube demonstrated its uselessness through both its form and its colouring; as a sombre parody of a socle, it stood in stark contrast to the courtyard's festive Baroque atmosphere. The sheer incongruity of the cubic shape evoked the break in civilization caused by the Nazi genocide, the black colour constituting an obvious symbol of mass death, of the disappearance of the figure into nothingness. Annihilation was thus equated with cultural disjunction, the cube acquiring the trappings of anti-matter. Though hailed as the ultimate conceptualization of the black abyss of the Holocaust, LeWitt's sculpture did not present a novel idea. Tony Smith, one of the pioneers of Minimal Art, had already created a black cube and endowed it with the title *Die* (1962).

126 Sol LeWitt, *Black Form Dedicated to the Missing Jews*, in the forecourt of Münster castle, 1987 (after 1989 in Hamburg-Altona).

Smith's work was, however, conceived as a sculpture for an interior, an undefined exhibition interior which could not provide the sort of dysfunctional friction which appeared – thanks to the Baroque environment – in Münster. In both works, black was celebrated not only as the colour of mourning (not all cultures follow that particular code, of course), but mainly as an evocation of the non-representational nature of darkness and annihilation. The black pedestal had a stark sacred aura of its own with distant echoes of Kaaba-like structures.

In 1989, LeWitt's cube was re-sited in less congenial surroundings, as a monument to the extinguished Jewish community of Hamburg-Altona.

MIRROR-LIKE REFLECTIONS

Public monuments are meant to commemorate historic events or personalities. As such, they tend to stand in contrast to society's changing views and tenets. By becoming a part of history, they allow us to measure time passing and to comprehend our personal evolution and that of society. As time goes by, the appellative 'tua res agitur' expressed by the monument weakens progressively, and its reflexive function amplifies itself.

The mirror is one of the oldest instruments of psychological cognition. By looking in a mirror, we attempt to find out something about ourselves. We might also use one – as actors sometimes do – to set ourselves before a significant back-

127 Klaus Schwabe, Model of a Thälmann monument destined for East Berlin, 1979/80.

ground. By installing a great mirror on the wall opposite his *Sabines*, David enabled visitors to his Paris studio (1799) to juxtapose or blend their poses with those of his Antique heroes. This procedure also served as a source of psychological knowledge or introspection.

In 1979, the East German sculptor Klaus Schwabe proposed a memorial to Ernst Thälmann, the German Communist leader murdered in 1944 at Buchenwald by the Nazis. It was conceived as a symbol of the revolutionary struggle in a general sense (illus. 127).[19] The lengthy plan presented its thematic structure in a complex way, requiring the viewer to walk along it. On the right side, a sculpture showed a group of victims of anti-revolutionary repression. The path then led to a group of concave mirrors inserted into a connecting wall. They confronted beholders with their own likenesses, thus questioning them about their roles in a society striving for a better future. On the right, there followed an allegory of ascending figures, no doubt moving towards a better tomorrow.

Critiques of the project concentrated from the outset on the fact that Schwabe's Thälmann monument did not include a figure of its nominal hero. After some hesitation, Schwabe inserted a figure in such a way that it would be reflected in the mirrors at the middle of the monument and thus be interposed with the reflected image of the viewer. Thus, the original idea was to some extent preserved. In 1980, Schwabe's project was judged to be too avant-garde; the Thälmann monument erected in 1983 in East Berlin was a clumsy exercise in traditional pathos. However, his idea of mirrors seems to have borne fruit. In the aforementioned 1986 Marx-Engels monument in East Berlin, the polished metallic stelae which surround the sculpture at some distance, while displaying small propaganda photos engraved in the metal, also permit a hazy reflection of the viewer's likeness. Also in 1986, as we have seen, Jochen Gerz referred to a mirroring function in his Harburg monument. The vanishing of his column into the ground could be thought of as a simile for its mirror-like, transitory nature.

We analyzed Micha Ullman's Berlin monument in the section devoted to the idea of negative space. But his *Library* should also be seen as an example of the use of reflection in monuments. In sunshine, the glass plate reflects our likenesses,

128 Maya Ying Lin, *Vietnam Veterans Memorial*, The Mall, Washington, DC, 1982.

and this reflection superimposes itself on the hazy image of the room below with its empty shelves. Ullman thus chose to explore a symbolic procedure akin to that of the Harburg monument. When the light is turned on inside the chamber during the night, it reveals much more clearly than the hazy-glassy daytime view the details of the subterranean chamber. Seen from a distance in the dark square, the illuminated plate exudes an eerie, disquieting gloom which contrasts markedly with the rugged pavement and sombre night.

In a structural sense, we can find a similar overlaying and reflecting effect in Maya Ying Lin's famous *Vietnam Veterans Memorial* in Washington, DC (1982; illus. 128).[20] In the 1980s, this monument was the subject of heated politico-aesthetic controversies; here we will concentrate on one aspect of those. The work consists of an identical pair of black granite walls inserted into the lawn of the Washington Mall and meeting at a right angle so that they point, through an act of intentional topographical symbolism, to the Lincoln Memorial and Washington Monument nearby. A complete, chronologically organized list of America's 58,000 Vietnam casualties is chiselled into the marble surfaces, though the word 'Vietnam' – in keeping with the Minimalist nature of the project – is nowhere to be found.

By walking along the monument, we see our likenesses reflected in the polished black marble with the names of the

129 Wolfgang Göchel, Joachim von Rosenberg and Hans-Norbert Burkert, *Deportation Memorial* (*'Mirrorwall'*), Hermann-Ehlers-Platz, Berlin-Steglitz, 1995.

dead superimposing themselves on our faces and bodies. It is a simple yet powerful symbol, bringing together our own existence with the open questions about the war in Vietnam and the scandal of other people's deaths. The height of the black walls rises to correspond with the increasing number of deaths in the late 1960s – and our reflections seem more minuscule in contrast. The height drops again to correspond with the war's last years. This all happens in direct visual juxtaposition with the viewer and poses questions about his or her own future. The reflection is distinct but not clear, for, after all, nothing in life is clear. The monument refuses to transmit an overt message, leaving us with the dead, our doubts and our fears.

Besides the Vietnam memorial, other mirroring monuments which aim to involve the viewer (to mention just one, the gripping *Deportation Memorial* in Berlin-Steglitz [1995; illus. 129], where a mirror wall with the names, the history and some photographs of the departed repeat the Washington effect) eschew definite answers. As if contradicting the famous adage of St Paul, they do not suggest that one day we will discover in a clear mirror, 'faciem ad faciem', the answers to our questions.

8 Public Monuments in the Third World

With the Western world becoming wary of political public monuments and the Communist bloc ceasing to exist, the main centre of gravity seems to have shifted to the Third World. Countries mostly ruled by non-democratic governments, if not by outright dictators, have to grapple with the problems of fusing their national traditions and myths with the dominant model of Western-style art. In the way they perceive monuments, the three countries chosen here as case studies present three distinctly separate positions. One country, Mexico, has drawn mainly on national traditions. The second, North Korea, took over the Soviet model, but enriched it with East Asian monarchical and cultic hyperboles. The third, Iraq, pursued in the 1980s an ambitious programme of Westernization in which Pop Art elements and Arab kitsch were fused in an impressive, if somewhat aberrant, way.

MEXICO'S GREAT HEADS

In the past 50 years, Mexico has created a fascinating, albeit exotic, monument culture of its own, one which reflects its mixture of Spanish, North American and indigenous civilizations as well as the dualistic nature of its political system, which combines democratic and oligarchic elements.[1]

When the government of Porfirio Diaz erected a group of patriotic monuments in the last two decades of the nineteenth century, it turned to Paris for inspiration (monuments on the Paseo de Reforma). The Independence column inaugurated in 1910 in Mexico City presents a less than adroit combination of the Berlin *Siegessäule*, the statues of the Place de la Concorde and the Parisian July column. The overall impression is of a profuse decorativeness in the vein of the 1893 International Exhibition in Chicago.

The Mexican Revolution began in the very year of the Independence column's unveiling. There were moments when the Revolution claimed and generated a pathos-ridden élan in

the Soviet mould. Today, when both experiments have run their course, the ultimate failings of Soviet propaganda and monumental art tend to stand in high relief in contrast with the much more 'folksy' and successful Mexican practice. The premises for the development of a revolutionary monumental art were quite different in the two countries. Mexico had no indigenous classicizing tradition, nor did it have an artistic avant-garde which could be compared to the Soviet one. Although no notable avant-garde movement appeared before the 1970s (Rivera, Siqueiros and Orozco did not qualify as avant-garde), the ruling élite eschewed its opposite – a southern classicism of the Mussolini type. Perennial Spanish Baroque impulses contributed to a propensity for combining different strands such as Aztec and Toltec forms.

Mexican public monuments often have a convivial appearance with an exuberant, if not outright vulgar, touch. They are moving without having to be viewed from an awe-inspiring distance: eminently approachable, they adorn not only the official, well-maintained central city districts but also the more run-down areas of the sprawling conurbations. This peculiar positioning and broad stylistic mixture seems to reflect the temperament of the country. The countless monuments devoted to the national hero Benito Juarez[2] show a marked repetitiveness of costume and attributes. Yet, they also display a sort of impromptu friendliness totally absent from the myriads of standardized Lenin statues.

130 Anonymous sculptor, Head of Benito Juarez, Mexicali, Baja California, c. 1970.

The dominant legacy of pre-Columbian Toltec art inspired the emergence of a very peculiar type of monument: massive portrait heads placed on small socles or (seemingly directly) atop low hills or mounds. These projects take advantage of the contrast between the pugnacious massiveness of the heads and the diminutiveness or absence of the base. Similarities with rock-hewn monuments such as Mussolini's famous 1937 Ethiopian head[3] are of a superficial nature, the Mexicans disclaiming any awe-inspiring detachment. The contrast between the heads' facial traits, with their seemingly natural-istic handling and the brutal disjunction in the region of the neck, intensifies their emotional appeal and inspires a strange feeling of omnipresence, perhaps a bit disquieting but not really threatening. These heads dot the landscape (illus. 130) and are often known by affectionate nicknames like 'El enterrado'. Hubertus von Pilgrim's *Konrad Adenauer* (1981; illus. 131), located in front of the former's office in the Palais Schaumburg in Bonn, owes much to this Mexican type, though the details are more expressionistic.

131 Hubertus von Pilgrim, Head of Konrad Adenauer, Palais Schaumburg, Bonn, 1981.

By attempting to make statues of so improbable a theme as
the *Monument to the Free Textbook*, the Mexicans tried to visual-
ize that element of leftist educational ideology that even the
Communist regimes had wisely refrained from depicting. The
monument located in Tijuana in Baja California[4] makes up for
the incongruity of its theme by a convincing combination of
Enlightenment pathos with unabashedly kitschy symbolism.
Such a linkage of seemingly incoherent modes constitutes the
Mexicans' obvious forte. Facing the entrapments of kitsch
with bravado, they use to good effect changes of scale which
offset popular aesthetics somewhat, but they also employ the
more refined procedure of isolating figures from their con-
texts. Thus, a heroic young soldier fallen in a fight with the
Americans is presented to us with all the naturalistic panache
of French fin-de-siècle monuments (illus. 132). But while in
France, mourning or allegorical figures would accompany the
dead, in Mexico the figure is placed directly in front of us,
shattering our visual stereotypes by the arched expressive-
ness of his body. The scandal of an all-too-youthful heroic
demise is presented with all the trappings of the Spanish
culture of death.

Mexico can hardly be called a model democracy, but the
semi-autocratic traits of its ruling élite have not impeded the
development of a truly populist art which reflects the Baroque
temper of the country and which knows how to cater for the

Grand and the Monumental. This domain of Mexican art has nonetheless remained – in marked contrast to the famous mural paintings – virtually unknown outside the country.

NORTH KOREAN STATUES AND THEIR APPEAL TO MEN AND BIRDS ALIKE

In examining the situations in North Korea and Iraq, we enter a zone of acute calamity. The mere mention of Kim-Il-Sung or his son and of Saddam Husain is bound to provoke questions. The conjunction of an extreme personality cult with the catastrophes which have occurred in both countries seems to preclude a non-moralizing treatment of the subject. In the case of Korea, aesthetic and moral repugnance are joined somewhat automatically.

The originality and specific achievements of the Kim-Il-Sung cult are grounded less in its sculptural products than in literature and ritual. Statues of him, including the well-known colossal Pjongjang monument, testify to a continuous influence of two or even three epochs of Soviet monumental sculpture. The specific smooth bronze modelling repeats Soviet techniques of the 1950s and, after a more rustic intermezzo in the 1960s, of the Brezhnevite 1970s. Kim's gigantic *ad-locutio* gesture repeats Lenin's favourite pose. Behind the figure, a relief of Korea's sacred mountain creates an analogy with its shape. Other details of the complex show a knowledge of Stalinist architecture in Moscow. But Kim's statues try to surpass the Soviet models by their colossal dimensions. It is obvious that he decided to pick up at the very spot where Stalin – absorbed by purges and war – temporarily left off. The famous *Dshuche* tower in Pjongjang combines archetypal light-tower symbolism with reminiscences of Soviet ideas from the 1920s (Tatlin) and 1930s (Palace of Soviets and the symbolism of the red star). Its electronically simulated jet of flame in the night is meant to signal the world-wide luminosity of Kim's idea of *Dshuche*, or self-reliance.

The literary and ceremonial underpinnings of the Kim cult spring from an indigenous tradition of metaphorical court flattery whose flowery hyperbole makes the Stalin cult seem pallid. When Kim finally died on 8 July 1994, mourning was, according to the official news agency, truly universal. Thus,

nobody in Korea was astounded by the fact that a statue of Kim in Sunyon County was repeatedly circled by wild geese honking with grief. On the first anniversary of the death, the Korean News Agency reported even more wondrous occurrences:[5] on several occasions and in different places, bees and birds respectfully circled the great leader's statues, thus expressing the nation's prayers for his immortality. These creatures also paid homage to the portraits of Kim's son and successor, Kim-Jong-Il. Statues appeared in the skies above three towns, thus fulfilling a 'revolutionary legend' that the deceased leader would guide the destiny of his nation from above. No other state cult in our times has invoked the motif of 'wondrous statues'. The tale about statues of Kim being reflected in the sky invokes the Miraculous without wholly accepting the Supernatural, a final fig leaf for an otherwise depraved and irrational piece of Communist ideology in the service of dynastic policies.

IRAQ IN THE 1980S

Saddam Husain's cult lends itself less easily to such condemnation.[6] In the 1980s (our narrative breaks off with the Gulf War), he looked to the West and the West did not consider him an outcast; he had, battling as he then was with the mullahs in Teheran, a useful role to play. This despot with all the traits of a desperado seems to have developed a certain faculty for discerning between artistic modes, at least in the sense of discerning high and low art. His own inclinations, judged by the styles of his palace interiors, follow Arab neo-Rococo taste, but do not translate directly into the official style of state buildings[7] and memorials. Saddam, or his artistic advisors, have learned to differentiate between the style of popular agitation and the prerequisites of Western-style architecture and monuments. He differentiates also between ephemeral cultic forms and structures designed to survive for centuries.

In popular propaganda of the 1980s (mostly connected with his victories in the war with Iran), Saddam espoused visual imagery rooted in a traditional Arab illustrative style fused with American billboard aesthetics. It is in these paintings and in the many gigantic Saddam silhouettes made from non-durable materials that a swaggering, flowery, Saddam cult, second only to Kim's, has been propagated (illus. 133). But

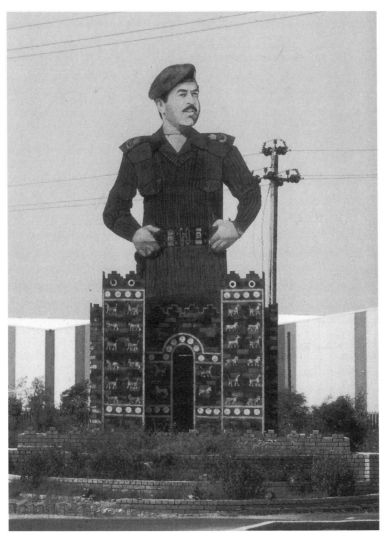

133 A plywood
figure of Saddam
Husain fixed to
the Ishtar Gate,
Baghdad, 1980s.

Saddam somehow avoided the embarrassment of seeing his
own face bronzed for eternity (as regards other parts of his
body he was more lenient). Thus, his figural likenesses are
restricted to billboard-style decorations.

The two political monuments Saddam's regime erected in
1982 and 1983 in Baghdad were excellent large-scale exercises
in modern architecture. *The Martyrs Monument* by Ismail
Fattah (1983) displays a very convincing form: two[8] wonder-
ful onion-profile domes are sliced through with a dramatic
vertical cut (illus. 134). The turquoise-blue ceramic tiles show
a reverence for Islamic artistic tradition, while the metal Iraqi

196

flag in the middle, placed on a translucent base constituting the roof of an underground museum, presents a respectable Pop-Art design. The contrast between the fine profiles of the domes and the fluttering flag is not as incongruous as it might seem. One should say in Saddam's defence that many more decent countries could have done much worse. Khalid-al-Rahal's *Monument to the Unknown Soldier* (1982) is a conservative application of the architectural and sculptural principles of the 1960s. It is a somewhat arid exercise in concrete gridding, but one which does not insult good taste or intelligence.

More problematic are the two monuments erected in celebration of Saddam's purported victory (in reality, the conflict ended in a bloody stalemate) over Iran. The war ended in the autumn of 1988, but planning seems to have begun much earlier. *The Victory Arch* unveiled in Baghdad in August 1989[9] consists of two gigantic forearms 90 m away from one another, holding inclined sabres (illus. 135). The sabres cross in the middle, thus forming a decorative arched structure. The forearms are Saddam's own, duly magnified to gigantic proportions. Five thousand captured Iranian war helmets fall from various cornucopias to the ground, while the raw steel of the giant blades was made from the victorious weapons of Iraqi 'martyrs'. This is an unabashed but symbolically multi-faceted ruler's cult.

When Saddam drafted his first idea for the monument during the war (1985), he must have thought of a kind of

134 Ismail Fattah, *The Martyrs Monument*, Baghdad, 1983.

135 Saddam
Husain, Khalil
al-Rahal and
Mohammad Ghani,
The Victory Arch,
Baghdad, 1989.

symbolic yoke beneath which Iranian captives would pass in humiliation. The important point here – strangely absent from Samir al-Khalil's major analysis – is that this arch is not an isolated monument. Through the stratagem of duplication (three hundred m away at the end of the square is a replica of it), the arch constitutes a kind of symbolic enclosure of a military parade ground. In such a context, its gaudy style (imitating an ephemeral decoration) makes more sense and seems justified on some level.

It is in this monument that art high and low were fused. It seems that by designing the arch (executed by two eminent Iraqi sculptors, Khalil al-Rahal and Mohammad Ghani), Saddam was aiming at a two-pronged symbolic function. For the Iraqis, it was to serve as an equivalent of the Arc de Triomphe, while for the vanquished it would be the yoke under which they would have to pass during a great victory parade. Saddam's design is clearly discernible: 'The worst condition for a person is to pass under a sword which is not his own . . .'[10]

I feel a certain morally perverse sympathy for the last monument erected on Saddam's orders before the Gulf War – namely the 80 life-size bronze statues of Iraqi officers and commanders who died on this small, Verdun-like battlefield (illus. 136), unveiled in the autumn of 1989 on the Basra corniche. Sculpted after family photos, they are placed on low pedestals and point accusingly across the waterway towards the Iranian shore. The figural complex exudes an unabashed aggressiveness enhanced by the theatrical – though by commemorative

198

standards logical – site. This is militarism pure and simple, at the right place and in full view of the enemy, impersonated by an impressive phalanx ready to cross the waterway once more. With refreshing honesty, this memorial hints at future aggression, a perspective only obliquely present in many European war memorials. By virtue of their gestures and their placement, the statues exude Pop-Art vivacity. A further Pop trait is the rough treatment of the bronze surfaces, which gives them an appealing crushed-can texture.

136 Statues of Iraqi officers fallen in the Shatt-al-Arab battles, Corniche, Basra, 1989.

Saddam might be one of the most despicable tyrants in living memory, but he is not a one-dimensional fool. He – or his advisors – have some awareness of the fact that different artistic forms are required for different purposes and places, a circumstance which both Stalin and Hitler would have been loath to acknowledge. Saddam showed better taste and had more money in the 1980s than Ceausescu or Kim-Il-Sung. The Iraqi penchant for Pop-Art vivacity and brashness illustrates a strand in the sculpture of public monuments which could be developed further, circumstances permitting. But not in Iraq itself.

9 Monuments in the 1990s and Beyond

The rise of ideologically neutral public sculpture has significantly eroded the functions of the public monument. In the mid-1990s, its future seems more open and undefined than ever before. No doubt some monuments of the old type will continue to be erected to fill the most obvious gaps in the historical and political Pantheons. This was the case with the statue of Arthur Harris, erected in London as late as 1992 to redress earlier omissions of the chief of Britain's wartime Bomber Command.[1] Strongly championed by veterans' groups, the statue caused some rumblings in Germany, where it was seen as a belated vindication of Harris's policy of saturation bombing. (The veterans' argument was that not honouring Harris would be tantamount to a British admission of guilt – an untoward notion in view of Thatcherite Hun-bashing and British qualms about reunified Germany.) The uproar in both countries was muted, however, and soon petered out, indicating that public monuments in the West have ceased to be a source of lasting political provocation. The same applies to the former socialist countries in Eastern Europe, where only a few monuments devoted to pre- or non-Communist political, military or religious leaders have been erected since 1989. The booming Moscow of Boris Yeltsin is a case apart; there, as if to compensate for the many empty socles, a number of new public monuments have come to public attention, espousing a lurid, baroque figurative style. They are mostly the work of a Georgian sculptural entrepreneur called Sereteli. More noteworthy is Mikhail Shemiakin's metaphorical St Petersburg *Monument to the Victims of State Terror* (1995),[2] in which the classicizing motif of the sphinx, seen often in the decorative sculpture of the city, has been transformed into a semi-baroque allegory of death and mystery. A kind of cathartic effect is achieved by the viewer's sudden realization that the monument does not belong to the seemingly homogenous repertoire of classicizing Petersburg sculpture. Nonetheless, one has to say that recent Western tendencies in the domain of

public monuments and art seem not to have influenced Russia at all.

Figural monuments of the old type now constitute a byway, though their importance in the Third World should not be underrated. The mainstream evolution of public monuments is less easily described. Many proposals or realized projects often opt for a semi-conceptual open form achieved by various means (including mirroring or inscriptions set out in open spaces) to involve spectators and make them accept and act upon specific messages. The many iconoclastic waves having successfully destroyed the myth of monumental eternalization, a work-in-progress or unfinished appearance seems more and more desirable. The confluence of public sculptures with that of public art[3] will become more and more frequent in the future; since the 1980s, the trend has been towards large-scale complexes attempting to organize or co-ordinate the symbolism of entire cities. We are witnessing an important caesura: the traditional involvement with a message and the semantics of the isolated monument is being replaced by a growing regard for its contextualization, both visual and symbolic.[4]

The message of these monuments is becoming more and more diffuse and open to personal interpretation. Thus, it is not surprising that two such different monuments as Brancusi's 1938 *Tirgu Iu War Memorial* (a pioneering work whose symbolism and relevance was comprehended only half a century later) and Maya Ying Lin's *Vietnam Veterans Memorial* share certain traits. Both force viewers to chart their own mental paths against the claims of organized patriotic-style mourning. Both also attempt a symbolic projection into a larger space – Brancusi's spatial disposition 're-enacting' Paris's central axis, Lin's symbolically linking two other key monuments in a triangular reference structure and suggesting, like Brancusi's work, a ritual walk.

The latter idea can be taken further. In a recent submission to the problematic Holocaust Memorial competition in central Berlin, two German artists, Renata Stih and Frieder Schnock, proposed a 'bus-stop Holocaust Memorial' to be located in the centre of Berlin. From this place, red buses specially marked with the inscription *Monument to the Jews murdered in Europe* would transport visitors to the Wannsee villa where the Final Solution was proclaimed and to the concentration camps

nearby. As a logical next step, a combined bus-train ride to Auschwitz – whose time schedule was elaborated by the artists – would follow. In one of the more extreme proposals in the same competition, Katharina Kaiser suggested that the site donated by the government for the memorial should be sold off in a ritual public auction and the proceeds used to establish a network of inscribed tablets all over Berlin which would guide visitors to places of Nazi terror. These forms of 'mobile' or 'decentralized' monuments would have lost any local specificity by projecting their symbolic messages over vast metropolitan and extra-urban expanses.

Of course, such projects also signify that the status of the monument as the expression of a principally static view of a personality or historical phenomenon is being questioned. The indefatigable Jochen Gerz, true to his steady belief in the virtues of participatory action, has engaged since the beginning of the 1990s in the transformation of a stereotypical, provincial First World War monument at Biron in France. After collecting statements from the local inhabitants about their feelings towards the monument as well as their reflections on the significance of the war, he had the most interesting observations inscribed on plaques and fastened them onto the existing obelisk. This procedure is to be continued in years to come, with new inscriptions covering and perhaps even surrounding the monument completely. New participatory elements like these often incorporate documentation of the process of their creation.

When he inserted his inscribed cobbles into the forecourt of Saarbrücken castle, Gerz, as we have seen, provided each one with a cemetery name and the date on which he had received confirmation of its existence. More important dates like those of the establishment or destruction of each cemetery were omitted. Though invisible, the dates and names constitute the only tangible semantic elements of the work. Thus, Gerz's monument documents equally the vanished traces of Jewish life and the laborious process of the *Spurensuche*, a term often used nowadays with regard to the establishment of memorials at sites of Nazi oppression.

We have referred frequently — perhaps too frequently — to monuments erected or projected in Germany. This German bias is justified by that country's contribution to the developments of the 1980s and 1990s. Since the mid-1980s, German

artists and critics have been at the forefront of the debate about public monuments. In a certain sense, this is a consequence of a paradoxical situation. A great nation with more than a hundred thousand patriotic war memorials has finally been forced – after a delay of almost four decades as regards the Federal Republic – to face its horrible past and to discuss, project and erect monuments devoted to the victims of its militaristic or outright genocidal policies.[5] Owing to the German penchant for theoretical speculation, the country has experienced an intense and varied debate about the symbolic forms required for a new generation of public monuments.

The traditional double meaning of the word 'Denkmal' (monument; sign of remembrance) was joined in the 1980s by a bewildering array of related terms and concepts ('Mahnmal', 'Denkzeichen', 'Gedenkmal', etc.), all of which evoke the primacy of intellectual reflection and eschew the traditional triumphalist context inherent in the concept of a monument. As such, these concepts and terms concur with the general evolution of the public monument towards process and polysemy.

The processes described here were started in the mid-1980s by a new generation eager for new forms of national atonement. That generation had to chart its own way through the domain of public art and rituals in a state of ongoing confrontation with Chancellor Kohl's peculiar brand of symbolic politics, as evidenced by his famous Bitburg cemetery pageant undertaken together with Ronald Reagan (1985). Moreover, the German debates about new commemorative forms were conducted against the background of rising nationalist sentiments of the traditional type. In what was by European standards a unique process, a number of ruined Wilhelmine monuments (i.e. Köln, Bonn, Berlin, Koblenz, Bad Kösen) were reconstructed by private right-wing sponsors between 1985 and 1997.[6] This particular sub-trend originated, paradoxically, in the East German decision to re-establish a dislocated equestrian statue of Frederick the Great in Berlin (1980).

Public attention was occupied by a number of serious tasks: the memorializing of the Holocaust and documentation and commemoration of other forms of totalitarian oppression, including the preservation of the last vestiges of the Berlin Wall. The forms used after 1985 were new ones: invisible monuments, negative forms, installation-type monuments and

pseudo-archaeological ones created by a ritualized *Spurensuche*.[7]

Retracing or excavating the foundations or ground plans of destroyed buildings is now seen as a legitimate form of memorial expression; we have mentioned the Börneplatz competition in Frankfurt (1986) and the new memorial of the Jewish barracks at Buchenwald. This tendency seems to be gaining ground; at the end of 1997, plans were formulated to excavate and lay bare (Vienna, Judenplatz) or even partly reconstruct (Regensburg, plans by the Israeli sculptor Dani Karavan) the foundation walls of medieval synagogues destroyed in vicious pogroms centuries ago. In both cases, the remains were meant to serve as memorials to anti-Jewish persecution; in Vienna, they were intended (unsuccessfully) to supersede Rachel Whiteread's unloved memorial project.

We should now refer to the last form in this new repertoire, so-called counter-monuments.[8] Whereas in earlier times, these manifested themselves in isolated confrontations — like the plans to oppose the statue of Dolet with that of Servet in Paris, or the arrangement of the Old Town Market Square in Prague, where from 1915 to 1918 Jan Hus faced a Counter-Reformation Marian statue – now they include attempts to visually complement or change the appearance of earlier monuments. In Hamburg, where a brutally expressive cubic Nazi war memorial had survived the British occupation intact (Richard Kuöhl's *76th Infantry Regiment Memorial* [1936; illus. 137]),[9]

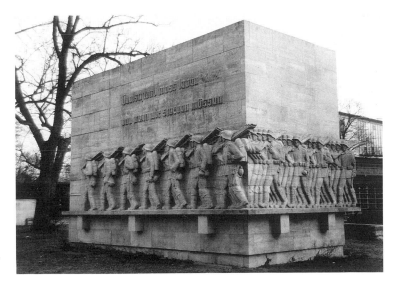

137 Richard Kuöhl, *76th Infantry Regiment Memorial*, Planten un Blomen, Hamburg, 1936.

the authorities decided in 1982 to open a competition for an anti-war memorial to be erected as a direct visual and symbolic addition and complement to the 'Nazi block'. As they put it, '. . . the massive power and violence of the [Nazi] monument . . . should be countered by a monument of mass extermination.'[10] The project which was selected provisionally, designed by Ulrich Böhme and Wulf Schneider, commented on and amplified the image of marching soldiers by showing rows of them sinking progressively 'into' the ground, thus illustrating the consequences of conquering marches and war (illus. 138). Grave slabs replace the soldiers who have completely disappeared; they also cross the public walkway leading into the compound. Visitors to the memorial compound would have walked over symbolic graves. This modern participatory rite (based on a medieval concept) prefigured to a certain extent the solution which Jochen Gerz used later for his Saarbrücken memorial. Rejecting the Böhme-Schneider project as too facile and literal a solution in the end, the Hamburg authorities went for a big name. They turned to Alfred Hrdlicka, who proposed four figural groups which were to show Nazi war crimes and the suffering of the civilian population. The overall design was to assume the shape of a broken swastika (illus. 139). Until now, only two parts – *Firestorm in Hamburg* and *Sinking of the Cap Arcona* – have been executed (illus. 140), and it does not seem that the other two

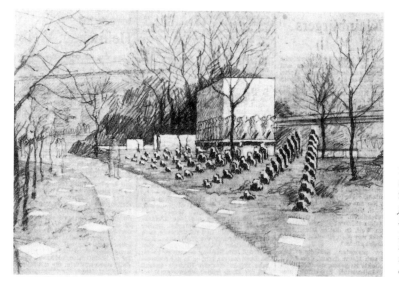

138 Ulrich Böhme and Wulf Schneider, *Project for a Counter-Monument to the 76th Infantry Regiment Memorial in Hamburg*, 1982, drawing.

139 Alfred Hrdlicka, First project for a counter-monument to the *76th Infantry Regiment Memorial* in Hamburg, 1983, drawing. Kunsthalle Hamburg.

parts will follow. Despite interesting details, Hrdlicka's additions are plagued by compositional problems similar to those of his Albertinaplatz monument in Vienna. The sculptural parts do not provide a sufficient counterbalance to primitive but poignant Nazi rhetoric.

If the principal aim of a counter-monument is to register protest or disagreement with an untenable prime object and to set a process of reflection in motion, then Hans Haacke's *Und ihr habt doch gesiegt* in Graz (1988) achieved notable success (illus. 141). Graz, the capital of Styria in Austria, was a hotbed of Nazi agitation in the 1930s. After the Anschluss, local Nazis celebrated in July 1938 with a grand meeting centred on a temporary monument, a high, black wooden pylon bearing the inscription *And you have won after all* (a cliché referring to the 'martyrs' of the abortive 1923 Munich coup). Fifty years later, when Austria had to face its Nazi heritage in the wake of the Waldheim affair, Haacke reconstructed the pylon with its provocative inscription for the Graz Art Festival. A kind of subscript enumerated the different categories of Styrian victims of the 1938 'victory'.[11]

Haacke's temporary installation (thus, the counter-monument belonged to the same category as the reference

object) provoked intense debate in this still very conservative city. Although by then the local establishment were paying lip-service to the idea of atonement, a vociferous opposition, including Austria's largest (and anti-Semitic) journal, the *Neue Kronen Zeitung*, made itself heard. The sequel had cinematic qualities: despite police protection, an arsonist succeeded in setting fire to the pylon one dark November night. On one of the following days, left-wingers and a couple of artists protested with a silent performance before the badly damaged monument. As onlookers gathered, the arsonist was discovered amongst them and arrested on the spot. The subsequent trial uncovered a local neo-Nazi group and ended with tough sentences for the wrongdoer and those who encouraged him. Graz was never the same.

A counter-monument can also be achieved by means of a transformational procedure. Among the more interesting recent objects of this type is Jenny Holzer's *Black Garden* (1988–91) in the German town of Nordhorn.[12] There, a conventional Wilhelmine war memorial has been changed (through the stratagem of surrounding it with black flowers and foliage) into a seasonally variable 'garden of mourning'. Endowing the garden with discreet architectural subdivisions and inscriptions, Holzer linked it with the growing category of memorial sites without prominent central signifiers.

The logical next step was to consign the whole counter-monument to a state of immateriality. Once again, we must

refer to the work of Holzer, who used the grim *Monument to the Battle of Nations* in Leipzig as the background for her 1996 laser projection *Kriegszustand*.[13] By projecting a series of inscriptions onto the sombre tower-block, Holzer paraphrased with ironic finesse the appellative and emphatic language of military proclamations. The Leipzig projection demonstrated vividly the growing role of appellative inscriptions in all kinds of public monuments. Another important aspect it highlighted is the sense of time passing. The end of the twentieth century is marked, in the words of Patricia Phillips, by a shift towards non-enduring public art: '. . . the presence of enduring objects has become as exotic as time itself . . .'[14]

Thus, changes referring to the historical process are being documented in public monuments by developing the thematic or symbolic possibilities inherent in the traditional iconographic repertoire. The urge to find successive rectifying

141 Hans Haacke, *Und ihr habt doch gesiegt*, installation, Marienplatz, Graz, 1988.

additions may of course assume the air of political correctness. After Vietnam veterans had succeeded in complementing Maya Ying Lin's Minimalist Washington memorial with natural-istic figures of three fighting men of different races, they were in turn confronted with the demands of feminist organizations to add a figure of a military nurse. The process thus commenced could be prolonged ad absurdum. Behind all these attempts stands a kind of determination to liberate the public monu-ment, if necessary by means of community participation, from that sort of indifference and unobtrusiveness which Robert Musil dealt with in his essay about 'invisible monu-ments'. In the light of this fundamental urge, even the extreme form of a truly 'invisible' monument forces the viewer to concentrate – in these visually overstimulated times – on its essential message. This message, however, no longer attempts to praise traditional political or cultural achievements. Con-veying the impact of catastrophes like the Holocaust or mounting environmental dangers and of alienation and cultural disjunction, it is a truthful expression of the demise of universally accepted figurative imagery and of our disturbed state of mind on the threshold to the third millennium.

On the whole, public sculpture has – despite its many facets – closely mirrored the aesthetic and functional needs of wide circles of contemporary society. If the public monument is to retain a place in the repertoire of new signs and symbols, it must recall old dangers and thus prefigure future ones. On this thought-provoking path, it will not be accompanied by the masses but by Stendhal's 'happy few'. Losing its status as a focus of national and social rites, it will become integrated into the mainstream of intellectual debate and controversy.

.

References

1 DEMOCRATIC 'STATUOMANIA' IN PARIS

1 The most important account is J. Hargrove, *The Statues of Paris: An Open-Air Pantheon* (New York and Paris, 1990). See also P. Marmottan, *Les Statues de Paris* (Paris, 1886); G. Pessard, *La Statuomanie parisienne: Etude critique sur l'abus des statues, liste des statues et monuments existants* (Paris, 1912); J. Adhémar, 'Les Statues parisiennes de grands hommes', *Gazette des Beaux-Arts*, LXXXIII (1974), pp. 150–56; Lin Young Bang, 'Les Statues commemoratives de Paris de 1870 à 1940' (PhD dissertation, Paris, 1970); M. Agulhon, 'Imagerie civique et décor urbain dans la France du XIXe siècle', *Ethnologie française*, V (1975), pp. 33–56; M. Agulhon, 'La statuomanie et l'histoire', *Ethnologie française*, VIII (1978), pp. 143–73; J. Lanfranchi, 'Statues de Paris, 1800–1940: Les Statues de grands hommes élevées à Paris des lendemains de la Révolution à 1940' (PhD dissertation, Paris, 1979); Anne Pingeot, ed., *La Sculpture française au XIXe siècle*, exhibition catalogue (Paris, 1986); S. Michalski, 'Die Pariser Denkmäler der III. Republik und die Surrealisten', *Idea*, VII (1988), pp. 91–107; Pierre Kjellberg, *Le Nouveau Guide des statues de Paris* (Paris, 1988); T. Burollet, ed., *Quand Paris dansait avec Marianne 1879–1889*, exhibition catalogue (Paris, 1989); Georges Poisson, *Guide des statues de Paris* (Paris, 1990).
2 R. Walter, 'Un Dossier delicat: Courbet et la colonne Vendôme', *Gazette des Beaux-Arts*, LXXXI (1973), pp. 173–84.
3 P. Angrand, 'Une – ou deux – Jeanne d'Arc sur la place des Pyramides', *Gazette des Beaux-Arts*, LXXVII (1971), pp. 341–52; A. Boime, *Hollow Icons: The Politics of Sculpture in Nineteenth-Century France* (Kent and London, 1987), pp. 88–95.
4 See G. Krumeich, *Jeanne d'Arc in der Geschichte. Historiographie – Politik – Kultur* (Sigmaringen, 1989), p. 179ff.
5 N. Ziff, 'Jeanne d'Arc and French Restoration Art', *Gazette des Beaux-Arts*, LXXXIII (1979), p. 37ff.
6 Hargrove, *Open-Air*, p. 191.
7 M. Agulhon, *Marianne into Battle: Republican Imagery and Symbolism in France, 1789–1880* (Cambridge, 1981), p. 168ff.
8 See D. Imbert, 'Le Monument des fréres Morice, place de la République', in Burollet, *Quand Paris*, pp. 32–48.
9 M. Dreyfous, *Dalou: Sa vie et son oeuvre* (Paris, 1902), pp. 95–140; J. M. Hunisak, *The Sculptor Jules Dalou: Studies in His Style and Imagery* (London and New York, 1977), pp. 216–30; *idem.*, 'Dalou's "Triumph of the Republic": A Study of Private and Public Meanings', in H. W. Janson, ed., *La Scultura nel XIX secolo*, Atti del XXIV Congresso Internazionale di Storia dell' Arte, vol. III (Bologna, 1982), pp. 169–75; Ute Hünigen, 'Le Triomphe de la République: Das Republikdenkmal von Jules-Aimé Dalou im Kontext der kunstpolitischen und künstlerischen Strömungen der III. Republik von 1870 bis 1899' (PhD dissertation, Munich, 1985).
10 D. L. Dowd, *Pageant-Master of the Republic: Jacques-Louis David and the French Revolution* (Lincoln, NE, 1948).
11 Hunisak, *Dalou's Triumph*, p. 174.
12 *Ibid.*, p. 174.
13 *Ibid.*, p. 173.

14 About this particular problem in sculpture, see F. H. Dowley, 'D'Angiviller's Grands Hommes and the Significant Moment', *Art Bulletin*, XXXIX (1957), pp. 259–77.

15 The statue, by Eugène Boverie (1901), showed the radical deputy Alphonse Baudin awaiting with the words, 'You will see how one dies for 25 francs a day' (a reference to his meagre salary as deputy) the salvo of Bonapartist troops storming his barricade in 1852.

16 A comparison of the monuments erected in Paris with the educational Pantheon of the Third Republic (see C. Amalvi, *Les Héros de l'histoire de France, recherche iconographique sur le Panthéon scolaire de la Troisième République* [Paris, 1979]) shows close correspondences. On official Republican imagery and the sponsorship of art, see M. R. Levine, *Republican Art and Ideology in Late Nineteenth Century France* (Ann Arbor, MI, 1986); M. Agulhon, *Marianne au pouvoir: L'Imagerie et la symbolique républicaines de 1880 à 1914* (Paris, 1989).

17 In a recorded conversation in 1883; see Hargrove, *Open-Air*, p. 111.

18 Thus, many provincial towns received serially manufactured figures of the Republic; see M. Agulhon, 'Les Statues du centenaire', *Gazette des Beaux-Arts*, CII (1988), pp. 131–6.

19 See Chapter 2, n. 17.

20 Franck Folliot, 'Des colonnes pour les héros', in *Les Architectes de la liberté: 1789–1799*, exhibition catalogue (Paris, 1989), pp. 305–20.

21 E. Hénard, *Etudes sur les transformations de Paris* (Paris, 1982) (articles from the years 1903–9), pp. 321–27.

22 G. Groud, 'Le Monument à Danton', in Burollet, *Quand Paris*, pp. 160–70.

23 Burollet, *Quand Paris*, p. 131.

24 J. Lalouette, 'Du bûcher au piédestal: Etienne Dolet, symbole de la libre pensée', *Romantisme*, LXIV (1989), pp. 85–100.

25 G. Groud, 'Le Monument à Etienne Dolet', in Burollet, *Quand Paris*, pp. 140–50.

26 The political controversy surrounding the Servet monument has been excellently studied by N. McWilliam; see 'Monuments, Martyrdom and the Politics of Religion in the French Third Republic', *Art Bulletin*, LXXVII (June 1995), pp. 186–206.

27 André Breton's *Nadja* (1928) included both a reference to the Dolet monument and a photo of it. The statue played an important role in the private Paris mythology of the young Henry Miller; see Brassaï, *Henry Miller in Paris* (Frankfurt am Main, 1981), p. 93.

28 A morphological analysis of this interesting development is still lacking; see, however, Hargrove, *Open-Air*, pp. 223–6; C. Chevillot, 'Urbanisme: Le Socle' in *La Sculpture française au XIXe siècle*, exhibition catalogue (Paris, 1986), pp. 241–53.

29 Michael Fried, *Absorption and Theatricality: Painting and Beholder in the Age of Diderot* (Chicago and London, 1988).

30 The best account of this conflict is C. Judrin, M. Laurent and D. Viéville, *Auguste Renoir: Le Monument des Bourgeois de Calais (1884–1895)*, exhibition catalogue (Calais, 1977), pp. 99–103.

31 See Adhémar, *Les Statues*, p. 151.

32 Pessard, *La Statuomanie*, pp. 13–14.

33 Quoted after P. Boussel, 'Statues', in *Dictionnaire de Paris* (Paris, 1964), p. 535.

34 *Ibid.*

35 R. Musil, 'Die Denkmale', in *Gesammelte Werke, ii: Prosa und Stücke, Kleine Prosa, Aphorismen, Autobiographisches, Essays und Reden, Kritik* (Reinbek, 1978), p. 506.

36 *Ibid.*, p. 509.

37 Quoted after *La Peinture sous le signe d'Apollinaire*, exhibition catalogue (Brussels, 1950), p. 31.

38 The best studies are M. C. Bancquart, *Paris des Surréalistes* (Paris, 1972);
 P. Gallisaires, *Das Paris der Surrealisten* (Hamburg, 1986).
39 See Michalski, 'Die Pariser Denkmäler', pp. 93–7; Bancquart, *Paris des
 Surréalistes*, pp. 84–5; Gallisaires, *Das Paris*, pp. 46–50; N. Chabert, ed.,
 *Monument & Modernité à Paris: Art, espace public et enjeux de mémoire
 1891/1996*, exhibition catalogue (Paris, 1996), pp. 68–71 (text by
 T. Dufrêne).
40 L. Aragon, *Le Paysan de Paris* (1926); translated after Aragon, *Oeuvres
 poétiques*, vol. III (Paris, 1974), p. 269.
41 A. Breton, *Nadja* (Paris, 1975), pp. 23–4; P. Soupault, *Les dernières nuits de
 Paris* (Paris, 1975), p. 175. Half a century later, Roland Dubillaud wrote an
 interesting novel taking up Surrealist motifs of 'living statues', *Méditations
 sur la difficulté d'être en bronze* (Paris, 1972).
42 Aragon, *Le Paysan*, p. 268.
43 P. Reverdy, 'L'Image', *Nord-Sud*, XIII (March 1918), p. 6.
44 R. Desnos, 'Pygmalion et le sphinx' (1928), in R. Desnos, *Nouvelles Hébrides
 et autres textes 1922–1930* (Paris, 1978), p. 466.
45 Hargrove, *Open-Air*, pp. 263–76.
46 For the destruction of the Paris statues, see Y. Bizardel, 'Les Statues
 parisiennes fondues sous l'Occupation (1940–44)', *Gazette des Beaux-Arts*,
 LXXXIII (1974), pp. 129–48; Michalski, 'Die Pariser Denkmäler', pp. 101–5;
 Hargrove, *Open-Air*, pp. 303–8.
47 Demolition scaffolding already surrounded the statues of Morice and
 Dalou when the order was rescinded. In my opinion, a connection might
 exist with Pétain's decision to convoke the National Assembly again in
 October 1943 and thus invest his regime with an air of Republican
 legitimacy. The Germans blocked the political aspects of the plan.
48 P. Dominique, 'Les faux dieux', *Candide*, 19 November 1942; anon., *La
 France Socialiste*, 13 November 1941. A good analysis of the aesthetic views
 of the young, radical Parisian fascists may be found in M. C. Cone, *Artists
 under Vichy: A Case of Prejudice and Persecution* (Princeton, 1992), pp. 20–5.
49 Quoted after Bizardel, 'Les Statues', p. 131.
50 *Les Erreurs monumentales du XIXe siècle à Paris* (Paris, 1936).
51 Jean Cocteau and Pierre Jahan, *La Mort et les statues* (Paris, 1946); 2nd edn
 (1977); see also P. Jahan, 'La Mort et les statues', *Gazette des Beaux-Arts*,
 LXXXIII (1974), pp. 153–6. I am grateful to M. Pierre Jahan for information
 about *La Mort et les statues* (conversation, Paris, September 1989).
52 Cocteau had already used this interesting motif in a 1922 poem, 'Hôtel de
 France': '. . . lachez tout! Gambetta part en ballon captif'; see Cocteau,
 Vocabulaire, Plein-Chant et autres poèmes (1922–46) (Paris, 1983), p. 28.
53 Desnos, 'Pygmalion et le sphinx', p. 468.
54 Roman Jakobson and Morris Halle, *Fundamentals of Language* (The Hague,
 1971), p. 92.

2 BISMARCK AND THE LURE OF TEUTONIC GRANITE

1 The most important article about the *Nationaldenkmal* idea is T. Nipperdey,
 'Nationalidee und Nationaldenkmal in Deutschland im 19. Jh.' (first
 published in 1968), which can be found in J. Schuchard and H. Claussen,
 eds, *Vergänglichkeit und Denkmal: Beiträge zur Sepulkralkultur* (Bonn, 1985),
 pp. 189–232; see also H. Schrade, *Das deutsche Nationaldenkmal: Idee,
 Geschichte, Aufgabe* (Munich, 1934) (somewhat tainted by Nazi ideology);
 G. Germann, *Neogotik* (Stuttgart, 1974), pp. 77–91. For Wilhelmine
 monuments in general, see S. Holsten, *Allegorische Darstellungen des Krieges
 1870–1914: Ikonologische und ideologiekritische Studien* (Munich, 1976);
 L. Tittel, 'Monumentaldenkmäler von 1871–1918 in Deutschland: Ein
 Beitrag zum Thema Denkmal und Landschaft', in E. Mai and S. Waetzold,

eds, *Kunstverwaltung, Bau- und Denkmalspolitik im Kaiserreich* (Berlin, 1981), p. 215ff.; H. Scharf, *Zum Stolze der Nation: Deutsche Denkmäler des 19 Jh.* (Dortmund, 1984); W. Hardtwig, 'Nationsbildung und politische Mentalität: Denkmal und Fest im Kaiserreich', in W. Hardtwig, *Geschichtskultur und Wissenschaft* (Munich, 1990), pp. 264–301; K. Belgum, 'Displaying the Nation: A View of Nineteenth-Century Monuments through a Popular Magazine', *Central European History*, XXVI (1993), pp. 457–77; F. Bauer, *Gehalt und Gestalt in der Monumentalsymbolik: Zur Ikonologie des Nationalstaates in Deutschland und Italien 1860–1914* (Munich, 1993).

2 In the vast literature, see H. E. Mittig, 'Zu Joseph Ernst von Bandels Hermannsdenkmal im Teutoburger Wald', *Lippische Mitteilungen aus Geschichte und Landeskunde*, XXVII (1986), pp. 200–23; G. Engelbert, ed., *Ein Jahrhundert Hermannsdenkmal 1875–1975* (Detmold, 1975); G. Nockemann, *Hermannsdenkmal* (Lemgo, 1975); G. Unverfehrt, 'Arminius als nationale Leitfigur', in Mai and Waetzold, eds, *Kunstverwaltung*, pp. 315–40.

3 L. Tittel, *Das Niederwalddenkmal 1871–1873* (Hildesheim, 1979); A. Laumann-Kleineberg, *Denkmäler des 19. Jh. im Widerstreit: Drei Fallstudien zur Diskussion zwischen Auftraggebern, Planern und öffentlichen Kritikern* (Frankfurt am Main, 1989), pp. 39–141.

4 K. Eschenfelder, ed., *'Ein Bild von Erz und Stein': Kaiser Wilhelm am Deutschen Eck und die Nationaldenkmäler*, exhibition catalogue: Mittelrhein-Museum, Koblenz (Koblenz, 1997); 'Das Denkmal am Deutschen Eck', *Koblenzer Beiträge zur Geschichte und Kultur*, III (1997); Laumann-Kleineberg, pp. 141–216.

5 On the Porta Westfalica and the Kyffhäuser, see G. Engelbert, 'Die Errichtung des Kaiser Wilhelm-Denkmals auf der Porta Westfalica', *Westfalen*, XXXI (1973), pp. 322–45; Laumann-Kleineberg, pp. 220–67; M. Arndt, 'Das Kyffhäuserdenkmal: Ein Beitrag zur politischen Ikonographie des zweiten Kaiserreiches', *Wallraf-Richartz Jahrbuch*, XL (1978), pp. 75–127; M. Stuhr, 'Das Kyffhäuser-Denkmal: Symbol und Gehalt', in K. H. Klingenberg, ed., *Historismus: Aspekte zur Kunst des 19. Jh.* (Berlin, 1986), pp. 157–82; C. Präger, 'Das Werk des Architekten Bruno Schmitz [1858–1916]' (PhD dissertation, Heidelberg, 1990); G. Mai, ed., *Das Kyffhäuser-Denkmal 1896–1996: Ein nationales Denkmal im europäischen Kontext* (Köln and Vienna, 1997).

6 In a vast literature, see P. Hutter, *'Die feinste Barbarei': Das Völkerschlachtdenkmal bei Leipzig* (Mainz, 1990); K. Keller and H. D. Schmid, eds, *Vom Kult zur Kulisse: Das Völkerschlachtdenkmal als Gegenstand der Geschichtskultur* (Leipzig, 1995).

7 R. Parr, *'Zwei Seelen wohnen, ach in meiner Brust!' Strukturen und Funktionen der Mythisierung Bismarcks 1860–1918* (Munich, 1992).

8 Karl Scheffler (1919), quoted after *Bismarck-Preussen, Deutschland und Europa*, exhibition catalogue (Berlin, 1990), p. 458.

9 See M. Stather, *Die Kunstpolitik Wilhelms II* (Konstanz, 1994), pp. 115–26.

10 About the monuments to Bismarck, see M. Ehrhardt, *Bismarck im Denkmal des In- und Auslandes* (Eisenach and Leipzig, 1903); V. Plagemann, 'Bismarck-Denkmäler', in H. E. Mittig and V. Plagemann, *Denkmäler im 19 Jh.* (Munich, 1972), pp. 217–52; H. W. Hedinger, 'Bismarck-Denkmäler und Bismarck-Verehrung', in Mai and Waetzold, eds, *Kunstverwaltung*, pp. 277–52; Scharf, *Zum Stolze der Nation*, pp. 111–29; K. Wilhelm, 'Der Wettbewerb zum Bismarck-Nationaldenkmal in Bingerbrück (1909–1912)', *Kritische Berichte*, XV (1987), pp. 32–47; D. Reinartz and Chr. Graf von Krockow, *Bismarck: Vom Verrat der Denkmäler* (Göttingen, 1991); P. Springer, 'Peter Behrens' Bismarck-Monument: Eine Fallstudie', *Niederdeutsche Beiträge zur Kunstgeschichte*, XXXI (1992), pp. 129–207; F. Reusse, *Das Denkmal an der Grenze seiner Sprachfähigkeit* (Stuttgart, 1995), pp. 100–22;

G. Kloss, *Bismarck-Türme und Bismarck-Säulen in Deutschland* (Petersberg, 1997).

11 See O. Kuntzemüller, *Die Denkmäler Kaiser Wilhelm des Grossen in Abbildungen mit erläuterndem Text* (Bremen, 1902); W. Vomm, *Reiterstandbilder des 19. und frühen 20. Jh. in Deutschland* (Bergisch-Gladbach, 1979), I, pp. 320–97.

12 R. Kütz, 'Die Chronik der Rudelsburg und ihrer Denkmäler', *Einst und Jetzt* (Sonderheft,1993), pp. 47–70.

13 About the German mythologizing of granite, see T. Raff, *Die Sprache der Materialien: Anleitung zu einer Ikonologie der Werkstoffe* (Munich, 1994), pp. 75, 110–26; Springer, 'Peter Behrens', pp. 173–5.

14 J. Langbehn, *Rembrandt als Erzieher* [1890] (Weimar, 1922), p. 277.

15 Springer, 'Peter Behrens', pp. 129–207.

16 Wilhelm, 'Bismarck-Nationaldenkmal', pp. 32–47; E. Mai, 'Vom Bismarckturm zum Ehrenmal: Denkmalformen bei Wilhelm Kreis', in E. Mai and G. Schmirber, eds, *Denkmal – Zeichen – Monument: Skulptur und öffentlicher Raum heute* (Munich, 1989), pp. 50–57.

17 See E. Poiré, *Les Monuments nationaux en Allemagne* (Paris, 1908), esp. pp. 260–65; F. Schmoll, 'Nationale Feindschaft und kulturelle Erinnerung: Zur Rezeption des Völkerschlachtdenkmals in Frankreich', in Keller and Schmid, eds, *Von Kult zur Kulisse*, pp. 105–25. A somewhat restricted socio-political comparison of France and Germany may be found in C. Tacke, *Denkmal im sozialen Raum: Nationale Symbole in Deutschland und Frankreich im 19. Jh.* (Göttingen, 1995).

3 MEMORIALS TO THE GREAT WAR

1 In a vast bibliography, see Karl von Seeger, *Das Denkmal des Weltkrieges* (Stuttgart, 1930); Rose E. B. Coombs, *Before Endeavours Fade: A Guide to the Battlefields of the First World War* (London, 1976); Meinhold Lurz, *Kriegerdenkmäler in Deutschland*, vol. VI (Heidelberg, 1987); Gerhard Armanski, *'und wenn wir sterben müssen': Die politische Ästhetik von Kriegerdenkmälern* (Hamburg, 1988); George L. Mosse, *Fallen Soldiers: Reshaping the Memory of the World War* (New York and London, 1990); Michael Hütt and Hans-Joachim Kunst, eds, *'Unglücklich das Land das Helden nötig hat': Leben und Sterben der Kriegsdenkmäler des ersten und zweiten Weltkrieges* (Marburg, 1990); Philippe Rive and Anette Becker, *Monuments de mémoire: Les Monuments aux morts de la première guerre mondiale* (Paris, 1991); Reinhart Koselleck and Michael Jeismann, eds, *Der politische Totenkult: Kriegerdenkmäler in der Moderne* (Munich, 1994); Rainer Rother, ed., *Die letzten Tage der Menschheit: Bilder des ersten Weltkrieges*, exhibition catalogue: Deutsches Historisches Museum, Berlin (Berlin, 1994); J. M. Winter, *Sites of Memory, Sites of Mourning: The Great War in European Cultural History* (Cambridge, 1995).

2 See the contradictions in the accounts of Volker Ackermann, *'Ceux qui sont pieusement morts pour la France . . .': Die Identität des Unbekannten Soldaten*, in Koselleck and Jeismann, *Der politische Totenkult*, pp. 281–314; Ken S. Inglis, 'Grabmäler für unbekannte Soldaten', in Christoph Stölzl, ed., *Die Neue Wache Unter den Linden: Ein deutsches Denkmal im Wandel der Geschichte* (Berlin, 1993), pp. 151–70.

3 A good account of early right-wing sentiments is Charles Vilain, *Le Soldat inconnu: Histoire et culte* (Paris, 1933).

4 See Inglis, 'Grabmäler'.

5 Alan Greenberg, 'Lutyens's Cenotaph', *Journal of the Society of Architectural Historians*, XLIX (1989), pp. 5–23. An extremely interesting German reaction to the Cenotaph is to be found in Arthur Holitscher, *Der Narrenführer durch Paris und London* [1925] (Frankfurt am Main, 1986), pp. 95–6. For the concept of the cenotaph, see Hermann Sturm, 'Ästhetische Zeichen des

Todes: Kenotaph und Nekropole', *Zeitschrift für Semiotik*, XI (1989), pp. 183–200.

6 See Joseph Schmoll gen. Eisenwerth, *Rodin-Studien* (Munich, 1983), pp. 46–7.

7 A succinct literary account was provided by the famous satirist Kurt Tucholsky as early as 1924: 'Vor Verdun', in Kurt Tucholsky, *Panter, Tiger & Co.* (Reinbek, 1972), p. 90.

8 See also Antoine Prost, 'Verdun', in Pierre Nora, *Les Lieux de mémoire*, vol. III: *La Nation* (Paris, 1986), pp. 111–41, esp. p. 122.

9 Translated (with modifications) after Eckhard Gruber, ' . . . death is built into life: War monuments and War memorials in the Weimar Republic', *Daidalos*, XLIX (15 September 1993), p. 71.

10 Siegfried Kracauer, *Ginster* [1929] (Frankfurt am Main, 1990), p. 109f.

11 Volker G. Probst, *Bilder vom Tode: Studien zum deutschen Kriegerdenkmal am Beispiel des Pietà-Motivs* (Hamburg, 1986).

12 Kurt Junghanns, *Bruno Taut* (Berlin, 1983), p. 55; Mosse, *Fallen Soldiers*, p. 103, describes Taut's project as having been realized – one of many factual errors in this otherwise very inspiring book.

13 Dietrich Schubert, 'Die Wandlung eines expressionistischen Krieger-Denkmals: Bernhard Hoetgers "Niedersachsenstein" 1915–1922', *Wallraf-Richartz Jahrbuch*, XLIV (1983), pp. 285–306.

14 For the Neue Wache, see Stölzl, *Die Neue Wache*; Walter Jens, preface to *Streit um die Neue Wache: Zur Gestaltung einer zentralen Gedenkstätte* (Berlin, 1993); Thomas E. Schmidt, Hans E. Mittig and Vera Böhm, eds, *Nationaler Totenkult: Die Neue Wache: Eine Streitschrift zur zentralen deutschen Gedenkstätte* (Berlin, 1995).

4 THE NAZI MONUMENTS

1 K. Arndt, 'Die NSDAP und ihre Denkmäler oder: Das NS-Regime und seine Denkmäler', in E. Mai and G. Schmirber, eds, *Denkmal – Zeichen – Monument* (Munich, 1989), pp. 69–80; Akademie der Künste, *Skulptur und Macht: Figurative Plastik in Deutschland der 30er und 40er Jahre* (Düsseldorf, 1984); Berthold Hinz, 'Das Denkmal und sein Prinzip', in Georg Bussmann, ed., *Kunst im 3. Reich* (Frankfurt am Main, 1980), pp. 217–50; Dieter Bartetzko, *Illusionen im Stein: Stimmungsarchitektur im deutschen Faschismus: Ihre Vorgeschichte in Theater- und Film-Bauten* (Reinbek, 1985), pp. 71–84. See also Mortimer G. Davidson, *Kunst in Deutschland 1933–1945, Vol. I: Skulptur* (Tübingen, 1988), unrivalled as a collection of photos but tainted by sympathy for the Nazi aesthetic.

2 See Wolf Jobst Siedler, 'Triumph der Vergänglichkeit: Wie es dazu kam, daß die seit je ungeliebte Siegessäule heute für das Unverwechselbare Berlins steht', *Frankfurter Allgemeine Zeitung*, 15 January 1994.

3 The Forum and the *Ehrentempel* are discussed in Alex Scobie, *Hitler's State Architecture: The Impact of Classical Antiquity* (University Park and London, 1990), pp. 51–63; Iris Lauterbach, ed., *Bürokratie und Kult: Das Parteizentrum der NSDAP am Königsplatz in München: Geschichte und Rezeption* (Berlin, 1995).

4 See Scobie, *Hitler's State Architecture*, and Robert R. Taylor, *The Word in Stone: The Role of Architecture in National Socialist Ideology* (Berkeley and Los Angeles, 1974).

5 For the role of *Bauplastik*, see the account of the Nazi critic Werner Rittich, *Architektur und Bauplastik der Gegenwart* (Berlin, 1938), and Magdalena Bushart, 'Bauplastik im Dritten Reich', in M. Bushart, B. Nicolai and W. Schuster, eds, *Entmachtung der Kunst: Architektur, Bildhauerei und ihre Institutionalisierung 1920 bis 1960* (Berlin, 1985), pp. 104–15.

6 See, for example, Frank Wagner and Gudrun Linke, 'Mächtige Körper:

Staatsskulptur und Herrschaftsarchitektur', in Neue Gesellschaft für Bildende Kunst, *Inszenierung der Macht: Ästhetische Faszination im Faschismus* (Berlin, 1987), pp. 63–78.

7 See the latest publication in a vast literature, Yvonne Karow, *Deutsches Opfer: Kultische Selbstauslöschung auf den Reichsparteitagen der NSDAP* (Berlin, 1997).

8 For a Marxist comparison of Stalinist and Hitlerite monuments, see Martin Damus, *Sozialistischer Realismus und Kunst im Nationalsozialismus* (Frankfurt am Main, 1981), pp. 51–73. See also Matthew Cullerne Bown, *Art under Stalin* (Oxford, 1991), and Robert C. Tucker, 'The Rise of Stalin's Personality Cult', *American Historical Review*, VIII/2 (April 1979), pp. 347–66.

9 See Rainer Stommer, *Die inszenierte Volksgemeinschaft: Die 'Thing-Bewegung' im Dritten Reich* (Marburg, 1985); Bartetzko, *Illusionen im Stein*, pp. 133–45.

10 See Chapter 5.

11 Rittich, *Architektur und Bauplastik*, p. 172.

12 Bernd Nicolai, 'Das Denkmal und sein Standort', in Mai and Schmirber, eds, *Denkmal – Zeichen – Monument*, pp. 106–9.

13 See, for example, Peter Schirmbeck, *Adel der Arbeit: Der Arbeiter in der Kunst der NS-Zeit* (Marburg, 1984), pp. 51–97.

14 See the latest publication, Marie Bouchard, 'Un Monument au travail: The projects of Meunier, Dalou, Rodin and Bouchard', *Oxford Art Journal*, II (November 1981), pp. 28–35.

15 Anonymous article in *Arbeitertum*, VIII/19 (1938), pp. 14–15.

16 Interestingly enough, the young Thorak had taken up the theme of a 'Monument to Labour' already in the pre-Nazi 1920s and had realized it in the style of Rodin. See Wilhelm von Bode, *Joseph Thorak* (Berlin, 1929), ills on pp. 77–83.

17 Kurt Lothar Tank, *Deutsche Plastik unserer Zeit* (Munich, 1942), p. 68.

18 Meinhold Lurz, 'Architektur für die Ewigkeit und dauerndes Ruherecht', in Mai and Schmirber, eds, *Denkmal – Zeichen – Monument*, pp. 81–2. There are good photos in Gerdy Troost, ed., *Das Bauen im Neuen Reich*, vol. II (Bayreuth, 1943), ills on pp. 20–25.

19 See Wolfgang Schäche, 'Die Totenburgen des Nationalsozialismus', *Arch+*, no. 71 (October 1983), pp. 72–5; Ekkehard Mai, 'Von 1930 bis 1945: Ehrenmäler und Totenburgen', in W. Nerdinger and E. Mai, eds, *Wilhelm Kreis: Architekt zwischen Kaiserreich und Demokratie 1873–1955* (Munich and Berlin, 1994), pp. 156–68. There are good photos in Hans Stephan, *Wilhelm Kreis* (Oldenburg, 1944) and in Troost, ed., *Das Bauen im Neuen Reich*.

20 Troost, *Das Bauen im Neuen Reich*, p. 7

21 Magdalena Bushart, 'überraschende Begegnungen mit alten Bekannten: Arno Breker's NS-Plastik in neuer Umgebung', in Berthold Hinz, ed., *NS-Kunst: 50 Jahre danach* (Marburg, 1989), p. 49.

5 THE COMMUNIST PANTHEON

1 V. I. Lenin, 'Decree on the Monuments of the Republic, 12th April 1918', in Lenin, *On Literature and Art* (London, 1965), p. 245.

2 See H. J. Drengenberg, *Die sowjetische Politik auf dem Gebiet der bildenden Kunst von 1917–1934* (Berlin, 1972), pp. 181–298; J. Bowlt, 'Russian Sculpture and Lenin's Plan of Monumental Propaganda', in H. A. Millon and L. Nochlin, eds, *Art and Architecture in the Service of Politics* (Cambridge, 1978), pp. 182–93; R. Stites, *Revolutionary Dreams: Utopian Visions and Experimental Life in the Russian Revolution* (New York and Oxford, 1989), pp. 83–90; K. Bajcurova, 'Plan monumentalnej propagandy: k evolucii leninskej idey', *Ars* (Bratislava), II (1989), pp. 37–48, with a comprehensive bibliography of Soviet publications. Good photos may be

found in M. German, *Die Kunst der Oktoberrevolution* (Düsseldorf, 1979), p. 10f., and in Drengenberg, figs 25–37. All of these publications offer only a fragmentary analysis.

3 See the testimony of A. Paquet, *Im kommunistischen Russland: Briefe aus Moskau* (Jena, 1919), p. 200.

4 Nikolay Punin, 'About Public Monuments' (*Art of the Commune*, 9 March 1919), quoted after H. Gassner, and E. Gillen, *Zwischen Revolutionskunst und Sozialistischem Realismus* (Köln, 1979), p. 446; Hubertus Gassner, 'Sowjetische Denkmäler im Aufbau', in Michael Diers, ed., *Mo(nu)mente: Formen und Funktionen ephemerer Denkmäler* (Berlin, 1983), pp. 152–77.

5 F. Reusse, *Das Denkmal an der Grenze seiner Sprachfähigkeit* (Stuttgart, 1995), p. 151.

6 L. Shadowa, *Malewitsch* (Munich, 1982), p. 79.

7 D. Schubert, 'Das Denkmal für die Märzgefallenen 1920 von Walter Gropius und seine Stellung in der Geschichte des neueren Denkmals', *Jahrbuch der Hamburger Kunstsammlungen*, xxi (1976), pp. 199–230.

8 W. Kandinsky, *Vom Punkt zur Linie und Fläche* (Bern, 1968), p. 54.

9 Gassner and Gillen, *Revolutionskunst*, p. 446.

10 Bertolt Brecht, *Gedichte* (Berlin, 1973), pp. 261–3.

11 On the Lenin cult, see N. Tumarkin, *Lenin Lives! The Lenin Cult in Soviet Russia* (Cambridge, MA, 1983); F. X. Coquin, 'L'Image de Lénine dans l'iconographie revolutionnaire et post-revolutionnaire', *Annales ESC* (March–April 1989), pp. 223–49.

12 See Tumarkin, *Lenin Lives!*, p. 157f., and the differing account by Benno Ennken, 'Leninkult und mythisches Denken in der sowjetischen Öffentlichkeit 1924', *Jahrbücher für Geschichte Osteuropas*, III (1996), pp. 431–55.

13 The influence of Malevich's 'architectons' has not been studied at all. It seems that until the end of the 1930s, they were well known all over Soviet Russia despite what has been written about Malevich's growing isolation from 1925/6 on. See Jean Hubert Martin, *Malévitch: Oeuvres de Casimir Severine Malévitch (1878–1935)*, exhibition catalogue (Paris, 1980).

14 No sufficient analysis of the Palace of Soviets as a Lenin monument exists. I. V. Eigel, *Boris Iofan* (Moscow, 1978), pp. 80–123, is hagiographic. See also A. Tarchanow and S. Kawtoradse, *Stalinistische Architektur* (Munich, 1992), pp. 25–32; I. Kazuss, 'Stalin und der Palast der Sowjets', in P. Noever, ed., *Tyrannei des Schönen: Architektur der Stalin-Zeit* (Vienna, 1994), pp. 151–69.

15 Tarchanow and Kawtoradse, *Stalinistische Architektur*, p. 29.

16 M. Warner, *Monuments & Maidens: The Allegory of the Female Form* (London, 1985), p. 12.

17 *Artists of the RSFSR over a Period of 15 Years*, exhibition catalogue (Leningrad, 1932). See photographs of the section in Martin, p. 93, which shows other similar 'architectons' with a figure (of Lenin?) on top. The questions of whether Malevich had inside information about the Palace competition in 1932 and about the real purposes of his projects cannot be answered here.

18 See E. Weiss, ed., *Kasimir Malewitsch: Werk und Wirkung* (Köln, 1995), p. 42f.

19 Iofan's collaborator on the interior – strongly dependent on the 'architectons' – was Malevich's pupil Nikolay Sujetin; see Shadowa, *Malewitsch*, p. 112, ill. 281. On the 1937 Soviet Paris Pavilion, see Eigel, *Boris Iofan*, p. 135ff. (biased); I. Golomstock, *Totalitarian Art in the Soviet Union, the Third Reich, Fascist Italy and the People's Republic of China* (New York, 1990), pp. 133–6. Iofan explained the Pavilion's conception in a brochure: *Pavilyon SSSR na Mezdunarodnoj Vystavke v Parizhe* (Moscow, 1938).

20 See the opposite conclusion in Anders Åman, *Architecture and Ideology in Eastern Europe during the Stalin Era* (Cambridge, MA, and London, 1992), p. 244. See also the self-laudatory account in A. Speer, *Inside the Third Reich* (London, 1979), p. 130.

21 Quoted after Golomstock, *Totalitarian Art*, p. 136.
22 See Václav Tomek, 'Die Statuen der Befreiung als Denkmäler der Fiktion', *Bauwelt*, LXXXIV (1993), pp. 332–5.
23 Soviet monuments and memorials devoted to the years 1941–5 are discussed (the Soviet literature is not analytical) in I. Azizjan and I. Ivanova, *Honour Eternal: Second World War Memorials* (Moscow, 1982); V. A. Golikova, ed., *Podvig Naroda: Pamjatniki Velikoj Otecestvennoj Vojny 1941–1945* (Moscow, 1984); I. E. Svetlov, *O sovetskoj skulpture 1960–1980* (Moscow, 1984), pp. 116–72; F. Kämpfer, 'Vom Massengrab zum Heroenhügel: Akkulturationsfunktionen sowjetischer Kriegsdenkmäler', in Koselleck and Jeismann, eds, *Der politische Totenkult*, pp. 327–49.
24 The rest of the heavily damaged *Siegesallee* was removed to a lapidarium in the early 1950s by the West Berlin authorities; see B. Erenz, 'Kaiser Wilhelms Hollywood', *Die Zeit*, 24 July 1987; P. Bloch, 'Das Lapidarium am Landwehrkanal', *Jahrbuch des Preussischen Kulturbesitzes*, XIV (1977), pp. 271–81.
25 See a 1946 photo in A. Balfour, *Berlin: The Politics of Order 1737–1989* (New York, 1990), p. 160.
26 See the illustration in *Art and Power: Europe under the Dictators 1930–1945*, exhibition catalogue: Hayward Gallery, London (London, 1995), p. 208.
27 An overall guide is provided by the official publication: B. Braunert, *Ehrenmal für die gefallenen sowjetischen Helden, Berlin-Treptow* (Berlin, 1983).
28 See Chapter 4, n. 19.
29 Z. Gitelman, 'History, Memory and Politics: The Holocaust in the Soviet Union', *Holocaust and Genocide Studies*, V (1990), pp. 23–37.
30 Photos and official information about the Khatyn memorial may be found in Golikova, ed., *Podvig Naroda*, pp. 311–13.
31 J. E. Young, 'The Biography of a Memorial Icon: Nathan Rapoport's Warsaw Ghetto Monument', *Representations*, XXVI (1989), pp. 69–103; K. Gebert, 'Die Dialektik der Erinnerung: Holocaust Denkmäler in Warschau', in J. E. Young, ed., *Mahnmale des Holocaust: Motive, Rituale und Stätten des Gedenkens* (Munich, 1994), pp. 97–106.
32 The dubious behaviour of the Communists at Buchenwald, including the so-called 'self-liberation', is aptly characterized in D. A. Hackett, *Der Buchenwald-Report* (Munich, 1996).
33 In the case of the Buchenwald monument, one has to start with the official publications: Akademie der Künste, *Das Buchenwald-Denkmal* (Dresden, 1960); I. Burghoff and L. Burghoff, *Nationale Mahn- und Gedenkstätte Buchenwald* (Berlin and Leipzig, 1970). For critical views, see V. Knigge, 'Fritz Cremer, "Das Buchenwalddenkmal", in M. Flacke, ed., *Auftragskunst der DDR 1949–1990* (Munich and Berlin, 1995), pp. 106–15; S. Farmer, 'Symbols That Face Two Ways: Commemorating the Victims of Nazism and Stalinism at Buchenwald and Sachsenhausen', *Representations*, XLIX (1995), pp. 97–119; M. Overesch, *Buchenwald und die DDR oder die Suche nach Selbstlegitimation* (Göttingen, 1995).
34 B. Brecht, *Arbeitsjournal, vol. II, 1942–1955* (Frankfurt am Main, 1975), p. 972 (note from 3 February 1952). A scathing critique of Brecht's Buchenwald plans may be found in the journal of the great Spanish writer Jorge Semprun, *Was für ein schöner Sonntag!* (Frankfurt am Main, 1981), p. 37. Semprun was himself an inmate of Buchenwald. For the *Thingstätten*, see Chapter 4, n. 9.
35 Ulrich Kuhirt, *Bildkunst und Baukunst* (Berlin, 1970), p. 159, goes so far as to state that the liberated inmates are symbolically defending the socialist system.
36 See the excellent analysis in Aman, *Architecture and Ideology*, pp. 197–204, and a short article about the urban setting by the monument's co-creators, J. Štursa and V. Štursova, 'Pomnik J. V. Stalina v Praze', *Architektura CSSR*,

xiv (1955), p. 190; see also Z. Hojda and J. Pokorny, *Pomniky a Zapomniky* (Prague, 1997), pp. 205–18.

37 See Aman, *Architecture and Ideology*, pp. 192–7; L. Beke, 'The Demolition of Stalin's Statue in Budapest', in S. Michalski, ed., *Les Iconoclasmes*, Actes, XXVIIe Congrès International d'Histoire de l'Art, Strasbourg, 1989, vol. iv (Strasbourg, 1992), pp. 275–84 ; J. Pótó, 'So wurde das Budapester Stalin-Denkmal errichtet', in F. Glatz, ed., *The Stalinist Model in Hungary* (Budapest, 1990), pp. 117–36; K. Sinkó, 'Political Rituals: The Raising and Demolitions of Monuments', in P. György and H. Turai, eds, *Art and Society in the Age of Stalin* (Budapest, 1992), pp. 73–86.

38 See S. R. Arnold, '"Das Beispiel der Heldenstadt wird ewig die Herzen der Völker erfüllen": Gedanken zum sowjetischen Heldenkult am Beispiel des Heldenkomplexes in Wolgograd', in Koselleck and Jeismann, *Der politische Totenkult*, p. 360; D. M. Reynolds, *Monuments and Masterpieces: Histories and Views of Public Sculpture in New York* (New York, 1988), p. 207; *Kunst im Dritten Reich: Dokumente der Unterwerfung* (Frankfurt am Main, 1980), p. 296.

39 See I. Grzesiuk-Olszewska, *Polska rzeźba pomnikowa w latach 1945–1995* (Warsaw, 1995), pp. 98–113.

40 *Sztuka* (Warsaw), viii / 1 (1981), pp. 13–18.

41 H. Henselmann, *Ideen, Bauten, Projekte* (Berlin, 1978), pp. 104–9.

42 See M. Rüger, 'Das Berliner Lenin-Denkmal', *Kritische Berichte*, xx / 3 (1992), pp. 36–44; M. Flacke, ed., *Auftragskunst der DDR 1949–1990* (Munich and Berlin, 1995), pp. 200–5; excellent photographs in V. B. Minima, *Nikolay Tomsky* (Moscow, 1980), ills 132–40.

43 See the protest brochure *Initiative Lenindenkmal: Demokratie in Aktion* (Berlin-Friedrichshain, 1992); H. E. Mittig, 'Gegen den Abriss des Berliner Lenin-Denkmals', in B. Kremer, *Demontage . . . revolutionärer oder restaurativer Bildersturm* (Berlin, 1992), p. 44f.; D. Axthelm-Hoffmann, 'The Demise of Lenin Square', *Daidalos*, xlix (1993), pp. 122–9.

44 See the half-official article by D. Eisold, 'Das Denkmals-Ensemble für das Marx-Engels Forum Berlin', *Bildende Kunst*, no. 3 (1986), pp. 104–8, and the opposite view in P. Springer, 'Rhetorik der Standhaftigkeit: Monument und Sockel nach dem Ende des traditionellen Denkmals', *Wallraf-Richartz Jahrbuch*, xlviii — xlix (1987–8), pp. 382–3.

45 P. Roettig, '"Proletarier der Welt vergibt mir": Von den Inschriften zu den Graffiti-Formen der Denkmalskommentare', *Neue Zürcher Zeitung*, 11 September 1992.

46 The fall of the Communist statues after 1989 is analyzed in *Erhalten, Zerstören, Verändern? Denkmäler der DDR in Ost-Berlin* (Berlin, 1970); T. Flierl, 'Denkmalsstürze in Berlin: Vom Umgang mit einem prekären Erbe', *Kritische Berichte*, xx / 3 (1992), pp. 45–53; A. Boime, 'Perestroika and the Destabilization of the Soviet Monuments', *Ars*, ii — iii (1993), pp. 211–16; F. Fiedler and M. Petzet, eds, *Bildersturm in Osteuropa*, ICOMOS: Hefte des Deutschen Nationalkomitees für Denkmalschutz, 13 (Munich, 1994); J. Tazbir, 'Wojna na pomniki', *Polityka*, 20 July 1996, pp. 3–8; Hojda and Pokorny, *Pomniky*, pp. 219–30. When revising this chapter, I greatly profited from Dario Gamboni's succinct synthesis in *The Destruction of Art: Iconoclasm and Vandalism since the French Revolution* (London, 1997), pp. 51–90.

47 K. Wodiczko, *Art public, art critique: Textes, propos et documents* (Paris, 1995), p. 16; Gamboni, *Destruction*, pp. 81–2.

48 See the agency note 'Getrennt zu Karl und Rosa', *Frankfurter Allgemeine Zeitung*, 11 January 1997.

49 See the last conflict in T. Urban, 'Streit über die Befreier Polens: Stadt Thorn liess Denkmal für gefallene Rotarmisten schleifen', *Süddeutsche Zeitung*, 7 September 1997.

50 Gamboni, *Destruction*, p. 78.

51 W. Schmid, 'Der metropolitane Glanz kehrt zurück', *Neue Zürcher Zeitung*, 7 December 1995.

6 IN QUEST OF A NEW HEROIC FORM

1 U. Jehle Schulte-Strathaus and Bruno Reichlin, *Il segno della memoria 1945–1995: BBPR monumento ai caduti nei campi nazisti* (Milan, 1995).

2 For that aspect of the Casa del Fascio, see K. W. Forster, 'Baugedanke und Gedankengebäude – Terragnis Casa del Fascio in Como', in H. Hipp and E. Seidl, eds, *Architektur als politische Kultur* (Berlin, 1996), pp. 263–64f.

3 H. Ladendorf, 'Das Denkmal der Luftbrücke', *Giessener Beiträge zur Kunstgeschichte*, I (1970), pp. 205–20.

4 Herbert Read, preface to *International Sculpture Competition: The Unknown Political Prisoner*, exhibition catalogue: Tate Gallery, London (London, 1953), p. 1.

5 For the competition, see *International Sculpture Competition: The Unknown Political Prisoner*; J. Marter, 'The Ascendancy of Abstraction for Public Art: The Monument to the Unknown Political Prisoner Competition', *Art Journal*, LIII/4 (1994), pp. 28–36; Glaves Smith in S. Nairne and N. Serota, *British Sculpture in the Twentieth Century* (London, 1981), pp. 37–40.

6 See *Reg Butler*, exhibition catalogue: Tate Gallery, London (London, 1983), pp. 18–24; R. Burstow, 'Butler's Competition Project for a Monument to the "Unknown Political Prisoner": Abstraction and Cold War Politics', *Art History*, XII (December 1989), pp. 472–96; H. E. Mittig, 'Sculpture et histoire: Deux monuments commemoratifs', in J. P. Ameline, ed., *Face à histoire 1933–1996: L'Artiste moderne devant l'événement historique*, exhibition catalogue: Centre Georges Pompidou, Paris (Paris, 1996), pp. 262–9.

7 About the plans for a Berlin location, see C. Fischer-Defoy in A. von Specht, ed., *Die Kunst hat nie ein Mensch allein besessen*, exhibition catalogue: Akademie der Künste, Berlin (Berlin, 1996), pp. 649–54.

8 Though Fischer-Defoy stresses the significance of financial and technical difficulties, in my opinion the impact of political conflict proved decisive.

9 Giacometti also inspired Butler through his early (1930s) concept of sculptural 'places'; see T. Dufrêne, 'Les "Places" de Giacometti ou le monument à rebours', *Histoire de l'art*, XXVII (1994), pp. 81–92.

10 K. A. Marling and J. Wetenhall, *Iwo Jima, Monuments, Memories and the American Hero* (Cambridge, MA, 1991), p. 62ff.

11 D. Ronte, 'Le Monument aux morts transportable d'Edward Kienholz', *L'Oeil*, CCXVI (1972), pp. 22–9; Johannes Heinrichs, 'Das Spiel mit den semiotischen Dimensionen im modernen Museum: Zur philosophischen Syntax neuer Kunst am Beispiel von Edward Kienholz' "Das tragbare Kriegerdenkmal"', *Zeitschrift für Ästhetik und Allgemeine Kunstwissenschaft*, XXV/2 (1980), pp. 244–69; H. W. Schmidt, *Edward Kienholz: The Portable War Memorial* (Frankfurt am Main, 1988).

12 L. Réau, *Histoire du vandalisme: Les Monuments détruits de l'art français* (Paris, 1959), vol. II, p. 258.

13 T. Burollet, 'Le Dépot de sculpture de la ville de Paris ou la survie de la statuaire parisienne', *Gazette des Beaux-Arts*, XCIII (October 1979), pp. 113–24.

14 June Hargrove, *The Statues of Paris: An Open-Air Pantheon* (New York and Paris, 1990), pp. 330–31.

15 P. Cabanne, 'La Guerre des statues', *Le Matin de Paris*, 12 January 1984.

16 E. Schmid, *Staatsarchitektur der Ära Mitterrand in Paris: Ästhetische Konzeption und politische Wirkung* (Regensburg, 1996), pp. 210–15.

17 See N. Chabert, ed., *Monument & modernité à Paris: Art, espace public et enjeux de mémoire 1891/1996* (Paris, 1996), p. 162f.

18 *Ibid.*, p. 182f.

1 P. Springer, 'Rhetorik der Standhaftigkeit: Monument und Sockel nach dem Ende des traditionellen Denkmals', *Wallraf-Richartz Jahrbuch*, XLVIII–XLIX (1987–8), pp. 365–408; G. Metken, 'Die Kunst des Verschwindens: Unsichtbare Denkmäler – Ein Situationsbericht', *Merkur*, XLVIII (June 1994), pp. 478–90.

2 G. Apollinaire, *Oeuvres en Prose*, vol. I (Paris, 1977), pp. 300–01.

3 C. Lichtenstern, *Pablo Picasso, Denkmal für Apollinaire: Entwurf zur Humanisierung des Raumes* (Frankfurt am Main, 1988), p. 12.

4 Quoted after Wulf Herzogenrath, 'Denkmäler wider das Vergessen', in R. Rother, ed., *Die letzten Tage der Menschheit*, exhibition catalogue: Deutsches Historisches Museum, Berlin (Berlin, 1994), pp. 449–50. See also M. de Michelis, *Heinrich Tessenow 1876–1950: Das architektonische Gesamtwerk* (Stuttgart, 1991), p. 306.

5 C. Oldenburg, *Proposals for Monuments and Buildings 1965–69* (Chicago, 1969), pp. 146f., 166f.

6 See also B. Haskell, *Claes Oldenburg, Object into Monument* (Pasadena Art Museum, 1971); M. Rosenthal, '"Ungezügelte" Monumente oder wie Claes Oldenburg auszog die Welt zu verändern', in G. Celant, ed., *Claes Oldenburg: Eine Anthologie* (Bonn, 1996), pp. 255–63.

7 See *Timm Ulrichs*, exhibition catalogue (Hannover, 1983), p. 74; Springer, p. 366; Cornelius Tauber, 'Eine Nekropole für Künstler', in Michael Willhardt, ed., *Der Alleinunterhalter* (Stuttgart, 1994), pp. 158–61.

8 See *Denkmal für die ermordeten Juden Europas*, exhibition catalogue: Neue Gesellschaft für Bildende Kunst, Berlin (Berlin, 1995), p. 170.

9 C. Kügler, 'Pharaonisch. Heiliger Berg zu durchbohren: Chillidas Pläne für Fuerteventura', *Frankfurter Allgemeine Zeitung*, 4 January 1997. For a comparison with the Newton cenotaph, see Adolf-Max Vogt, *Boullées Newton Denkmal: Sakralbau und Kugelidee* (Basel and Stuttgart, 1969), p. 46.

10 Quoted after J. E. Young, *The Texture of Memory* (New Haven and London, 1993), p. 45. See also the brochure edited by H. Eichel, 'Aschrottbrunnen – Eine offene Wunde der Stadtgeschichte' (Kassel, 1990).

11 W. von Brincken, 'Sturm auf die Bibliothek: Holocaust-Denkmal Entwurf von Rachel Whiteread', *Kunst-Zeitung*, 11 (October 1996), p. 22; I. Santner, 'Zählt Beton oder Geschichte? Kontroverse in Wien um Holocaust-Mahnmal und Reste einer alten Synagoge', *Weltwoche*, 6 Feburary 1997.

12 J. Lingwood, *Rachel Whiteread. House* (London, 1997).

13 See U. Jenni, *Alfred Hrdlicka, Mahnmal gegen Krieg und Faschismus* (Graz, 1993); C. Heinrich, *Strategie des Erinnerns: Der veränderte Denkmalsbegriff in der Kunst der achtziger Jahre* (Munich, 1993), pp. 83–118.

14 See H. Dickel, 'Das fehlende Haus: Christian Boltanski in Berlin', *Ästhetik und Kommunikation*, LXXVIII (1992), pp. 42–8, and, for a general analysis of installations, idem, 'Installationen als ephemere Formen von Kunst', in M. Diers, ed., *Mo(nu)mente: Formen und Funktionen ephemerer Denkmäler* (Berlin, 1993), pp. 223–40.

15 M. Steinhauser, '"Erinnerungsarbeit – Zu Jochen Gerz" Mahnmalen. Works of Memory – On Jochen Gerz's Memorials', *Daidalos*, XLIX (1993), pp. 104–14; E. Bollinger, 'Das Unsichtbare Denkmal', *Semit*, III (1992), pp. 96–8; F. Reusse, *Das Denkmal an der Grenze seiner Sprachfähigkeit* (Stuttgart, 1995), pp. 273–84; H. Pfütze, 'Unsichtbar – versenkt – im Traum: Mahnmale und öffentliche Skulpturen von Jochen Gerz', *Merkur*, LI (February 1997), pp. 128–37; Stadtverband Saarbrücken, ed., *2146 Steine – Mahnmal gegen Rassismus* (Stuttgart, 1993).

16 Bollinger, 'Das Unsichtbare Denkmal', p. 97.

17 See the documentation in J. Gerz and E. Shalev Gerz, *Das Harburger*

Mahnmal gegen Faschismus. The Harburg Monument against Fascism (Stuttgart, 1994); Reusse, *Das Denkmal*, pp. 266–72; see also J. Lichtenstein and G. Wajcman, '"Wir wissen, daß das Verdrängte uns immer verfolgt": Jochen Gerz im Gespräch', *Kunstforum*, CXXVIII (October–December 1994), pp. 197–9.

18 See K. Bussmann and K. König, eds, *Skulptur-Projekte in Münster 1987*, exhibition catalogue: Westfälisches Landesmuseum, Münster (Münster, 1987), under 'Sol LeWitt', pp. 173–8.

19 See *Plastik und Raum: Denkmäler und Denkmalsprojekte* (Magdeburg, 1980), pp. 51, 56–7; H. Adam, 'Erinnerungsrituale – Erinnerungsdiskurse –Erinnerungstabus: Politische Denkmäler der DDR zwischen Verhinderung, Veränderung und Realisierung', *Kritische Berichte*, XX / 3 (1992), p. 29.

20 The *Vietnam Veterans Memorial* has been the subject of a growing – not always relevant – body of literature. See the articles in J. Walsh and J. Aulich, eds, *Vietnam Images: War and Representation* (London, 1989); E. Ezell, *Reflections on the Wall: The Vietnam Veterans Memorial* (Harrisburg, 1987); and the bibliography in the last publication by C. L. Griswold, 'The Vietnam Veterans Memorial and the Washington Mall: Philosophical Thoughts on Political Iconography', *Critical Inquiry*, XII / 4 (Summer 1996), pp. 688–719. There are even some critics who think that the mirroring effect was not planned; see T. Barucki, 'Ameryka-Ameryka', *Architektura*, no. 4 (1987), pp. 27–8.

8 PUBLIC MONUMENTS IN THE THIRD WORLD

1 H. Escobedo, *Mexican Monuments, Strange Encounters* (New York, 1989).

2 See also Comision Nacional para la commemoracion del Centenarion de fallacimento de Don Benito Juarez, *Juárez en el Arte* (Mexico City, 1972).

3 *Art and Power: Europe under the Dictators 1930–1945*, exhibition catalogue: Hayward Gallery, London (London, 1995), p. 139.

4 Escobedo, *Mexican Monuments*, p. 52.

5 See the translation of the official pronouncements of the North Korean News Agency: 'Wolken von Bienen und Libellen', *Frankfurter Allgemeine Zeitung*, 31 July 1995. For the cult of Kim and the monuments, see Dae-Sook-Suh, *Kim-Il-Sung: The North Korean Leader* (New York, 1988), p. 212ff.

6 The major – though somewhat biased – study is Samir al-Khalil, *The Monument: Art, Vulgarity and Responsibility in Iraq* (Berkeley, Los Angeles and London, 1991).

7 A good analysis of this aspect is to be found in A. Baran, *Culture, History and Ideology in the Formation of Bathist Iraq, 1968–1989* (New York, 1991), pp. 78–83.

8 Al-Khalil, *The Monument*, pp. 25–7.

9 *Ibid.*, pp. 49–50.

10 *Ibid.*, p. 3.

9 MONUMENTS IN THE 1990S AND BEYOND

1 J. Taylor, 'London's Latest "Immortal": The Statue of Sir Arthur Harris of Bomber Command', *Kritische Berichte*, XX / 3 (1992), pp. 96–102.

2 V. Kriwulin, 'Die üppige Fäulnis: Denkmal für die Opfer des Staatsterrors in St. Petersburg', *Frankfurter Allgemeine Zeitung*, 17 May 1995.

3 On the confluence of public sculptures and public monuments, see V. Plagemann, *Kunst im öffentlichen Raum: Anstösse der 80er Jahre* (Köln, 1988); E. Mai and G. Schmirber, *Denkmal – Zeichen – Monument: Skulptur im öffentlichen Raum heute* (Munich, 1989); H. Senie, ed., *Contemporary Public*

Sculpture: Tradition, Transformation and Controversy (Oxford, 1992);
W. J. T. Mitchell, ed., *Art and the Public Sphere* (Chicago and London, 1992);
D. S. Friedman, 'Public Things in the Atopic City: Late Notes on the Tilted
Arc and the Vietnam Veterans' Memorial', *Art Criticism*, x (1994),
pp. 66–104. See also the thematic articles in *Art Journal*, XLVIII / 4 (1989),
and *Sculpture*, XI / 2 (1992).

4 P. Reichel, 'Berlin nach 1945 – Eine Erinnerungslandschaft zwischen
Gedächtnis-Verlust und Gedächtnisinszenierung' in H. Hipp and E. Seidl,
Architektur als politische Kultur (Berlin, 1996), p. 294.

5 See, for example, M. Winzen, 'The Need for Public Representation and the
Burden of the German Past', *Art Journal*, XLVIII (1989), pp. 309–14.

6 U. Mainzer, 'Historische Denkmäler und aktuelle Denkmalspflege', in
Historische Denkmäler im Dienst der Gegenwart, Bensberger Protokolle, 81
(Bergisch-Gladbach, 1994), pp. 151–90.

7 J. Ruerup, *Topographie des Terrors: Gestapo, SS und Reichssicherheitsamt auf
dem Prinz-Albrecht Gelände* (Berlin, 1989).

8 See J. E. Young, 'The Counter-monument: Memory against Itself in
Germany Today' in Mitchell, *Art and the Public Sphere*, pp. 49–78.

9 On the Hamburg Nazi memorial, see V. Plagemann, *Vaterstadt, Vaterland
. . . Denkmäler in Hamburg* (Hamburg, 1986), pp. 143–7.

10 On the first Hamburg counter-monument project, see H. G. Behr, 'Der
Klotz bleibt . . . aber er wird zum antifaschistischen Mahnmal', *Konkret*, XII
(1983), pp. 86–92. On Hrdlicka's monument, see the polemic between D.
Schubert, *Kritische Berichte*, XV (1987), pp. 8–18, and G. Werner, *Kritische
Berichte*, XVI (1988), pp. 57–65; see also the critique in G. Armanski, *'Und
wenn wir sterben müssen': Die politische Ästhetik von Kriegsdenkmälern*
(Hamburg, 1988), pp. 33–68; M. Hütt, 'Alfred Hrdlicka's Umgestaltung des
Hamburger Denkmals für das Infanterieregiment Nr. 76', in M. Hütt and
H. J. Kunst, eds, *'Unglücklich das Land das Heroen nötig hat': Leben und
Sterben der Kriegsdenkmäler des ersten und zweiten Weltkrieges* (Marburg,
1990), p. 112ff.

11 See W. Fenz, 'The Monument Is Invisible, the Sign Visible', *October*, XLVIII
(Spring 1989), pp. 75–8; H. Haacke, 'Und ihr habt doch gesiegt', *October*,
XLVIII (Spring 1989), pp. 79–87.

12 S. Dylla, *Jenny Holzer – Black Garden* (Nordhorn, 1994); S. Ungar-Grudin,
Darkness Visible: Jenny Holzer's Countermemorial in Nordhorn (Nordhorn,
1996); Brigitte Franzen, 'Jenny Holzers Schwarzer Garten in Nordhorn:
Über die Translokation eines mythologisierten Ortes und die
zeitgenössische Überformung eines Kriegerdenkmals', *Kritische Berichte*,
XXIV / 3 (1996), pp. 49–55.

13 See *Jenny Holzer, Kriegszustand*, exhibition catalogue (Leipzig, 1996).

14 See P. Phillips, 'Temporality and Public Art', in H. Senie and F. Webster,
eds, *Critical Issues in Public Art: Content, Context and Controversy* (New
York, 1992), p. 297.

Select Bibliography

This is both a select bibliography and a guide to literature on political monuments and public art in the last quarter of the twentieth century. Publications of secondary importance or topical references to other themes mentioned in the notes have, on the whole, been omitted; on the other hand, some important general publications not mentioned in the notes have been included. Essays in large volumes devoted to political monuments have not been listed separately.

Adam, Hubertus, 'Zwischen Anspruch und Wirkungslosigkeit: Bemerkungen zur Rezeption von Denkmälern in der DDR', *Kritische Berichte*, XIX (1991), pp. 44–64
——, 'Erinnerungsrituale – Erinnerungsdiskurse – Erinnerungstabus: Politische Denkmäler der DDR zwischen Verhinderung, Veränderung und Realisierung', *Kritische Berichte*, XX / 3 (1992), pp. 29–36
Adhémar, Jean, 'Les Statues parisiennes de grands hommes', *Gazette des Beaux-Arts*, LXXXIII (March 1974), pp. 150–56
Agulhon, Maurice, 'Imagerie civique et décor urbain dans la France du XIXe siècle', *Ethnologie française*, V (1975), pp. 33–56
——, 'La "Statuomanie" et l'histoire', *Ethnologie française*, VIII (1978), pp. 145–73
——, *Marianne into Battle: Republican Imagery and Symbolism in France 1789–1880* (Cambridge, 1981)
——, *Marianne au pouvoir, l'imagerie et la symbolique republicaines de 1880 à 1914* (Paris, 1989)
Akademie der Künste, *Skulptur und Macht: Figurative Plastik in Deutschland der 30er und 40er Jahre*, exhibition catalogue (Düsseldorf, 1984)
Akademie der Künste der DDR, *Das Buchenwald-Denkmal* (Dresden, 1960)
Al-Khalil, Samir, *The Monument: Art, Vulgarity and Responsibility in Iraq* (Berkeley, 1991)
Allen, Leslie, *Liberty: The Statue and the American Dream* (New York, 1985)
Åman, Anders, *Architecture and Ideology in Eastern Europe during the Stalin Era: An Aspect of Cold War History* (Cambridge, MA, 1992)
Aragon, Louis, *Le Paysan de Paris* [1926], *Oeuvres poétiques*, vol. III (Paris, 1974)
Armanski, Gerhard, '. . . und wenn wir sterben müssen': *Die politische Ästhetik von Kriegerdenkmälern* (Hamburg, 1988)
Arndt, Monika, 'Das Kyffhäuserdenkmal: Ein Beitrag zur politischen Ikonographie des zweiten Kaiserreiches', *Wallraf-Richartz Jahrbuch*, XL (1978), pp. 75–127
——, '"Ehre, wem Ehre gebührt"? Karikaturen zur "Denkmalsinflation" der wilhelminischen Zeit' in *Mittel und Motive der Karikatur in fünf Jahrhunderten: Bild als Waffe*, ed. G. Langemeyer (Munich, 1985), pp. 431–40
Art and Power: Europe under the Dictators 1930–1945, exhibition catalogue: Hayward Gallery, London (London, 1995)
Arviddsson, C., and L. Blomquist, eds, *Symbols of Power: The Aesthetics of Political Legitimation in the Soviet Union and Eastern Europe* (Stockholm, 1987)
Azizjan, I., and I. Ivanova, *Honour Eternal: Second War Memorials* (Moscow, 1982)
Bajcurova, Katarina, 'Plan monumentalnoj propagandy: k evolucii leninskej idey', *Ars* (Bratislava), II (1989), pp. 37–48
Bancquart, Marie-Claire, *Paris des Surréalistes* (Paris, 1972)

Bang, Lin Young, 'Les Statues commémoratives de Paris de 1870–1940' (PhD dissertation, Paris, 1970)

Baran, Amatzia, *Culture, History and Ideology in the Formation of Bathist Iraq, 1968–1989* (New York, 1991)

Barcellini, Serge, and Annette Wievorka, *Passant, Souviens-toi! Les Lieux du souvenir de la Seconde Guerre Mondiale en France* (Paris, 1995)

Bartetzko, Dieter, *Illusionen im Stein: Stimmungsarchitektur im deutschen Faschismus: Ihre Vorgeschichte in Theater- und Film-Bauten* (Reinbek, 1985)

Bauer, Franz, *Gehalt und Gestalt in der Monumentalsymbolik: Zur Ikonologie des Nationalstaates in Deutschland und in Italien 1860–1914* (Munich, 1993)

Becker, Annette, *Les Monuments aux Morts: Mémoire de la Grande Guerre* (Paris, 1988)

Beke, László–, 'The Demolition of Stalin's Statue in Budapest', in *Les Iconoclasmes*, ed. S. Michalski, Actes, XXVIIe Congrès International d'Histoire de l'Art, vol. IV (Strasbourg, 1992), pp. 275–84

Belgum, Kirsten, 'Displaying the Nation: A View of Nineteenth-Century Monuments through a Popular Magazine', *Central European History*, XXVI (1993), pp. 457–77

Bizardel, Yvon, 'Les Statues parisiennes fondues sous l'Occupation (1940–1944)', *Gazette des Beaux-Arts*, LXXXIII (March 1974), pp. 129–48

Bloch, Peter, 'Vom Ende des Denkmals', in *Festschrift Wolfgang Braunfels*, ed. F. Piel and J. Traeger (Tübingen, 1977), pp. 25–30

Boime, Albert, *Hollow Icons: The Politics of Sculpture in Nineteenth-Century France* (Kent and London, 1987)

Boockmann, Hartmut, 'Denkmäler: Eine Utopie des 19. Jahrhunderts', *Geschichte in Wissenschaft und Unterricht*, XXVIII (1977), pp. 160–73

Boorman, Derek, *At the Going Down of the Sun: British First World War Memorials* (York, 1988)

Borg, Alan, *War Memorials from Antiquity to the Present* (London, 1991)

Bowlt, John, 'Russian Sculpture and Lenin's Plan of Monumental Propaganda', in *Art and Architecture in the Service of Politics*, ed. H. A. Millon and L. Nochlin (Cambridge, MA, 1978), pp. 182–93

Bown, Mathew Cullerne, *Art under Stalin* (Oxford, 1991)

Brendel, Janos, ed., *Pomniki w XIX wieku* (Poznan, 1993)

Breton, André, *Nadja* [1928] (Paris, 1975)

Bürgerinitiative Berlin-Friedrichshain 1992, ed., *Initiative Lenindenkmal: Demokratie in Aktion* (Berlin, 1992)

Burollet, Thérèse, 'Le Dépôt des sculptures de la Ville de Paris ou la survie de la statuaire Parisienne', *Gazette des Beaux-Arts* (October 1979), pp. 113–24

——, ed., *Quand Paris dansait avec Marianne: 1789–1889*, exhibition catalogue: Musée du Petit Palais, Paris (Paris, 1989)

Burstow, Robert, 'Butler's Competition Project for a Monument to "The Unknown Political Prisoner": Abstraction and Cold War Politics', *Art History*, XII (1989), pp. 472–96

Bushart, Magdalena, 'Bauplastik im Dritten Reich', in Magdalena Bushart, Bernd Nicolai and Wolfgang Schuster, eds, *Entmachtung der Kunst: Architektur, Bildhauerei und ihre Institutionalisierung 1920 bis 1960* (Berlin, 1985), pp. 104–14

Chabert, No'lle, ed., *Monument & modernité à Paris: Art, espace public et enjeux de mémoire 1891/1996*, exhibition catalogue (Paris, 1996)

Cocteau, Jean, and Pierre Jahan, *La Mort et les statues* (Paris, 1946); 2nd edn (Paris, 1977)

Coombs, Rose E. B., *Before Endeavours Fade – A Guide to the Battlefields of the First World War* (London, 1976)

Coquin, F. X., 'L'Image de Lénine dans l'iconographie révolutionnaire et post-révolutionnaire', *Annales ESC* (March–April 1989), pp. 223–49

Curl, James F., *A Celebration of Death* (London, 1980)

Damus, Martin, *Sozialistischer Realismus und Kunst im Nationalsozialismus* (Frankfurt am Main, 1981)

Diers, Michael, ed., *Mo(nu)mente: Formen und Funktionen ephemerer Denkmäler* (Berlin, 1993)

Doezema, Marianne, and June Hargrove, *The Public Monument and Its Audience*, exhibition catalogue: Cleveland Museum of Art (Cleveland, 1977)

Dowley, Francis H., 'D'Angiviller's "Grands Hommes" and the Significant Moment', *Art Bulletin*, XXXIX (1957), pp. 259–77

Dubillaud, Roland, *Méditation sur la difficulté d'être en bronze* (Paris, 1972)

Eichel, Horst, ed., 'Aschrottbrunnen – Offene Wunde der Stadtgeschichte' (Kassel, 1990)

Eigel, I. V., *Boris Iofan* (Moscow, 1978)

Ellenius, Allan, *Den offentliga konsten och ideologierna: Studier över verk fram 1800 – och 1900 – talen* (Stockholm, 1971)

Engelbert, Günter, 'Die Errichtung des Kaiser Wilhelm-Denkmals auf der Porta Westfalica', *Westfalen*, XXXI (1971), pp. 322–45

——, *Ein Jahrhundert Hermannsdenkmal 1875–1975* (Detmold, 1975)

Engelhardt, Rudolf, *Das Niederwalddenkmal* (Bingen, 1973)

Ennken, Benno, 'Leninkult und mythisches Denken in der sowjetischen Öffentlichkeit 1924', *Jahrbücher für Geschichte Osteuropas*, XLIV (1996), pp. 431–53

Erhard, Ernst-Otto, 'Nachdenken über Denkmäler', *Du: Die Kunstzeitschrift*, no. 10 (1982), pp. 26–79

Erhardt-Apolda, Max, *Bismarck im Denkmal des In- und Auslandes* (Eisenach and Leipzig, 1903)

Escobedo, Helen, ed., *Mexican Monuments, Strange Encounters* (New York, 1989)

Ezell, E., *Reflections on the Wall: The Vietnam Veterans Memorial* (Harrisburg, 1987)

Farmer, Sarah, 'Symbols That Face Two Ways: Commemorating the Victims of Nazism and Stalinism at Buchenwald and Sachsenhausen', *Representations*, XLIX (Winter 1995), pp. 97–119

Fenz, Werner, 'The Monument Is Invisible, the Sign is Visible', *October*, XLVIII (Spring 1989), pp. 75–8

Fiedler, Werner, and Michael Petzet, eds, *Bildersturm in Osteuropa*, ICOMOS: Hefte des Deutschen Nationalkommitees für Denkmalsschutz, 13 (Munich, 1994)

Flacke, Monika, ed., *Auftragskunst in der DDR 1949–1990* (Munich and Berlin, 1995)

Franzen, Brigitte, 'Jenny Holzers Schwarzer Garten in Nordhorn: Über die Translokation eines mythologisierten Ortes und die zeitgenössische Überformung eines Kriegerdenkmals', *Kritische Berichte*, XXIV / 3 (1996), pp. 49–55

Gallisaires, Pierre, *Das Paris der Surrealisten* (Hamburg, 1986)

Gamboni, Dario, *The Destruction of Art: Iconoclasm and Vandalism since the French Revolution* (London, 1997)

Gerz, Jochen, and Esther Shalev-Gerz, *Das Harburger Mahnmal gegen Faschismus. The Harburg Monument against Fascism* (Stuttgart, 1994)

Gitelman, Zvi, 'History, Memory and Politics: The Holocaust in the Soviet Union', *Holocaust and Genocide Studies*, V (1990), pp. 23–37

Golikova, V. A., ed., *Podvig naroda: Pamjatniki Velikoj Otecestvennoj Vojny* (Moscow, 1984)

Golomstock, Igor, *Totalitarian Art in the Soviet Union, the Third Reich, Fascist Italy and the People's Republic of China* (New York, 1990)

Greenberg, Alan, 'Lutyens' Cenotaph', *Journal of the Society of Architectural Historians*, XLIX (1989), pp. 5–23

Griswold, Charles F., 'The Vietnam Veterans Memorial and the Washington

Mall: Philosophical Thoughts on Political Iconography', *Critical Inquiry*, XII (Summer 1996), pp. 688–719

Gruber, Eckhard, '". . . death is built into life": War Monuments and War Memorials in the Weimar Republic', *Daidalos*, XLIX (15 September 1993), pp. 72–82

Grudin, Eva Ungar, *Darkness Visible: Jenny Holzer's Countermemorial in Nordhorn* (Nordhorn, 1996)

Haacke, Hans, 'Und ihr habt doch gesiegt', *October*, XLVIII (Spring 1989), pp. 79–87

Haas, Hans, and Hannes Stekl, *Bürgerliche Selbstdarstellung: Städtebau, Architektur, Denkmäler* (Vienna, Köln and Weimar, 1995)

Hardtwig, Wolfgang, 'Nationsbildung und politische Mentalität: Denkmal und Fest im Kaiserreich', in *Geschichtskultur und Wissenschaft* (Munich, 1990), pp. 264–301

Hargrove, June, *The Statues of Paris: An Open-Air Pantheon: The History of Statues to Great Men* (Antwerp, 1989)

Haskell, Barbara, ed., *Claes Oldenburg, Object into Monument*, exhibition catalogue: Pasadena Art Museum (Pasadena, 1971)

Hedinger, Hans-Walter, 'Bismarck-Denkmäler und Bismarck-Verehrung', in *Kunstverwaltung, Bau- und Denkmalspolitik im Kaiserreich*, ed. E. Mai and S. Waetzold (Berlin, 1981), pp. 277–314

Heinrich, Christoph, *Strategien der Erinnerung: Der veränderte Denkmalsbegriff in der Kunst der achziger Jahre* (Munich, 1993)

Heinrichs, Johannes, 'Das Spiel mit den semiotischen Dimensionen im modernen Museum: Zur philosophischen Syntax neuer Kunst am Beispiel von Edward Kienholz' "Das tragbare Kriegerdenkmal"', *Zeitschrift für Ästhetik und Allgemeine Kunstwissenschaft*, XXV/2 (1980), pp. 244–69

Hinz, Berthold, 'Das Denkmal und sein Prinzip', in Georg Bussman, ed., *Kunst im 3. Reich: Dokumente der Unterwerfung* (Frankfurt am Main, 1980), pp. 217–30

Hoffmann-Curtius, Kathrin, 'Altäre des Vaterlandes: Kultstätten nationaler Gemeinschaft in Deutschland seit der französischen Revolution', *Anzeiger des Germanischen Nationalmuseums* (1989), pp. 283–309

Hojda, Zdenek, and Jirri Pokorny, *Pomniky a Zapomniky* (Prague, 1997)

Hünigen, Ute, 'Le Triomphe de la République: Das Republikdenkmal von Jules-Aimé Dalou im Kontext der kunstpolitischen und künstlerischen Strömungen der III Republik von 1870–1918' (PhD dissertation, Munich, 1985)

Hunisak, John, *The Sculptor Jules Dalou: Studies in His Style and Imagery* (New York, 1977)

——, 'Dalou's "Triumph of the Republic": A Study of Private and Public Meanings', in H. W. Janson, ed., *La Scultura nel xix secolo*, Atti del XXIV Congreso di Storia dell'Arte (Bologna, 1982), pp. 169–76

Hütt, Michael, and Hans-Joachim Kunst, eds, *'Unglücklich das Land das Helden nötig hat': Leben und Sterben der Kriegsdenkmäler des ersten und zweiten Weltkrieges* (Marburg, 1990)

Hutter, Peter, *'Die feinste Barbarei': Das Völkerschlachtdenkmal bei Leipzig* (Mainz, 1990)

Inglis, Ken S., 'Grabmäler für unbekannte Soldaten', in *Die Neue Wache Unter den Linden: Ein deutsches Denkmal im Wandel der Geschichte*, ed. Christoph Stölzl (Berlin, 1993), pp. 151–70

Jahan, Pierre, 'La Mort et les statues', *Gazette des Beaux-Arts* (March 1974), pp. 153–6

Janson, Horst W., *The Rise and Fall of the Public Monument* (Tulane University, 1976)

——, *19th Century Sculpture* (New York, 1985)

Jenni, Ulrike, *Alfred Hrdlicka: Mahnmal gegen Krieg und Faschismus* (Graz, 1993)

230

Jens, Walter, ed., *Streit um die Neue Wache: Zur Gestaltung einer zentralen Gedenkstätte* (Berlin, 1993)

Judrin, C., D. Viéville and M. Laurent, *Auguste Renoir: Le Monument des Bourgeois de Calais (1884–1895)*, exhibition catalogue (Calais, 1977)

Kazuss, Igor, 'Stalin und der Palast der Sowjets', in *Tyrannei des Schönen: Architektur der Stalin-Zeit*, ed. P. Noever, exhibition catalogue (Vienna, 1944), pp. 151–64

Keller, Katrin, and Hans-Dieter Schmid, eds, *Vom Kult zur Kulisse: Das Völkerschlachtdenkmal als Gegenstand der Geschichtskultur* (Leipzig, 1995)

Kerssen, Ludger, *Das Interesse am Mittelalter im deutschen Nationaldenkmal* (Berlin, 1975)

Kloss, Günter, *Bismarck-Türme und Bismarck-Säulen in Deutschland* (Petersberg, 1997)

Koselleck, Reinhart, 'Kriegerdenkmale als Identitätsstiftungen der Überlebenden', in *Identität: Poetik und Hermeneutik*, VIII, ed. O. Marquard and K. H. Stierle (Munich, 1979), pp. 255–76

—— and Michael Jeismann, eds, *Der politische Totenkult: Kriegerdenkmäler in der Moderne* (Munich, 1994)

Krauss, Rosalind E., *Passages in Modern Sculpture* (London, 1977)

Kuntzemüller, Otto, *Die Denkmäler Kaiser Wilhelm des Grossen in Abbildung mit erläuterndem Text* (Bremen, 1902)

Ladendorf, Heinz, 'Das Denkmal der Luftbrücke', *Giessener Beiträge zur Kunstgeschichte*, I (1970), pp. 205–20

Lanfranchi, Jacques, 'Statues de Paris, 1800–1940: Les Statues de grands hommes élevées à Paris des lendemains de la Révolution à 1940' (PhD dissertation, Paris, 1979)

Laumann-Kleineberg, Antje, *Denkmäler des 19. Jahrhunderts im Widerstreit: Drei Fallstudien zur Diskussion zwischen Auftraggebern, Planern und öffentlichen Kritikern* (Frankfurt am Main, 1989)

Lichtenstern, Christa, *Pablo Picasso: Denkmal für Apollinaire: Entwurf zur Humanisierung des Raumes* (Frankfurt am Main, 1988)

Lipp, Wilfried, *Natur – Geschichte – Denkmal: Zur Entstehung des Denkmalsbewusstseins der bürgerlichen Gesellschaft* (Frankfurt am Main and New York, 1987)

——, ed., *Denkmal – Werte – Gesellschaft: Zur Pluralität des Denkmalsbegriffs* (Frankfurt am Main and New York, 1993)

Lurz, Meinhold, 'Die Kriegerdenkmalsentwürfe von Wilhelm Kreis', in Berthold Hinz, ed., *Die Dekoration der Gewalt: Kunst und Medien im Faschismus* (Gießen, 1979), pp. 185–97

——, *Kriegerdenkmäler in Deutschland*, vols I–VI (Heidelberg, 1985–7)

Mai, Ekkehard, 'Von 1930 bis 1945: Ehrenmäler und Totenburgen', in W. Nerdinger and E. Mai, eds, *Wilhelm Kreis: Architekt zwischen Kaiserreich und Demokratie 1873–1955* (Munich, 1994), pp. 156–67

——, and Gisela Schmirber, eds, *Denkmal – Zeichen – Monument: Skulpturen und öffentlicher Raum heute* (Munich, 1989)

Mai, Gunther, ed., *Das Kyffhäuser-Denkmal 1896–1996: Ein nationales Denkmal im europäischen Kontext* (Köln and Vienna, 1997)

Marling, Karal Ann, and John Wetenhall, *Iwo Jima, Monuments, Memories and the American Hero* (Cambridge, MA, and London, 1991)

Martin, Jean Hubert, *Malévitch: Oeuvres de Casimir Severinovitch Malévitch (1878–1935)*, exhibition catalogue (Paris, 1980)

McWilliam, Neil, 'Monuments, Martyrdom and the Politics of Religion in the Third Republic', *Art Bulletin*, LXXVII (June 1995), pp. 186–206

Metken, Günter, 'Die Kunst des Verschwindens: Unsichtbare Denkmäler – ein Situationsbericht', *Merkur*, XLVIII (June 1994), pp. 478–90

Metschies, Michael, 'Rekonstruktion als Bereinigung der Geschichte? Zur

Wiederbelebung von Denkmälern der preußisch-deutschen Vergangenheit', *Rheinische Heimatpflege*, XXXIII (1996), pp. 174–83

Michalski, Sergiusz, 'Die Pariser Denkmäler der III. Republik und die Surrealisten', *Idea*, VII (1988), pp. 91–107

Mitchell, W. J. T., ed., *Art and the Public Sphere* (Chicago and London, 1992)

Mittig, Hans-Ernst, 'Zu Joseph Ernst von Bandels Hermannsdenkmal im Teutoburger Wald', *Lippische Mitteilungen aus Geschichte und Landeskunde*, XXXVII (1968), pp. 200–23

——, 'Die Entstehung des ungegenständlichen Denkmals', in *Actes du XXII Congrés International d'Histoire de l'Art* (Budapest, 1972), vol. II, pp. 469–74

——, 'Das Denkmal', in W. Busch, ed., *Funkkolleg Kunst: Eine Geschichte der Kunst im Wandel ihrer Funktionen*, vol. II (Munich and Zurich, 1991), pp. 532–59

——, 'Gegen den Abriß des Berliner Lenin-Denkmals', in B. Kremer, ed., *Demontage . . . revolutionärer oder restaurativer Bildersturm* (Berlin, 1992), p. 44f.

——, 'Auf der Suche nach Alternativen zum Mahnmal', in *Kunst und Literatur nach Auschwitz* (Berlin, 1993), p. 158ff.

——, and Volker Plagemann, *Denkmäler im 19 Jh., Deutung und Kritik* (Munich, 1972)

Moriarty, Catherine, 'The Absent Dead and Figurative World War Memorials', *Transactions of the Ancient Monuments Society*, XXXIX (1995), pp. 7–40

Mosse, George L., *Fallen Soldiers: Reshaping the Memory of the World Wars* (New York and London, 1990)

Müller, H., 'Denkmalsstil und Menschenbild im 19 Jh.', *Jahrbuch des Preussischen Kulturbesitzes*, XIV (1977), pp. 241–71

Müller-Bohn, H., *Die Denkmäler Berlins: Ihre Geschichte und Bedeutung* (Berlin, 1905)

Musil, Robert, 'Die Denkmale', in *Gesammelte Werke II: Prosa und Stück, Kleine Prosa, Aphorismen, Autobiographisches, Essays und Reden, Kritik* (Reinbek, 1978), pp. 506–9

Muther, Richard, 'Die Denkmalsseuche', in Richard Muther, *Aufsätze über bildende Kunst* (Berlin, 1914), vol. II, pp. 59–68

Nairne, Sandy, and Nicholas Serota, *British Sculpture in the Twentieth Centuty* (London, 1981)

Neue Gesellschaft für Bildende Kunst, *Inszenierung der Macht: Ästhetische Faszination im Faschismus* (Berlin, 1987)

——, *Denkmal für die ermordeten Juden Europas: Eine Streitschrift* (Berlin, 1995)

Nicolai, Bernd, 'Das Nationaldenkmal für Kaiser Wilhelm I auf der Schlossfreiheit', in H. Engel and W. Ribbe, eds, *Hauptstadt Berlin – wohin mit der Mitte?* (Berlin, 1993), pp. 115–23

——, and Kristine Pollack, 'Kriegerdenkmäler – Denkmäler für den Krieg?', in Akademie der Künste, ed., *Skulptur und Macht* (Berlin, 1983), pp. 61–93

Nipperdey, Thomas, 'Nationalidee und Nationaldenkmal in Deutschland im 19. Jh.', *Historische Zeitschrift*, CCVI (1968), pp. 529–85

Nora Pierre, ed., *Les Lieux de mémoire*, vols I: *La République* (Paris, 1984); III: *La Nation* (Paris, 1986)

Oldenburg, Claes, *Proposals for Monuments and Buildings, 1965–1969* (Chicago, 1969)

Overesch, Manfred, *Buchenwald und die DDR oder die Suche nach Selbstlegitimation* (Göttingen, 1995)

Penny, Nicholas, 'English Sculpture and the First World War', *Oxford Art Journal*, II (November 1981), pp. 36–42

Pfütze, Hermann, 'Unsichtbar – versenkt – im Traum: Mahnmale und öffentliche Skulpturen von Jochen Gerz', *Merkur*, LI (February, 1997), pp. 128–37

Pingeot, Anne, ed., *La Sculpture française au XIXe siècle*, exhibition catalogue (Paris, 1986)

Plagemann, Volker, *Vaterstadt, Vaterland … Denkmäler in Hamburg* (Hamburg, 1986)

——, ed., *Kunst im öffentlichen Raum: Anstöße der 8oer Jahre* (Köln, 1989)

Poiré, Eugène, *Les Monuments nationaux en Allemagne* (Paris, 1908)

Poisson, Georges, *Guide des statues de Paris* (Paris, 1990)

Pótó, Janos, 'So wurde das Budapester Stalin-Denkmal errichtet', in *The Stalinist Model in Hungary*, ed. F. Glatz (Budapest, 1990), pp. 117–36

Präger, Christmut, 'Das Werk des Architekten Bruno Schmitz (1858–1916)' (PhD dissertation, Heidelberg, 1990)

Probst, Volker G., *Bilder vom Tode: Studien zum deutschen Kriegerdenkmal am Beispiel des Pietà-Motivs* (Hamburg, 1986)

Puvogel, Ulrike, ed., *Gedenkstätten für die Opfer des Nationalsozialismus* (Bonn, 1987)

Raith, Frank-Bertolt, *Der heroische Stil: Studien zur Architektur am Ende der Weimarer Republik* (Berlin, 1997)

Read, Herbert, ed., *International Sculpture Competition: The Unknown Political Prisoner*, exhibition catalogue (London, 1953)

Reck, Hans Ulrich, 'Inszenierung der Todesparadoxie zwischen Magie und Historie: Zur Sprache der Denkmäler im 20 Jh.', *Kunstforum International*, CXXVII (July–September 1994), pp. 184–215

Reichel, Peter, *Politik mit der Erinnerung: Gedächtnisorte im Streit um die national-sozialistische Vergangenheit* (Munich and Vienna, 1995)

——, 'Berlin nach 1945 – eine Erinnerungslandschaft zwischen Gedächtnis-Verlust und Gedächtnis-Inszenierung', in H. Hipp and E. Seidl, eds, *Architektur als politische Kultur* (Berlin, 1996), pp. 273–96

Reinartz, Dirk, and Christian Graf von Krockow, *Bismarck, Vom Verrat der Denkmäler* (Göttingen, 1991)

Reusse, Felix, *Das Denkmal an der Grenze seiner Sprachfähigkeit* (Stuttgart, 1995)

Reynolds, Donald Martin, *Monuments and Masterpieces: Histories and Views of Public Sculptures in New York* (New York, 1988)

Rittich, Werner, *Architektur und Bauplastik der Gegenwart* (Berlin, 1938)

Rive, Philippe, and Annette Becker, eds, *Monuments de mémoire: Les Monuments aux morts de la première guerre mondiale* (Paris, 1991)

Roettig, Petra, '"Proletarier der Welt vergibt mir": Von der Inschrift zu den Graffiti-Formen der Denkmalkommentare', *Neue Zürcher Zeitung* (11 September 1992)

Roos, Jane Mayo, 'Rodin's Monument to Victor Hugo: Art and Politics in the Third Republic', *Art Bulletin*, LXVIII (1986), pp. 632–56

Rother, Rainer, ed., *Die letzten Tage der Menschheit: Bilder des ersten Weltkrieges*, exhibition catalogue: Deutsches Historisches Museum, Berlin (Berlin, 1994)

Rüger, Maria, 'Das Berliner Lenin-Denkmal', *Kritische Berichte*, XX (1992), pp. 36–44

Rürup, Reinhard, *Topographie des Terrors: Gestapo, SS und Reichssicherheits-hauptamt auf dem 'Prinz-Albrecht-Gelände': Eine Dokumentation* (Berlin, 1989)

Schäche, Wolfgang, 'Die Totenburgen des Nationalsozialismus', *Arch +*, 71 (October 1983), pp. 72–5

Scharf, Helmut, *Zum Stolze der Nation: Deutsche Denkmäler im 19. Jahrhundert* (Dortmund, 1983)

——, *Kleine Kunstgeschichte des deutschen Denkmals* (Darmstadt, 1984)

Scharfe, Siegfried, *Deutschland über alles – Ehrenmale des Weltkrieges* (Königstein i. T. and Leipzig, 1940)

Schmid, Erik, *Staatsarchitektur der Ära Mitterrand in Paris: Ästhetische Konzeption und politische Wirkung* (Regensburg, 1996)

Schmidt, Hans, *Das Hermannsdenkmal im Spiegel der Welt* (Detmold, 1974)

Schmidt, Hans-Werner, *The Portable War Memorial: Moralischer Appell und politische Kritik* (Frankfurt am Main, 1988)

Schmidt, Thomas E., Hans-Ernst Mittig and Vera Böhm, eds, *Nationaler*

Totenkult: Die Neue Wache: Eine Streitschrift zur zentralen deutschen
Gedenkstätte (Berlin, 1995)

Schnabel, Franz, 'Die Denkmalskunst und der Geist des 19. Jahrhunderts', Die
Neue Rundschau, I (1939), pp. 415–36

Schneckenburger, Manfred, Aushäusig: Kunst für öffentliche Räume
(Regensburg, 1974)

Schneider-Gross, Mechthild, 'Denkmäler für Künstler im 19 Jh. in Frankreich'
(PhD dissertation, Frankfurt, 1977)

Schönfeld, Martin, '"Erhalten, zerstören, verändern": Diskussionsprozesse um
die politischen Denkmäler der DDR in Berlin', Kritische Berichte, XIX (1991),
pp. 39–43

Schrade, Hubert, Das deutsche Nationaldenkmal: Idee, Geschichte, Aufgabe
(Munich, 1934)

Schubert, Dietrich, 'Das Denkmal für die Märzgefallenen 1920 von Walter
Gropius und seine Stellung in der Geschichte des neueren Denkmals',
Jahrbuch der Hamburger Kunstsammlungen, XXI (1976), pp. 199–230

——, 'Die Wandlung eines expressionistischen Kriegerdenkmals: Bernhard
Hoetgers "Niedersachsenstein" 1915–1922', Wallraf-Richartz Jahrbuch, XLIV
(1983), pp. 285–306

——, 'Hamburger Feuersturm und Cap Arcona: Zu Alfred Hrdlickas
Gegendenkmal in Hamburg', Kritische Berichte, XV (1987), pp. 8–18

Schuchard, Jutta, and Horst Claussen, eds, Vergänglichkeit und Denkmal:
Beiträge zur Sepulkralkultur (Bonn, 1985)

Schulte-Strathaus, Ulrike Jehle, and Bruno Reichlin, Il segno della memoria
1945–1995: BBPR monumento ai caduti nei campi nazisti (Milan, 1995)

Seeger, Karl von, Das Denkmal des Weltkrieges (Stuttgart, 1930)

Senie, Harriet, ed., Contemporary Public Sculpture: Tradition, Transformation and
Controversy (Oxford, 1992)

——, and Sally Webster, eds, Critical Issues in Public Art: Content, Context and
Controversy (New York, 1992)

Sinkó, Katalin, 'Political Rituals: The Raising and Demolition of Monuments',
in Art and Society in the Age of Stalin, ed. Peter György and Hedvig Turai
(Budapest, 1992), pp. 73–86

Soupault, Philippe, Les derniéres nuits de Paris [1928] (Paris, 1975)

Spielmann, Jochen, 'Entwürfe zur Sinngebung des Sinnlosen: Zu einer Theorie
des Denkmals als einer Manifestation des "kulturellen Gedächtnisses":
Der Wettbewerb für ein Denkmal in Auschwitz' (PhD dissertation, Berlin,
1990)

Springer, Peter, 'Rhetorik der Standhaftigkeit: Monument und Sockel nach
dem Ende des traditionellen Denkmals', Wallraf-Richartz Jahrbuch,
XLVIII–XLIX (1987–8), pp. 365–408

——, 'Peter Behrens' Bismarck-Monument: Eine Fallstudie', Niederdeutsche
Beiträge zur Kunstgeschichte, XXXI (1992), pp. 129–207

Stather, Martin, Die Kunstpolitik Wilhelms III (Konstanz, 1994)

Steinhauser, Monika, 'On Jochen Gerz's Memorials', Daidalos, XLIX (1993),
pp. 104–14

Stites, Richard, Utopian Dreams and Experimental Life in the Russian Revolution
(New York and Oxford, 1989)

Stölzl, Christoph, ed., Die Neue Wache Unter den Linden: Ein deutsches Denkmal
im Wandel der Geschichte (Berlin 1993)

Stommer, Rainer, Die inszenierte Volksgemeinschaft: Die 'Thing-Bewegung' im
Dritten Reich (Marburg, 1985)

Stuhr, Michael, 'Das Kyffhäuser-Denkmal: Symbol und Gehalt', in Historismus
– Aspekte zur Kunst des 19 Jh., ed. K. H. Klingenburg (Berlin, 1986),
pp. 157–82

Sturm, Hermann, 'Ästhetische Zeichen des Todes: Kenotaph und Nekropole',
Zeitschrift für Semiotik, XI (1989), pp. 183–200

Tacke, Charlotte, *Denkmal im sozialen Raum: Nationale Symbole in Deutschland und Frankreich im 19 Jh.* (Göttingen, 1995)

Tamms, Friedrich, 'Die Kriegsehrenmäler von Wilhelm Kreis', *Kunst im Dritten Reich*, VII/3 (1943), p. 50f.

Tarchanow, Alexej, and Sergej Kawtoradse, *Stalinistische Architektur* (Munich, 1992)

Taylor, John, 'London's Latest "Immortal": The Statue to Sir Arthur Harris of Bomber Command', *Kritische Berichte*, XX (1992), pp. 96–102

Taylor, Robert R., *The Word in Stone – The Role of Architecture in the National Socialist Ideology* (Berkeley and Los Angeles, 1974)

Tazbir, Janusz, 'Wojna na Pomniki', *Polityka*, no. 2046 (20 July 1996), pp. 3–8

Timm, Albrecht, *Der Kyffhäuser im deutschen Geschichtsbild* (Göttingen, 1961)

Tittel, Lutz, *Das Niederwalddenkmal 1871–1883* (Hildesheim, 1979)

——, 'Monumentaldenkmäler von 1871–1918 in Deutschland: Ein Beitrag zum Thema Denkmal und Landschaft', in *Kunstverwaltung, Bau- und Denkmalspolitik im Kaiserreich*, ed. E. Mai and S. Waetzold (Berlin, 1981), p. 215ff.

Traeger, Jörg, 'Über die Säule der Großen Armee auf der Place Vendôme in Paris', in *Festschrift für Wolfgang Braunfels*, ed. F. Piel and J. Traeger (Tübingen, 1977), pp. 405–18

Trier, Eduard, 'Notizen zum neuen Denkmal', in *Der Mensch und die Künste: Festschrift für Heinrich Lützeler* (Düsseldorf, 1962), pp. 494–99

Trimborn, Jürgen, 'Denkmäler als Wirklichkeit und Traum: Zum Umgang mit politisch-historischen Denkmälern der deutschen Vergangenheit', *Alte Stadt*, XXII (1995), pp. 175–93

Tumarkin, Nina, *Lenin Lives! The Lenin Cult in Soviet Russia* (Cambridge, MA, 1983)

Unfried, Berthold, 'Gedächtnis und Geschichte: Pierre Nora und die lieux de mémoire', *Österreichische Zeitschrift für Geschichtswissenschaft*, II (1991), pp. 79–98

Vogt, Adolph-Max, *Boullées Newton-Denkmal: Sakralbau und Kugelidee* (Basel and Stuttgart, 1969)

Vogt, Arnold, *Den Lebenden zur Mahnung: Denkmäler und Gedenkstätten: Zur Traditionspflege und historischer Identität vom 19. Jahrhundert bis zur Gegenwart* (Hannover, 1993)

Vomm, Wilhelm, 'Reiterstandbilder des 19. und frühen 20. Jahrhunderts in Deutschland' (PhD dissertation, Köln, 1979)

Walsh, Jeffrey, and James Aulich, eds, *Vietnam Images: War and Representation* (London, 1989)

Walter, Rodolphe, 'Un Dossier délicat: Courbet et la colonne Vendôme', *Gazette des Beaux-Arts*, LXXXI (January 1973), pp. 173–84

Warner, Marina, *Monuments & Maidens: The Allegory of the Female Form* (London, 1985)

Warnke, Martin, *Political Landscape* (London, 1994)

Weschenfelder, Klaus, ed., *'Ein Bild von Erz und Stein': Kaiser Wilhelm am Deutschen Eck und die Nationaldenkmäler*, exhibition catalogue: Mittelrhein-Museum, Koblenz (Koblenz, 1997)

Wilhelm, Karin, 'Der Wettbewerb zum Bismarck-Nationaldenkmal in Bingerbrück (1909–1912): Ein Beitrag zum Problem der Monumentalität', *Kritische Berichte*, XV (1987), pp. 32–47

Winter, J. M., *Sites of Memory, Sites of Mourning: The Great War in European Cultural History* (Cambridge, 1995)

Winzen, Matthias, 'The Need for Public Representation and the Burden of the German Past', *Art Journal*, LXVIII (1989), pp. 309–14

Wodiczko, Krzysztof, *Art public, art critique: Textes, propos et documents* (Paris, 1995)

Young, James E., 'The Biography of a Memorial Icon: Nathan Rapoport's Warsaw Ghetto Memorial', *Representations*, xxvi (1989), pp. 69–103
——, 'The Counter-Memorial: Memory against Itself in Germany Today', *Critical Inquiry*, xviii (1992), p. 268ff.
——, *The Texture of Memory: Holocaust Memorials and Meaning* (New Haven and London, 1993)
——, ed., *Mahnmale des Holocaust: Motive, Rituale und Stätten des Gedenkens* (Munich, 1994)

Photographic Acknowledgements

The author and publishers wish to express their thanks to the following sources of illustrative material and/or permission to reproduce it:

Herbert Ahrens: 31; Judah Altmann, 100; Anders Åman: 93, 95; Archiv Rolf Spille, Delmenhorst: 46; Arkivbild Stockholm: 96; Karl Arndt: 57; Associated Press: 112; the author: 3, 4, 5, 6, 13, 17, 18, 19, 32, 33, 34, 35, 36, 37, 39, 40, 43, 47, 50, 51, 52, 56, 70, 85, 87, 89, 90, 91, 101, 102, 115, 116, 117, 118, 121, 129; Bibliothèque Nationale de France, Paris: 8, 10, 14; Mrs Rosemary Butler: 10, 106, 107, 108, 111; DACS, London, © 1998: 1, 86, 141; Hans Haacke: 141; June Hargrove: 2; Horst Hoheisel: 120; Institut für Kunstgeschichte, Technische Universität Braunschweig: 15, 16, 20, 23, 24, 26, 27, 42, 48, 49, 53, 55, 58, 69, 72, 104; Pierre Jahan/Edition Seghers (from *La Mort et les statues*, Paris, 1946): 9, 11, 21, 22; I. Kitlitschka: 84; Kulturbehörde in Hamburg: 138; Landesbildstelle Berlin: 54, 98, 99; Mittelrhein-Museum Koblenz: 28, 29; Musée Nationale d'Art Moderne, Paris: 78; Museum of Modern Art, New York (James Thrall Soby Bequest), © 1998: 1; Claes Oldenburg and Coosje van Bruggen: 119; Z. Pacholski: 97; Photothèque des Musées de la Ville de Paris: 7, 12; Projektgruppe Mahnmal, HBK Saar: 123, 124; Rheinisches Bildarchiv Köln: 114; Julia Ricker: 131; The A. V. Schusev State Research and Scientific Museum of Architecture: 71, 75, 76, 79; Stadtarchiv Koblenz: 30, 31; Franz Stoedtner: 25; Tomasz Torbus: 137, 140; Westfälischer Landesmuseum, Münster/R. Wakonigg: 126; Ulrich Windoffer (photo courtesy of Klaus Schwabe): 127, and J. P. Zajaczkowski: 73.